HOLLYWOOD *Celebrates* THE HOLIDAYS

1920–1970

Karie Bible &
Mary Mallory

Pat,
I love to sing-a with you!
Celebrate holidays in style
with old Hollywood!
Mary 12/7/15

Schiffer Publishing Ltd

4880 Lower Valley Road • Atglen, PA 19310

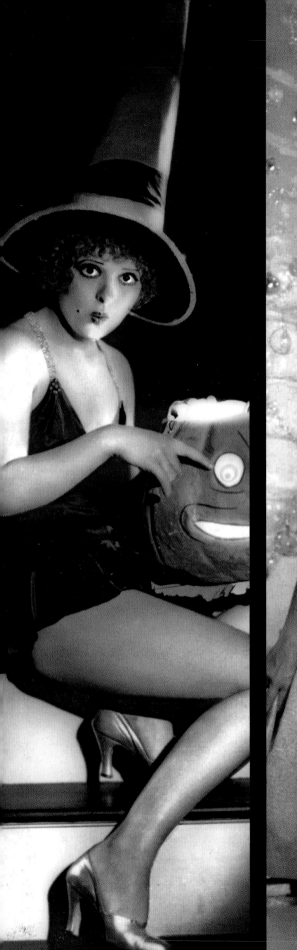
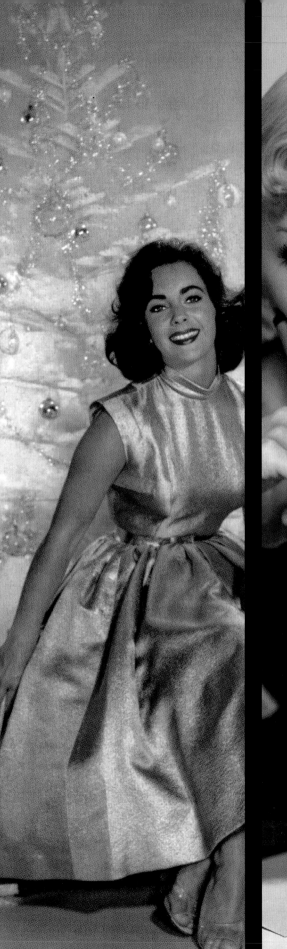
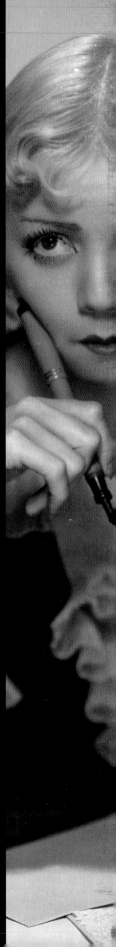

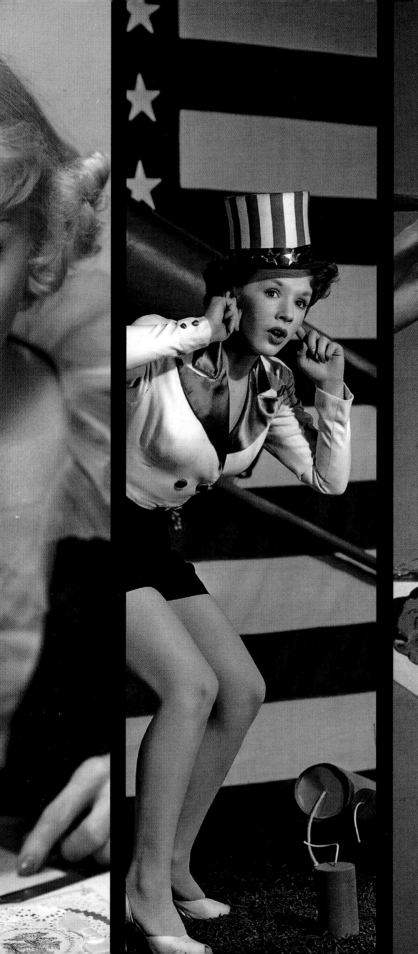
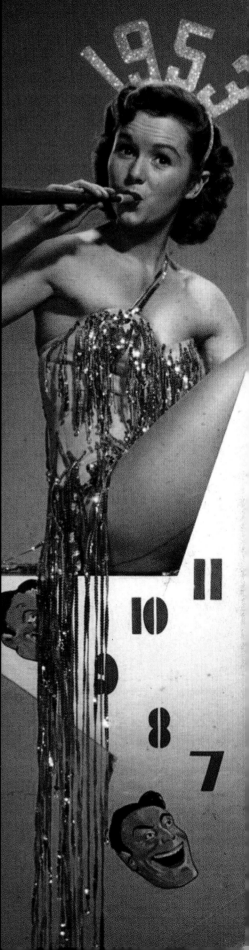

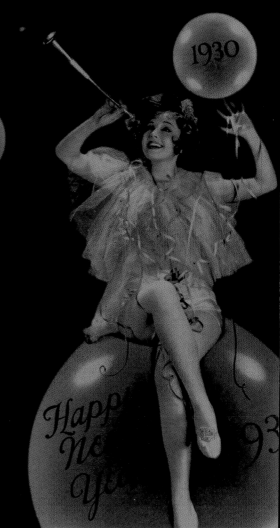

Contents

Acknowledgments

Without the gracious, generous help and knowledgeable information provided by the multi-talented Mark A. Vieira, this book would not have been possible. We appreciate contributions by other generous collectors, such as Darin Barnes, Derek Boothroyd, Thomas Gladysz, Randy Haberkamp, Donna Hill, Jeffrey Mantor, Marc Wanamaker, and Joseph Yranski. Several people, including Marc Wanamaker, Richard Bann, John Hillman, Mike Hawks, Sue Kane, Christina Rice, David Stenn, Emily Leider, and Howard Mandelbaum of Photofest, provided invaluable help and advice. Sue Slutzky generously provided resources and wonderful graphic suggestions, along with Photoshop assistance. Thanks to John Bengtson, Jason Silver, Rowena Silver, and our families.

Introduction

Thumbing through vintage fan magazines and local newspapers a few years ago, we grew fascinated with the sometimes stunning, sometimes kitschy seasonal holiday art produced for decades by Hollywood motion picture studios. On a lark, we began collecting these eye-catching images: scouring eBay, searching vintage paper shows, and visiting movie collectible stores. As our collections multiplied, we realized these striking photographs would make a captivating, exciting book.

How did film studios dream up such fantastic images to employ in publicity campaigns? They grew out of movie producers' recognition in the early 1910s that personality photographs could be employed as selling tools in a plethora of periodicals and newspapers desperate for copy and illustrated matter to fill their many editions. The studios therefore devised elaborate promotional campaigns, creating and selling fantasies of glorious stars and filmic dreams during the Golden Age of classic cinema.

To accomplish this, studios established their own publicity departments and hired stills photographers to shoot portraits, candids, and scene stills to fulfill this important purpose. These mouth-watering images would not exist without the creative eye and skill of these men who played an essential role in crafting the image of stars, composing the gorgeous photos employed in various news media. These finely crafted images captured and ignited public interest in celebrities over the next several decades.

During this same period, major businesses harnessed the power of advertising, enticing consumers into buying new goods and services, especially around holiday time. What were originally simple observances of holidays grew into elaborate spending opportunities. Costumes, decorations, and special foods were designed and packaged by companies for these special days and they heavily advertised around them. As the holidays grew in popularity, so did profits.

Newspapers and magazines quickly realized holidays could drive revenue, creating special advertising editions and allowing greater opportunities for businesses to reach consumers through this dedicated ad space. These special editions required additional material tailored around these subjects, offering wonderful publicity opportunities for studios eager to promote rising stars and established personalities.

Hollywood studios thus designed extensive publicity campaigns built around iconic and popular subjects like holidays to fill the expanding copy needs of various news media, as well as designing propaganda urging support of the war effort during World War II. Lavish attention to lighting, costuming, and detail produced gorgeous works of art in the early years, giving way to more simple, easily produced images decades later.

Hollywood's iconic images helped mythologize stereotypes around the holidays—manipulating public opinion and beliefs about how and why to celebrate—while at the same time saluting the glamour and glory of movie and television stars. These stunning photographs helped craft illusions for the world to emulate.

CHAPTER ONE

New Year's Eve

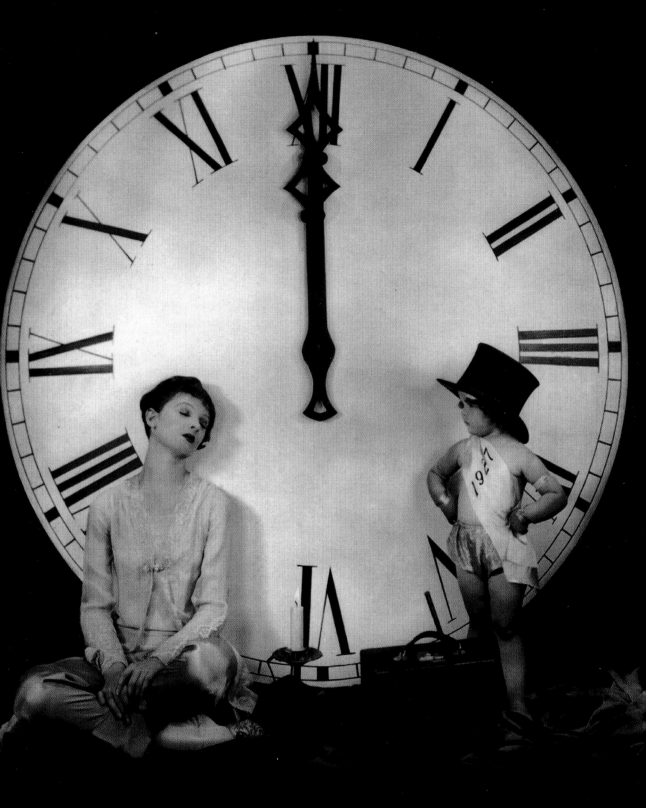

Myrna Loy falls asleep before the clock hits midnight on
New Year's Eve, much to the dismay of 1927's "Baby
New Year." The baby in this photograph is often
misidentified as Shirley Temple, who was not born until
1928. *Courtesy Author's Collection*

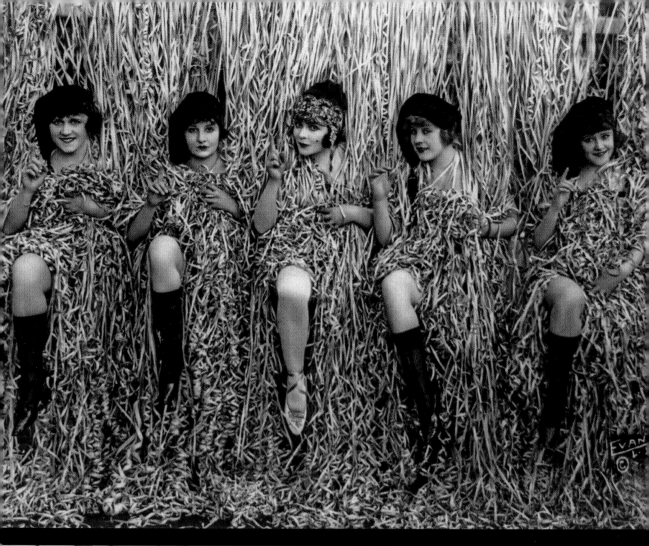

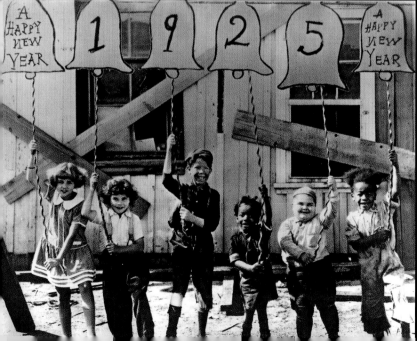

Mack Sennett's Bathing Beauties celebrate the New Year. Photographer Nelson Evans invented cheesecake photography with his shots of scantily clad young women. In 1915, they began appearing in short films and publicity photos. Keystone historian Simon Louvish said it best: "Sex and fun were a Sennett signature from day one." *Courtesy Author's Collection*

The stars of Hal Roach's *Our Gang* (aka *The Little Rascals*) ring in the New Year of 1925. Pictured left to right are Mary Kornman, Jackie Condon, Mickey Daniels, Allen "Farina" Hoskins, Joe Cobb, and Eugene Jackson, who comprised the original cast and would later be replaced by more recognizable names. *Courtesy Author's Collection*

1928

Audrey Ferris prepares for take-off at the dawn of 1928. She starred opposite Rin Tin Tin that year and was named a WAMPAS Baby Star. Ferris landed several supporting roles in the late 1920s and early 1930s, but her career quickly faded into obscurity. *Courtesy Author's Collection*

Buster Keaton makes his list of New Year's resolutions for 1929—ironically the start of a long downward spiral. His career faltered in the late 1920s when he signed with Metro-Goldwyn-Mayer. After many years of hardship, Keaton was rediscovered by a new generation and finally recognized as one of the silent era's great geniuses. *Courtesy Collections of the Margaret Herrick Library*

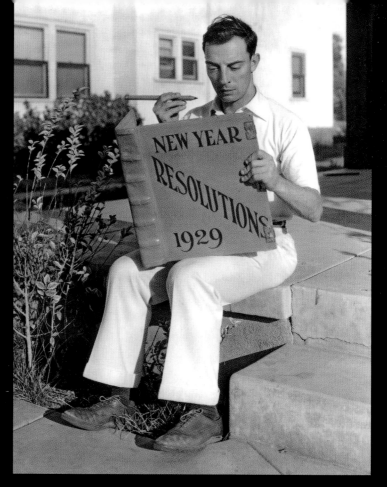

Below: Thelma Todd takes to the blacksmith shop to hammer out a New Year's greeting for 1932. Nicknamed "The Ice Cream Blonde" and "Hot Toddy," Todd proved to be a gifted comedienne. Her untimely death at twenty-nine was due to carbon monoxide poisoning, but the circumstances surrounding it remain a mystery. *Courtesy Author's Collection*

Opposite: Nancy Carroll sits atop a champagne bubble to help ring in 1930. Her effervescent, bubbly personality matched the heady, dizzying spirit of the 1920s. As the country fell further into the depths of the Great Depression, though, the dark mood of the day was reflected in the rise of more hard-boiled actresses. *Courtesy Author's Collection*

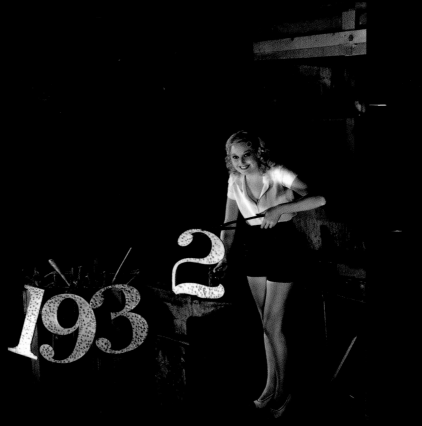

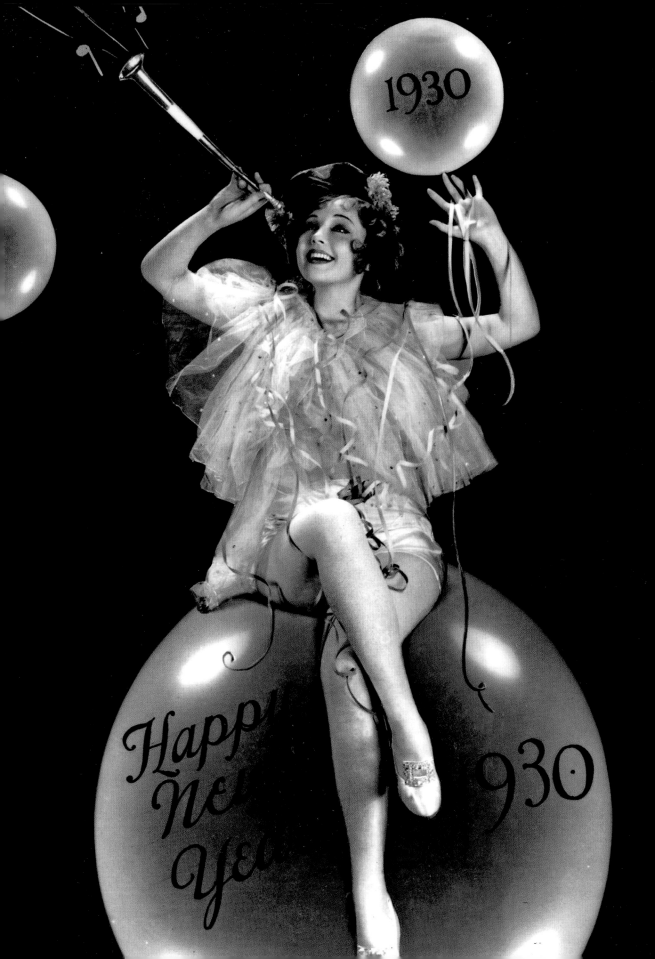

Betty Grable's New Year's Eve attire consists of a swimsuit and diamonds as she celebrates to the tune of "Auld Lang Syne." Fox insured her famous legs for one million dollars with Lloyd's of London. *Courtesy Author's Collection*

Below: Frances Drake is swathed in sequins and blowing a party horn to usher in 1935. Her screen career began in 1933, and included such notable films as *Mad Love* (1935) with Peter Lorre and *The Invisible Ray* opposite Bela Lugosi and Boris Karloff (1936). *Courtesy Author's Collection*

Opposite: Madge Evans stands amid dropped balloons celebrating a buoyant start for the year 1936. She was typecast as the "nice girl," playing supporting roles in *Dinner at Eight* (1933) co-starring Jean Harlow, *The Mayor of Hell* with James Cagney (1933), and *Pennies from Heaven* (1936) opposite Bing Crosby. *Courtesy Author's Collection*

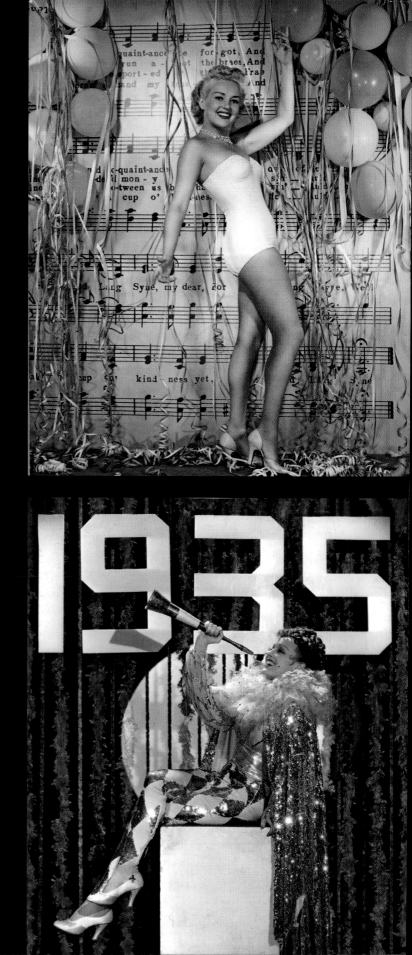

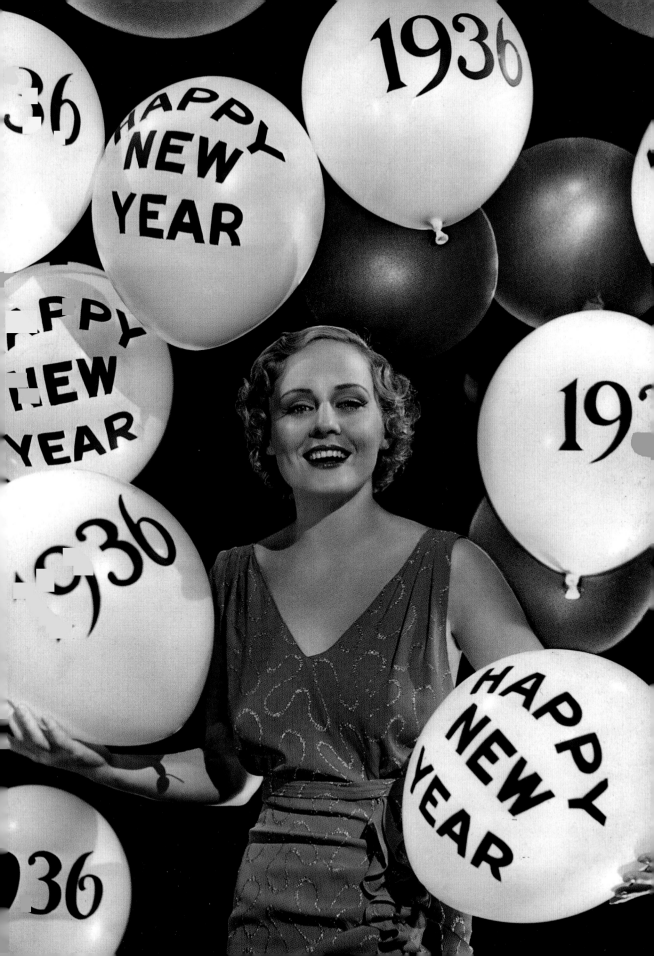

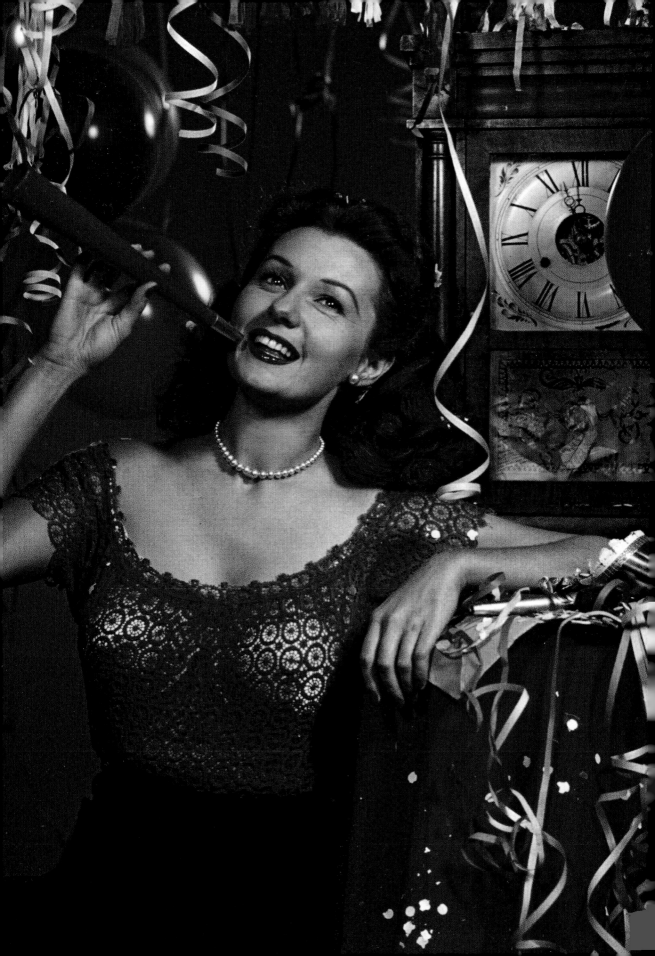

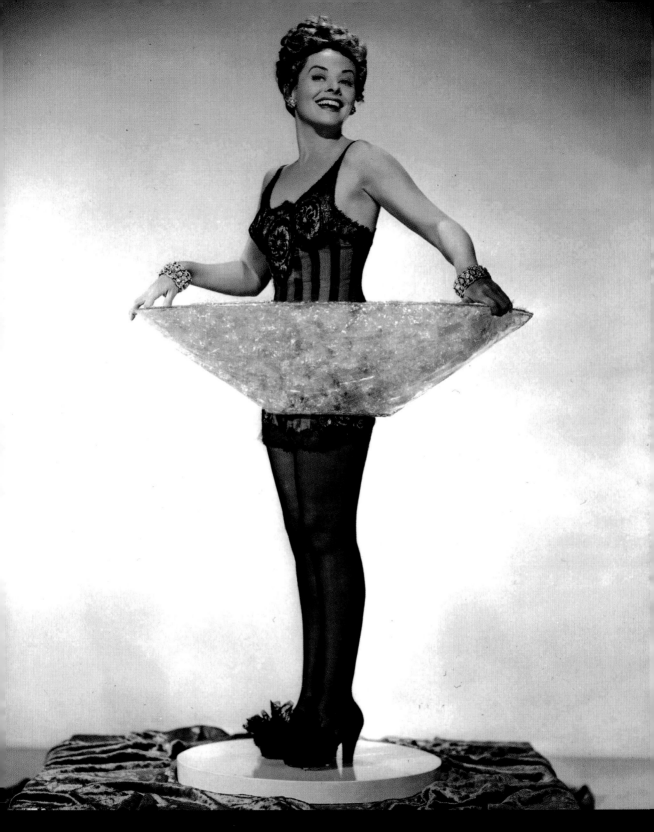

Opposite: Rhonda Fleming waits for the clock to strike midnight in this color publicity still. She starred in several Technicolor productions, including *Inferno* (1953) and *Those Redheads from Seattle* (1953). Fleming's flame red hair and creamy complexion photographed beautifully, earning her the nickname "The Queen of Technicolor." *Courtesy Author's Collection.*

Above: Paulette Goddard serves herself up as a glass of champagne for a New Year's Eve toast. She starred opposite Charlie Chaplin (her rumored husband) in *Modern Times* (1936) and *The Great Dictator* (1940). Goddard received an Academy Award® nomination for Best Supporting Actress for the World War II film *So Proudly We Hail!* (1943). *Courtesy Author's Collection.*

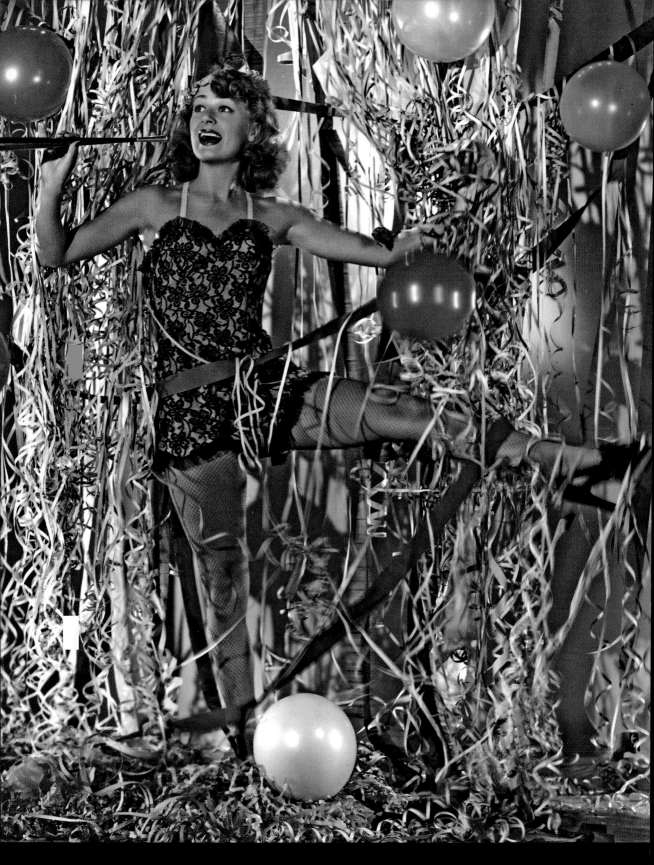

June Havoc kicks up her heels for the holidays in this publicity still from 1941. Dubbed "Baby June," she and her sister Gypsy Rose Lee were pushed into performing as children. Havoc was at her best playing tough brassy women in *Gentleman's Agreement* (1947) and *The Story of Molly X* (1949). *Courtesy Author's Collection*

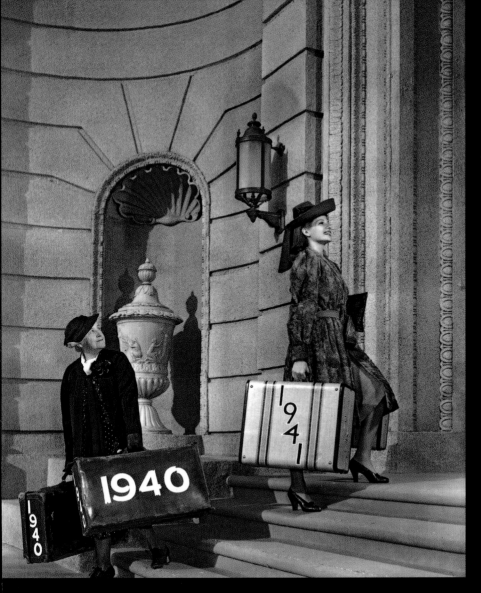

Rita Hayworth packs her suitcase and prepares for an exciting year in 1941. She became known as "The Love Goddess" of the 1940s and lit up the screen in classics including *You Were Never Lovelier* (1942), *Cover Girl* (1944), *Gilda* (1946), and *The Lady from Shanghai* (1948). *Courtesy Collections of the Margaret Herrick Library*

Comedian W. C. Fields dresses as Santa Claus and rings in 1938 in the company of some beautiful Paramount starlets. Oddly enough, he seems to be holding a doll. Perhaps it was left over from one of the children who made the "naughty" list instead of the "nice" one. *Courtesy Marc Wanamaker, Bison Archives*

19

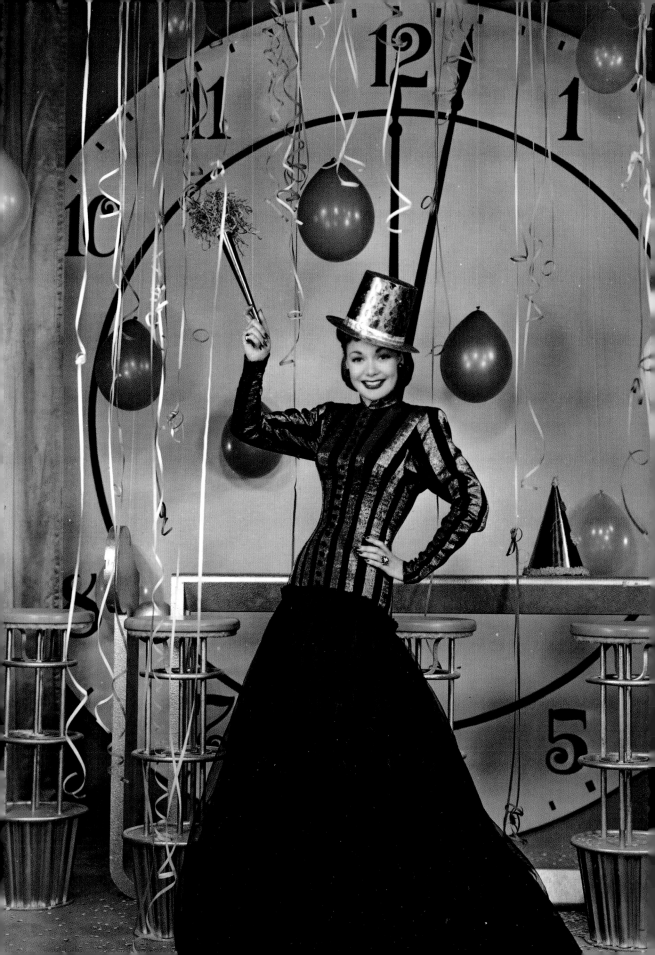

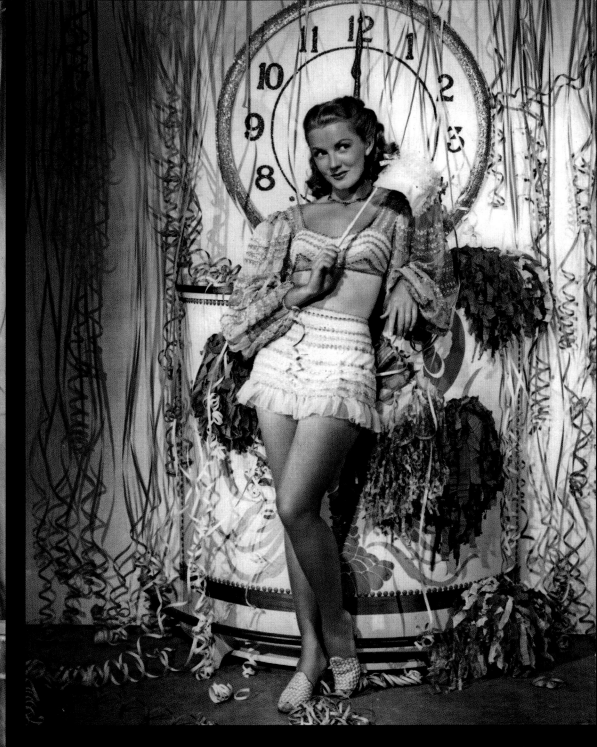

Opposite: Jane Wyman celebrates the New Year in style. Wyman co-starred in two films with her then-husband, future President Ronald Reagan. She earned four Academy Award nominations, picking up the statuette for *Johnny Belinda* (1948). In later years, she found a meaty role in the series *Falcon Crest* (1981–1990). *Courtesy Author's Collection*

Above: Phyllis Coates opts for a sparkling two-piece instead of a traditional evening gown for New Year's Eve. She is best remembered for her role as Lois Lane in *Adventures of Superman* (1952–53). In 1994, she played Lois Lane's mother in the series *Lois and Clark: The New Adventures of Superman*. *Courtesy Author's Collection*

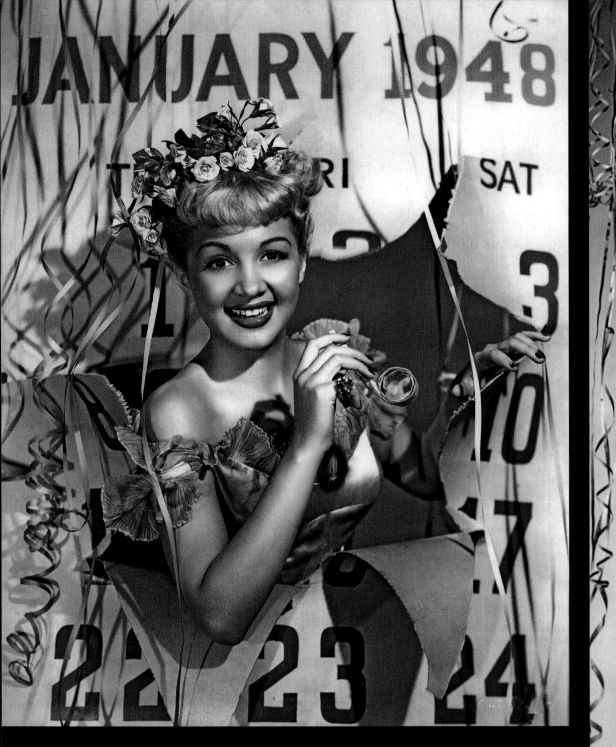

Above: Olga San Juan bursts out of a calendar, announcing the beginning of 1948. Dubbed "The Puerto Rican Pepper Pot," she became a lively, scene-stealing co-star in musicals of the 1940s, appearing with Bing Crosby in *Blue Skies* (1946) and *Variety Girl* (1947), and with Betty Grable in *The Beautiful Blonde from Bashful Bend* (1949). *Courtesy Author's Collection*

Opposite: Curvaceous Anita Ekberg celebrates the New Year while holding her small white terrier. Her seductive frolic in Rome's Trevi Fountain in Federico Fellini's *La Dolce Vita* (1960) earned her a place in film history. Ekberg remained based in Europe, where her talent was utilized in numerous films. *Courtesy Author's Collection*

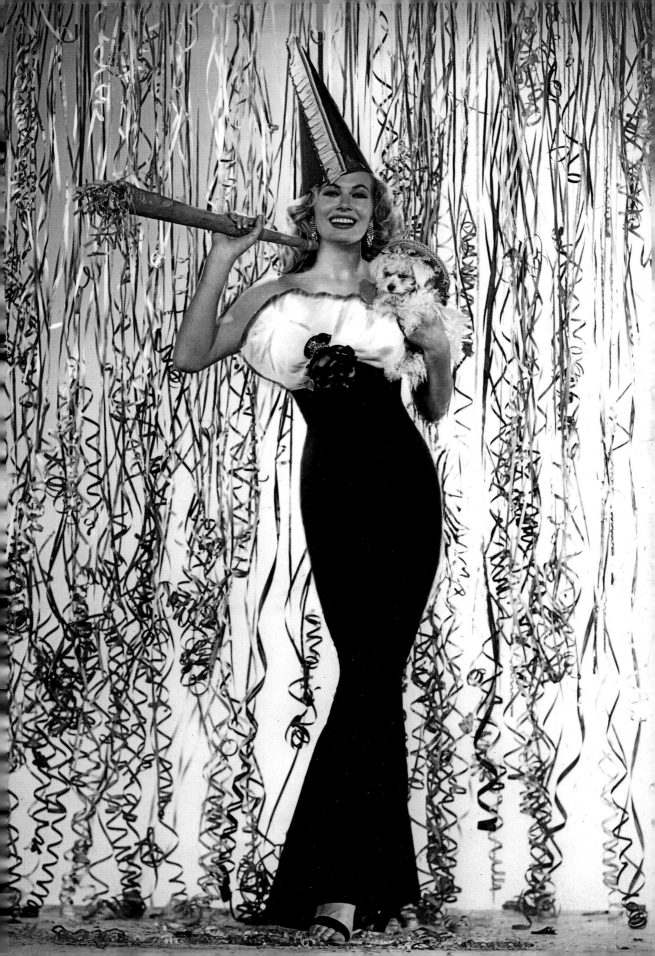

HAPPY NEW YEAR

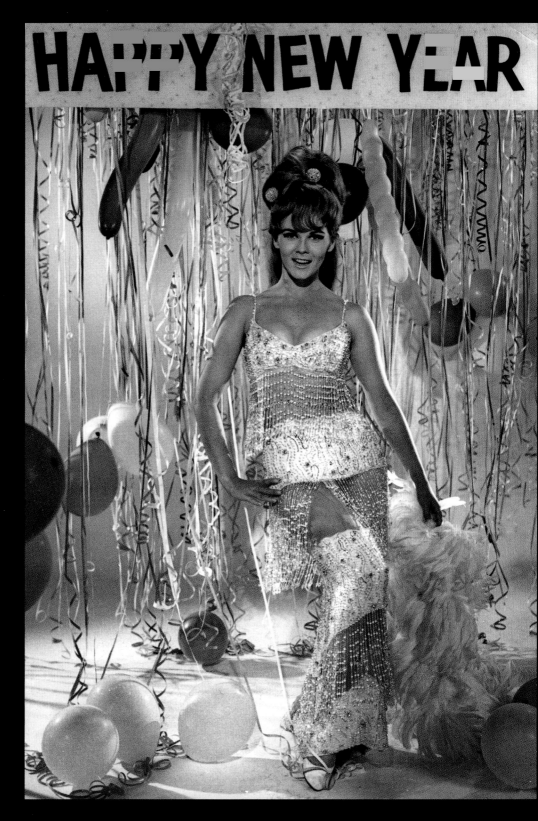

Ann-Margret greets the New Year in swingin' sixties style. She became a hot commodity, starring in *Bye Bye Birdie* (1963) and *Viva Las Vegas* (1964). In the 1970s, she transitioned to more serious roles and picked up Oscar® nominations for her performances in *Carnal Knowledge* (1971) and *Tommy* (1975). *Courtesy Author's Collection*

[VERSO:] Season Greetings Hollywood, Calif. "Gott Nytt Ar" Well that's what lovely Ann-Margret would say at this time of the year in her native Sweden. In Hollywood, where she stars in Columbia's holiday release, "Murderers' Row", the actress wishes everyone a "Happy New Year" in this manner. 12/27/66

CHAPTER TWO

Valentine's Day

Opposite: Universal contract player Kathryn Crawford and her little terrier "heart" Valentine's Day in this Ray Jones photograph. Perky Crawford appeared in early Universal talkies and musicals like *Modern Love* (1929) with Charley Chase, *Red Hot Rhythm* (1929), and *King of Jazz* (1930) with band leader Paul Whiteman before quickly retiring from the screen. *Courtesy Author's Collection*

[VERSO:] Kathryn Crawford, Universal player, includes her dog in her Valentine greetings.

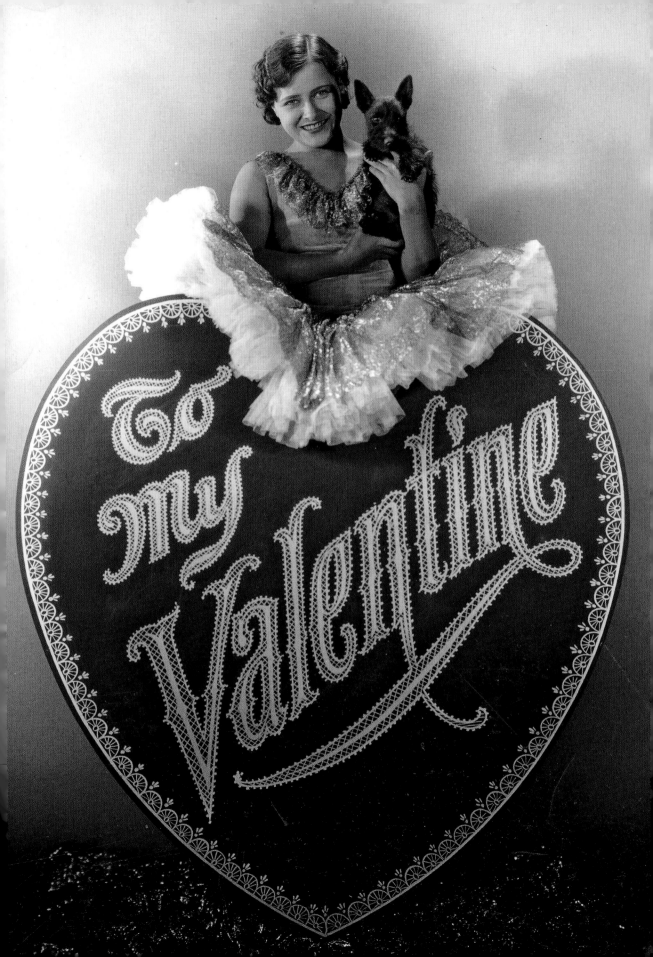

Madcap Alice White contemplates sweet nothings to write her Valentine. Bubbly and vivacious on screen, White found her showbiz break working as a secretary for director Josef von Sternberg before wisecracking her way through *Showgirl in Hollywood* (1930), *The Naughty Flirt* (1931), and *Employees' Entrance* (1933). *Courtesy Author's Collection*

[VERSO:] Alice White pauses from her "Cross Country Cruise" to send you a Valentine.

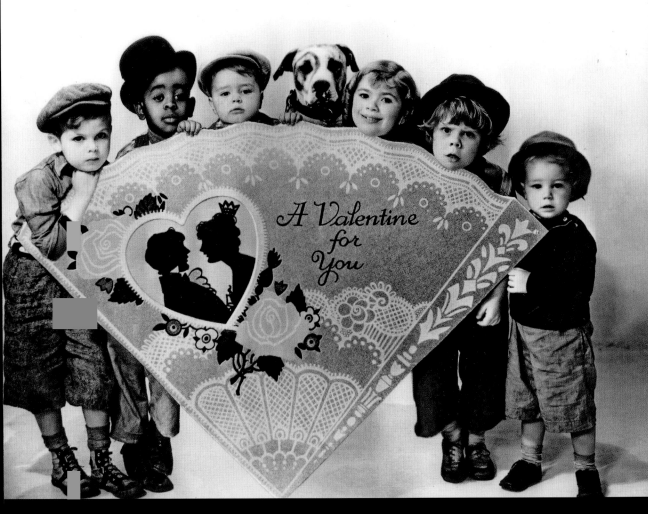

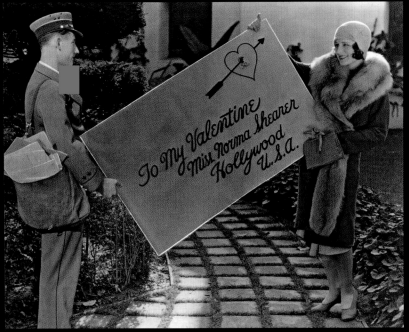

The fetching young cast of producer Hal Roach's *Our Gang* offers sweet Valentine greetings. Introduced to the screen in 1922, the beloved *Our Gang* shorts showcased cute kids performing mischievous antics. Dickie Moore, Matthew "Stymie" Beard, George "Spanky" McFarland, Petey the Dog, Dorothy De Borba, Tommy Bond, and Tommy McFarland say hello. *Courtesy Author's Collection*

Elegant Norma Shearer happily receives a giant Valentine's card from a secret admirer hand-delivered by her local postman. Rising from comely young ingénue into M-G-M's "First Lady of the Screen," Shearer successfully switched between comedy and drama throughout her career, winning an Academy Award for *The Divorcée* in 1930. *Courtesy Darin Barnes Collection*

Spunky little Mary Carlisle gives her heart to one lucky Valentine. Appearing as a party girl in Cecil B. DeMille's lavish *Madam Satan* in 1930, Carlisle rose to playing breezy, dewy-eyed coed roles opposite stars like Bing Crosby. She eventually retired from the screen after marrying James Blakeley. *Courtesy Author's Collection*

Diminutive, vulnerable Janet Gaynor sends sweet, old-fashioned Valentine greetings. Winning the first Best Actress Oscar for *Sunrise* (1927) and her romantic performances opposite Charles Farrell in *7th Heaven* (1927) and *Street Angel* (1928), Gaynor later married renowned M-G-M costume designer Gilbert Adrian and retired from the screen. *Courtesy Author's Collection*

[VERSO:] Janet Gaynor chooses an old-fashioned design for her Valentine card this year. Her next picture will be "One More Spring."

Flouncy Wynne Gibson offers an animated "I Love You" to her Valentine sweetheart. Typically playing hard-nosed dames like gangster molls and lovable tramps, Gibson appeared in such films as *Ladies of the Big House* (1931), *If I Had a Million* (1932), and *The Crime of the Century* (1933). *Courtesy Author's Collection*

Wholesome songbird Deanna Durbin offers a colorful and hearty Valentine's Day pose. Durbin's graceful coloratura voice and bubbly personality saved Universal Studios from bankruptcy in the late 1930s. She received a special Academy Award in 1938 "for bringing to the screen the spirit and personification of youth." *Courtesy Author's Collection*

VALENTINE GREETINGS

Warner Bros. features strong-willed actress Bette Davis as a special Valentine's Day treat. The fiery, opinionated thespian gained acclaim for portraying strong, liberated women in such films as *Jezebel* (1938), *The Letter* (1940), *The Little Foxes* (1941), and *All About Eve* (1950), winning two Academy Awards for her galvanizing performances. *Courtesy Author's Collection.*

Above: Statuesque young Paramount starlet Betty Grable gives a flirty Valentine's Day smile to adoring fans. Selected as American GIs' number one "pin-up girl" during World War II, Grable's peek-a-boo over her shoulder shot by photographer Frank Powolny graced many a pilot's bomber. *Courtesy Author's Collection*

Opposite: Sex vixen Marilyn Monroe sets hearts aflutter in her slinky Valentine's Day pose. Romantic heartthrob to millions of lusty males, Monroe remained unlucky in love, marrying and divorcing first husband James Dougherty, baseball legend Joe DiMaggio, and finally renowned playwright Arthur Miller. She tragically died alone in 1962. *Courtesy Author's Collection*

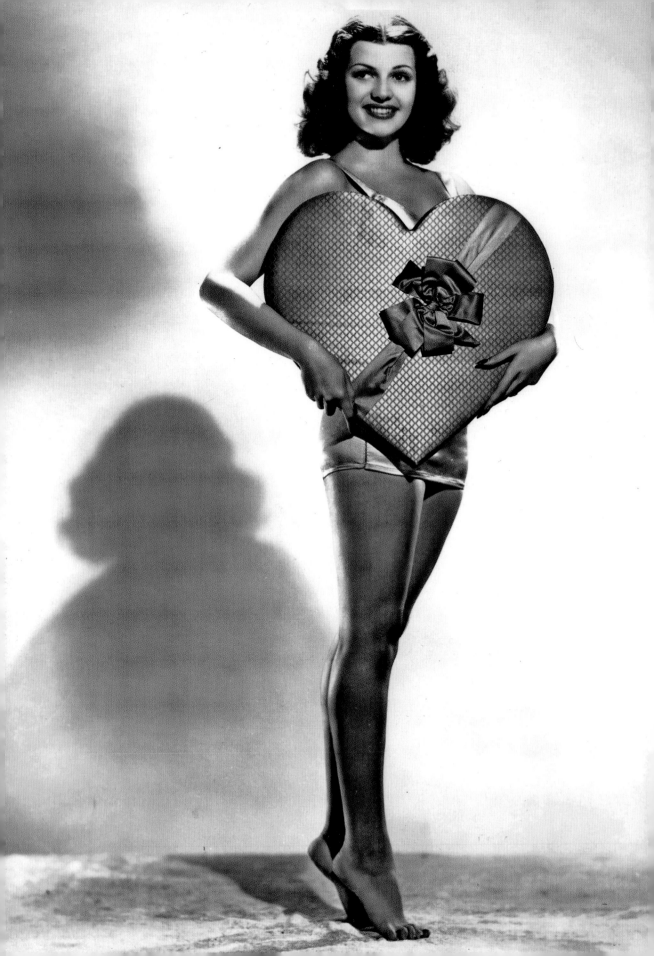

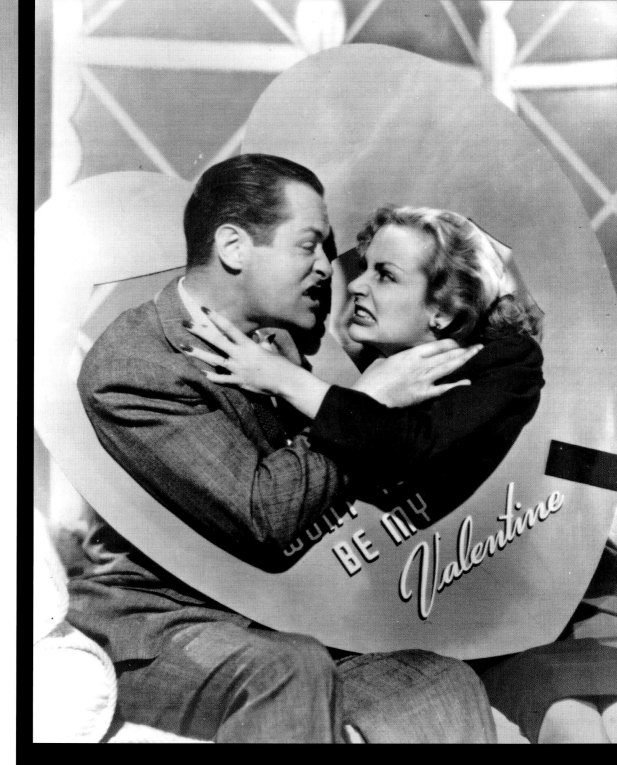

Opposite: 1940s "Love Goddess" Rita Hayworth asks "Chocolates or me?" to potential Valentine's Day suitors. Oozing sexuality in the 1946 film *Gilda*, Hayworth burned down the screen as she cooed "Put the Blame on Mame" and teasingly removed long black gloves. Her sultry portrait graced the atomic bomb dropped on Bikini Island. *Courtesy Author's Collection*

Above: Squabbling co-stars Robert Montgomery and Carole Lombard send spirited Valentine's greetings to each other. Sophisticated Montgomery and comedy queen Lombard played bickering spouses who discover they are not legally married to each other in director Alfred Hitchcock's 1941 screwball comedy *Mr. and Mrs. Smith. Courtesy Author's Collection*

Scantily clad Cupid Peggy Knudsen seeks out Prince Charming on Valentine's Day. Nicknamed "The Lure," confident, curvaceous Knudsen appeared in *The Big Sleep* (1946) and *Humoresque* (1946), but stardom seemed to elude her. Relegated to one-dimensional tough-girl parts, she eventually turned to television. *Courtesy Author's Collection*

A scantily clad Charlie McCarthy sets minds reeling as a pint-sized Cupid. Artfully blending a toddler's body, butterfly wings, and refined Charlie's head, this 1940s version of Photoshop emits creepy and frightening vibes. Ventriloquist Edgar Bergen's sarcastic zingers and impeccable timing darkened the edges of the debonair little puppet. *Courtesy Author's Collection*

Sensuous, haughty Yvonne De Carlo flaunts her flesh in this sexy Valentine's Day pose. Best remembered for starring in the iconic 1960s television show *The Munsters*, De Carlo ignited film screens with her roles in *The Song of Scheherazade* (1947), *Brute Force* (1947), and *Criss Cross* (1949). *Courtesy Author's Collection*

Refined, elegant Audrey
Hepburn shoots from the
heart on this Valentine's
Day. Making her American
debut in the romantic
comedy *Roman Holiday*
(1953) with Gregory Peck,
Hepburn gave her
characters a touch of
dignity and class with her
wholesome and innocent
appeal. She later served as a
United Nations UNICEF
special ambassador.
Courtesy Author's Collection

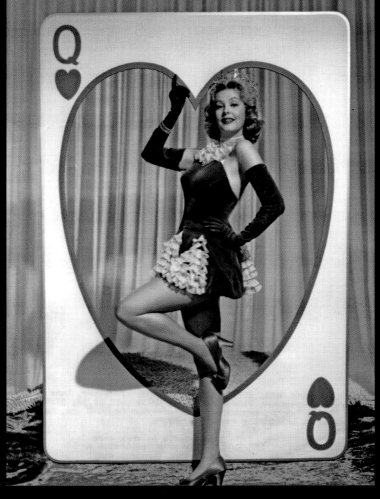

Sultry Arlene Dahl serves as a sensuous Queen of Hearts, captivating potential Valentines. Married six times—including to actors Lex Barker and Fernando Lamas—Dahl played elegant femme fatales throughout her career. Leaving motion pictures behind, she became a beauty columnist, writer, and marketer of lingerie and cosmetics. *Courtesy Author's Collection*

French waif Leslie Caron offers a little "ooh la la" for a tantalizing Valentine's Day treat. Discovered by legendary dancer Gene Kelly for the film *An American in Paris* (1951), vulnerable Caron stole hearts in *Daddy Long Legs* (1955) opposite Fred Astaire and as the courtesan *Gigi* in 1958. *Courtesy Author's Collection*

Above: Southern belle Julie Adams' sharp smiles pierce hearts for Valentine's Day. Starring as Julia Adams in films *Hollywood Story* (1951) and *Bend of the River* (1952), the actress gained immortal fame for her role in the 1954 science fiction cult classic *Creature From the Black Lagoon*. *Courtesy Author's Collection*

[VERSO:] ON GUARD! SHE'LL TOUCH YOUR HEART All set to match her foils with Dan Cupid's bow and arrow on St. Valentine's Day is Julia Adams, new dazzler on the Hollywood horizon. She gets star billing for the first time in "Bend of the River," Universal-International's big outdoor drama teaming her with James Stewart and Arthur Kennedy. Other new films bringing Julia to the screen shortly include "Finders Keepers," a comedy starring her with Tom Ewell and Evelyn Varden, and "Treasure of Lost Canyon," in which Julia stars with William Powell, Rosemary DeCamp and Charles Drake.

Opposite: Sweet, innocent Yvette Mimieux cherishes Valentine chocolates and gifts from her sweetheart. Achieving big screen success in the dystopian *The Time Machine* and the teen romance *Where the Boys Are*—both in 1960—Mimieux often played otherworldly roles. She was married to legendary musical director Stanley Donen for thirteen years. *Courtesy Author's Collection*

[VERSO:] SWEET VALENTINE....A box of sweets from her sweetheart, that's what lovely young MGM star Yvette Mimieux received Valentine's Day. Now starring in George Pal's Production, "The Time Machine," she's soon to be seen in "Platinum High School," an Albert Zugsmith Production, both Metro-Goldwyn-Mayer releases.

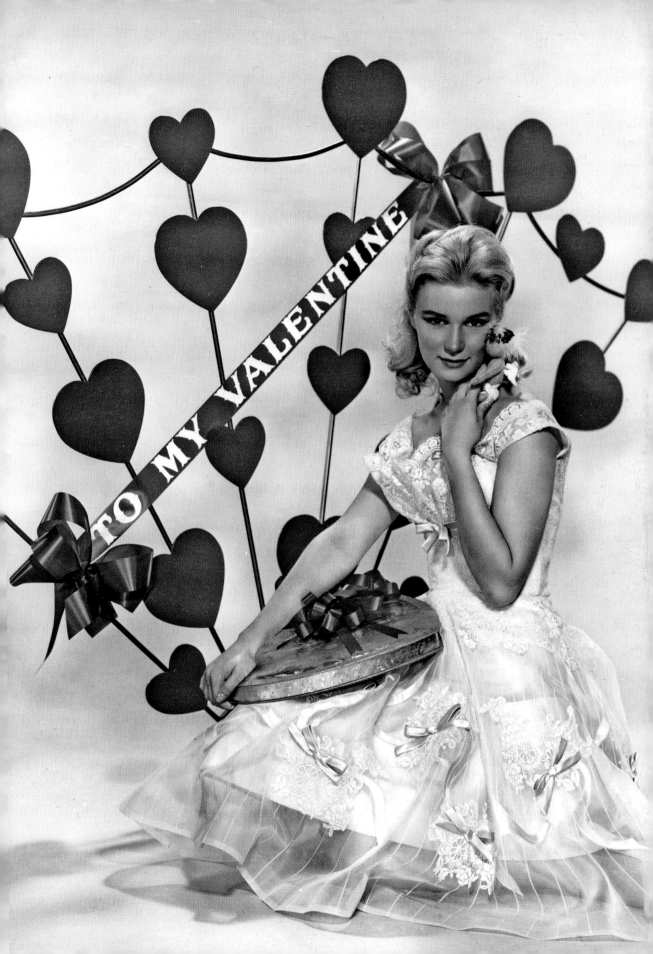

CHAPTER THREE

St. Patrick's Day

Opposite: Carole Landis gives St. Patrick's Day a sexy
spin in her two-piece ensemble. She co-starred in films
and entertained the troops on a USO tour during World
War II. Beset by career disappointments, financial
problems, and four failed marriages, she died of a drug
overdose at age twenty-nine. *Courtesy Author's Collection*

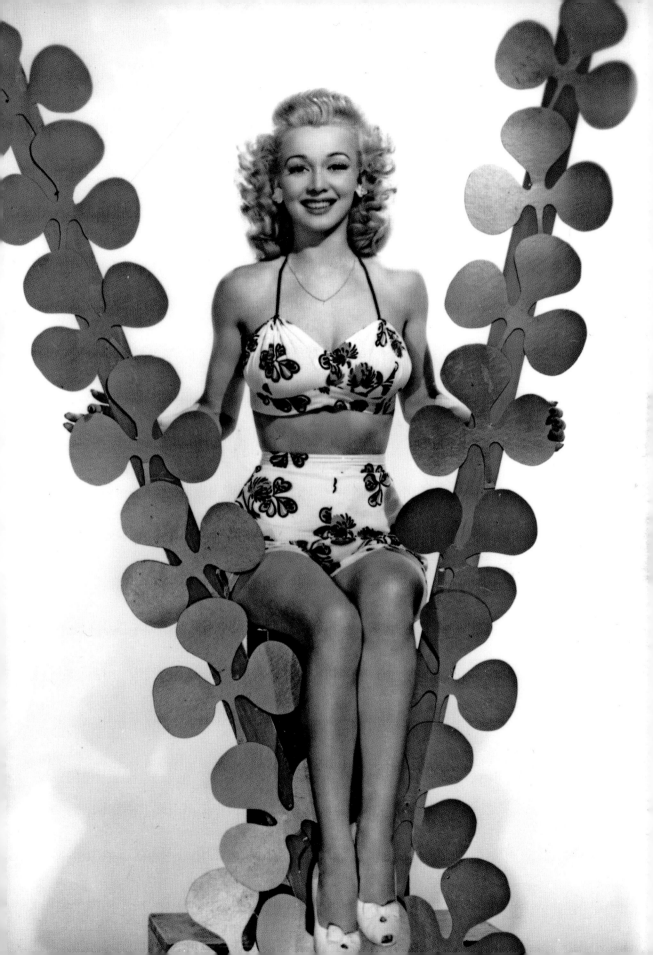

Lovely Virginia Bruce is adorned in shamrocks for St. Patrick's Day. She was briefly married to matinee idol John Gilbert and played supporting roles in *The Great Ziegfeld* (1936) and *Night Has A Thousand Eyes* (1948), and starred in *The Invisible Woman* (1940). *Courtesy Author's Collection*

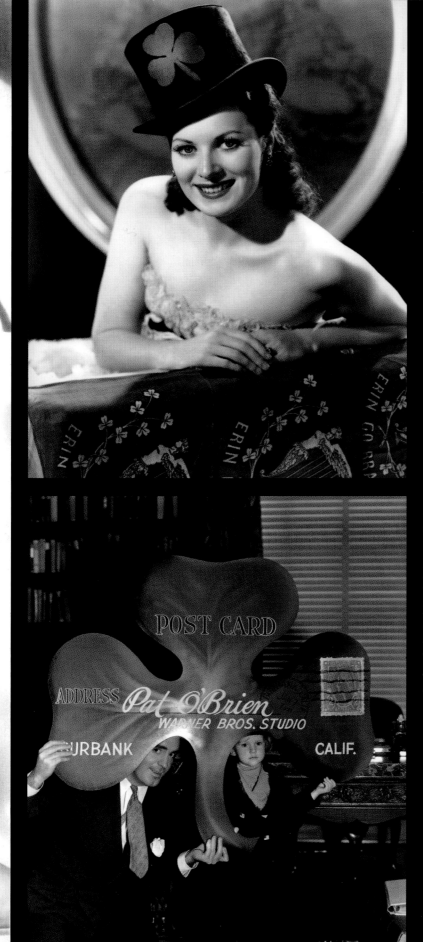

Irish-born lass Maureen O'Hara is the pride of her country in this fetching publicity still. Her titan red hair, striking looks, and innate acting ability made her the ideal leading lady for films such as *How Green Was My Valley* (1941), *The Quiet Man* (1952), and *McLintock!* (1963).
Courtesy Author's Collection

Pat O'Brien sends a shamrock postcard greeting from Warner Bros. O'Brien often portrayed Irish or Irish-American characters, co-starring in nine films with James Cagney, including the classic *Angels with Dirty Faces* (1938). O'Brien socialized with several friends who were dubbed "The Irish Mafia," including Cagney, Spencer Tracy, and Frank McHugh.
Courtesy Author's Collection

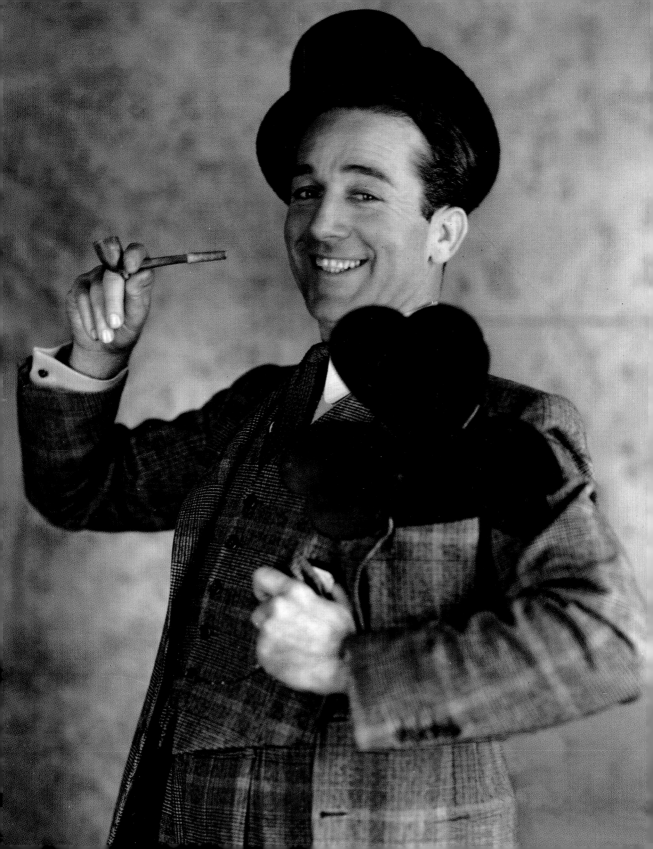

Opposite: Dapper gent Jack Mulhall has the luck of the Irish with a career that began in 1910 and lasted until his final film appearance in 1959. The peak of his success came in the silent era, where he played leading roles opposite stars such as Mabel Normand, Colleen Moore, Dorothy Mackaill, and the Talmadge sisters. *Courtesy Author's Collection*

[VERSO:] RIGHT FROM THE AULD SOD! – Jack Mulhall, First National star, digs out the old clay pipe, shamrock and Irish hat in memory of good St. Patrick. For Jack hails from the County Cork by right of ancestry.

Right: Ireland native Angela Greene avoids being pinched on St. Paddy's Day by wearing this sweater with green shamrocks. She played "Tess Trueheart" in the *Dick Tracy* television series in 1950 and later starred for Roger Corman in *Night of the Blood Beast* (1958). *Courtesy Author's Collection*

Alluring actress Martha Vickers tends to her garden of shamrocks. Playing the "bad girl" to the hilt, she had a breakthrough role in *The Big Sleep* (1946) opposite Humphrey Bogart and Lauren Bacall. Other notable films include *The Man I Love* (1947) with Ida Lupino and *Ruthless* (1948) co-starring Zachary Scott. *Courtesy Author's Collection*

Glamorous Ann Sheridan gives a knowing wink to one lucky leprechaun. Dubbed "The Oomph Girl," her sultry presence lit up several films in the noir genre, including *They Drive By Night* (1940), *Nora Prentiss* (1947), and *Woman on the Run* (1950). *Courtesy Author's Collection*

Ravishing redhead Lucille Ball poses as an Irish maid during her early years in Hollywood. She worked in film for twenty years before starring in her legendary sitcom *I Love Lucy*, which made her one of the most beloved comediennes of all time.
Courtesy Author's Collection

Miscellaneous Holidays

Opposite: A demure Gloria DeHaven honors those who gave their lives by preparing poppies for Memorial Day. Besides playing her own mother, Flora Parker DeHaven, in the film *Three Little Words* (1950), DeHaven gave teen idol Frank Sinatra his first screen kiss in the 1944 film *Step Lively. From the Author's Collection.*

[VERSO:] POPPY GIRL…Gloria De Haven, Metro-Goldwyn-Mayer actress, prepares a basket of boutonnieres made with California poppies in observance of Memorial Day. The young actress recently completed a starring role in "Scene of the Crime" starring Van Johnson.

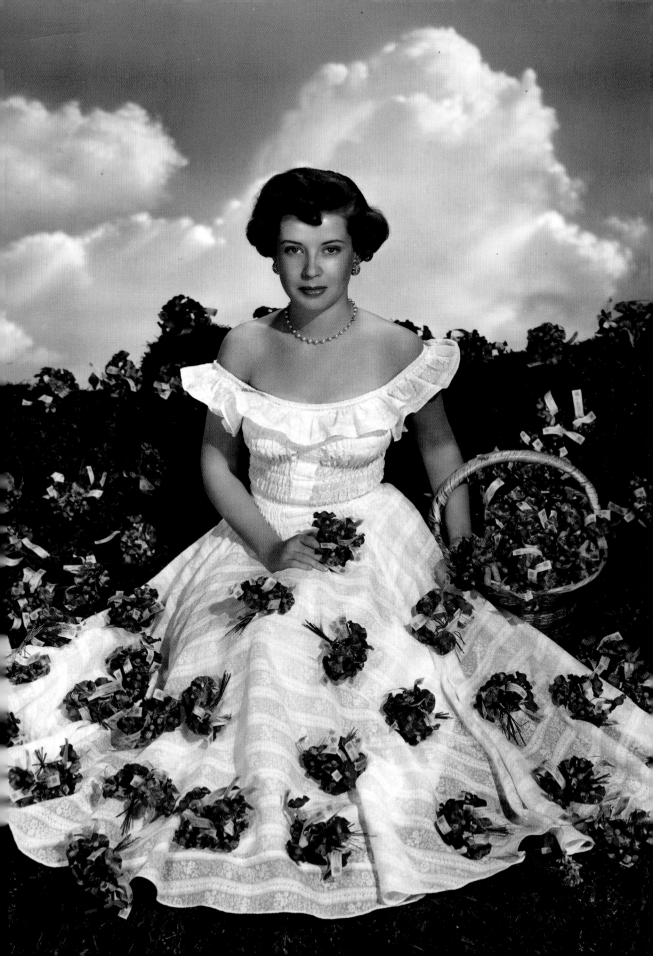

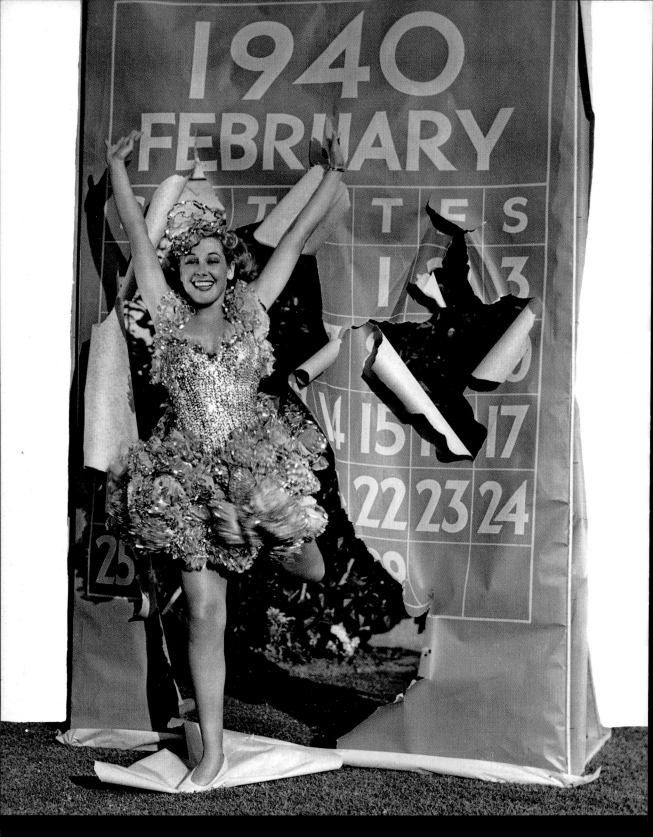

Enthusiastic Judith Barrett jumps for joy in anticipation of pitching woo to Hollywood's eligible bachelors. Born Lucille Kelly in T████ Barrett played leading roles in such 1930s Hollywood "B" pictures as *The Gracie Allen Murder Case* (1939), *Television Spy* (1939), and *Those Were the Days!* (1940). *Courtesy Jeffrey Mantor, Larry Edmunds Bookshop*

[VERSO:] WHOOPEE! The fact that 1940 will be Leap Year seems to have a strange effect on Judith Barrett, █ █Venus from Venus, Texas," who is featured in Paramount's "Those Were the Days." But if Judy really goes around hunting a man looking like this—well, the line forms on the right, men, and hold your own tickets!

Babelicious Bebe Daniels plays George Washington as she considers chopping down that cherry tree. Impish, mischievous Daniels played opposite Harold Lloyd in *Lonesome Luke* shorts in the late 1910s before starring as playgirls and femme fatales in lavish Cecil B. DeMille and Paramount features during the 1920s. *Courtesy Author's Collection*

[VERSO:] BEBE DANIELS * WASHINGTON'S BIRTHDAY ART.

LOS ANGELES——Bebe, let your conscience be your guide——Bebe Daniels, Paramount player, read a story about fame and fortune coming to a little boy who once chopped down a youthful cherry tree and then decided not to pass the buck. "Perhaps history repeats itself" quoth Bebe.

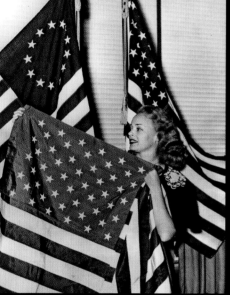

Lovely, patriotic Virginia Gilmore salutes America's Stars and Stripes on its special day. One-time wife of Yul Brynner, Gilmore headlined *Winter Carnival* (1939), *Western Union* (1941), and *Pride of the Yankees* (1942) during her relatively short career before giving up on films and turning to teaching and the stage. *Courtesy Author's Collection*

[VERSO:] HISTORY OF THE AMERICAN FLAG
NEW YORK: Commemorating the 175th Anniversary of the first American flag, actress Virginia Gilmore displays a proposed flag of fifty stars, which would include the territories of Alaska and Hawaii if they were admitted to statehood. She is flanked by an original Betsy Ross flag of 13 stars and the present day standard of 48 stars. Flag Day will be celebrated Saturday, June 14.

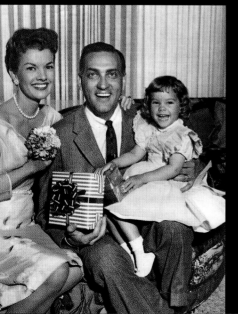

Pretty Texan Gale Storm earns a day of rest on Mother's Day. Winning the Jesse L. Lasky "Gateway to Hollywood" contest in 1939, wholesome Storm moved to Hollywood and began appearing in "B" films. She achieved success headlining two hit television shows: *My Little Margie* (1952–1955) and *The Gale Storm Show* (1956–1960). *Courtesy Author's Collection*

[VERSO:] HAPPY MOTHER'S DAY—Gale Storm enjoys Mother's Day as she accepts gifts from husband, Lee Bonnell, and daughter, Susanna. "The Gale Storm Show" is presented Monday through Friday on ABC-TV.

Hollywood Goes to War

Opposite: Fay Wray honors those who gave their lives to keep America free by laying a Memorial Day wreath. She gained acclaim co-starring opposite Teutonic Erich von Stroheim in his 1928 masterpiece *The Wedding March* and achieved immortality by bewitching a giant ape in the fantasy adventure *King Kong* (1933). *Courtesy Author's Collection*

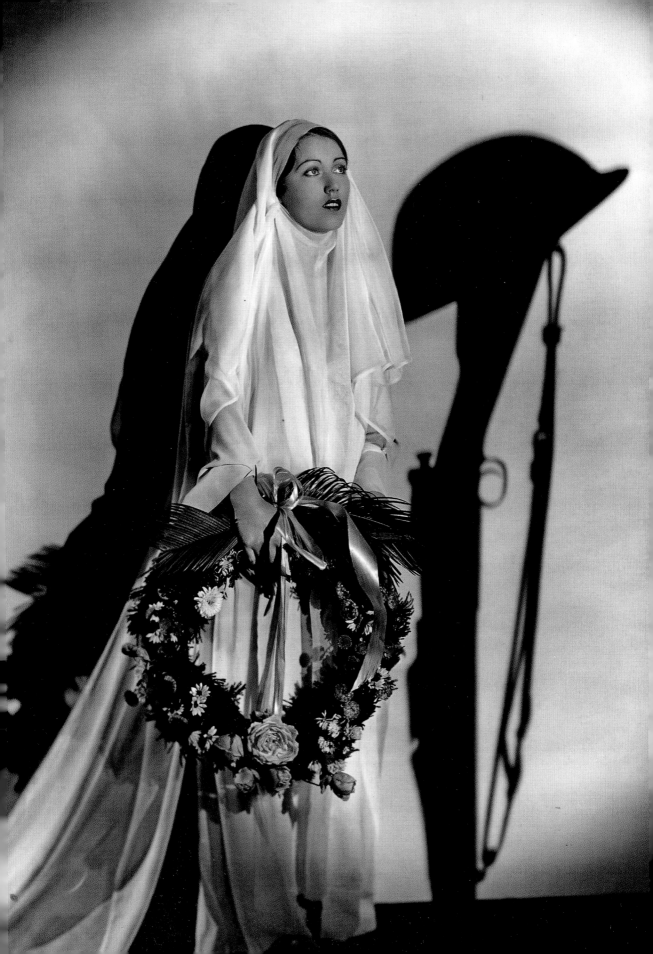

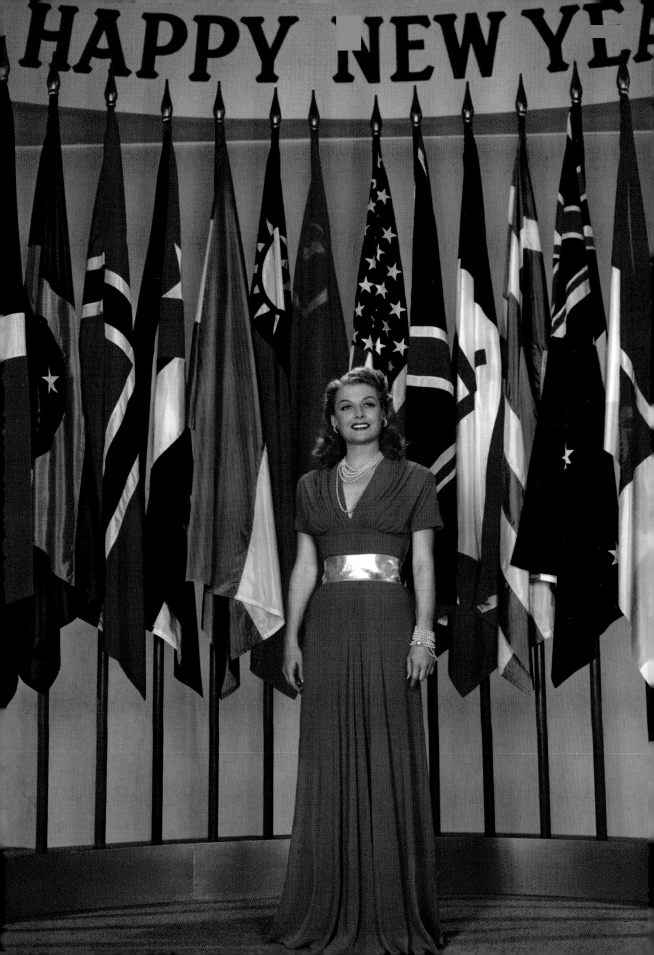

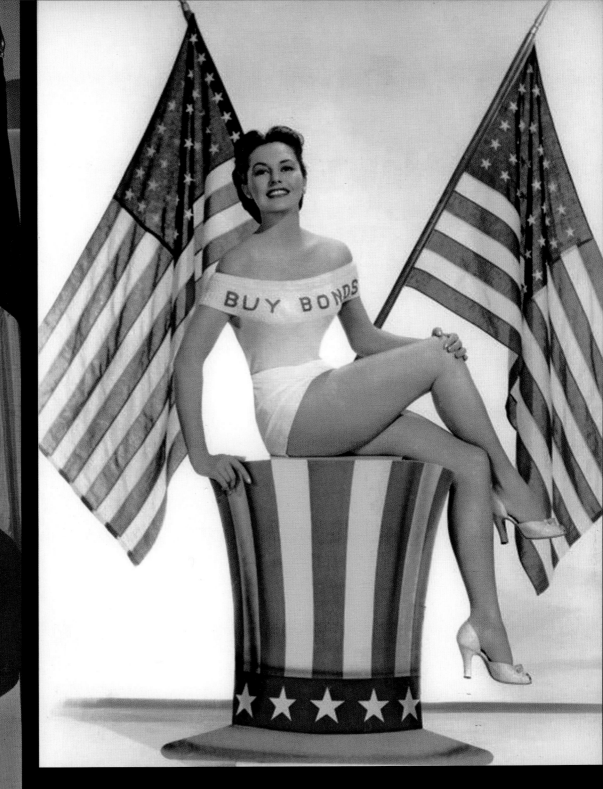

Opposite: A glamorous Ann Sheridan offers salutary New Year's greetings to the flags of America and her war allies during the 1940s. Sexy, sensuous portraits by legendary stills photographer George Hurrell gave Sheridan "oomph," elevating her to stardom. She starred in musicals, comedies, and melodramas at Warner Bros. in the 1940s. *Courtesy Author's Collection*

Above: Cyd Charisse flaunts her assets, urging patriotic Americans to purchase war bonds during World War II. A gifted dancer, the leggy Charisse enticed Gene Kelly in the dream ballet sequence of *Singin' in the Rain* (1952) and bewitched Fred Astaire in *The Band Wagon* (1953). *Courtesy Author's Collection*

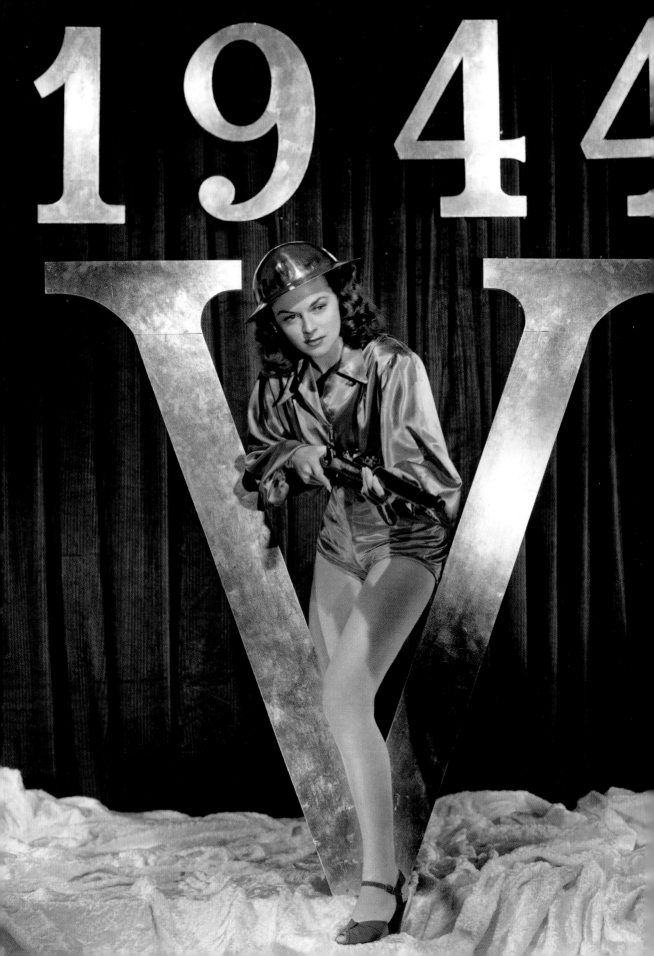

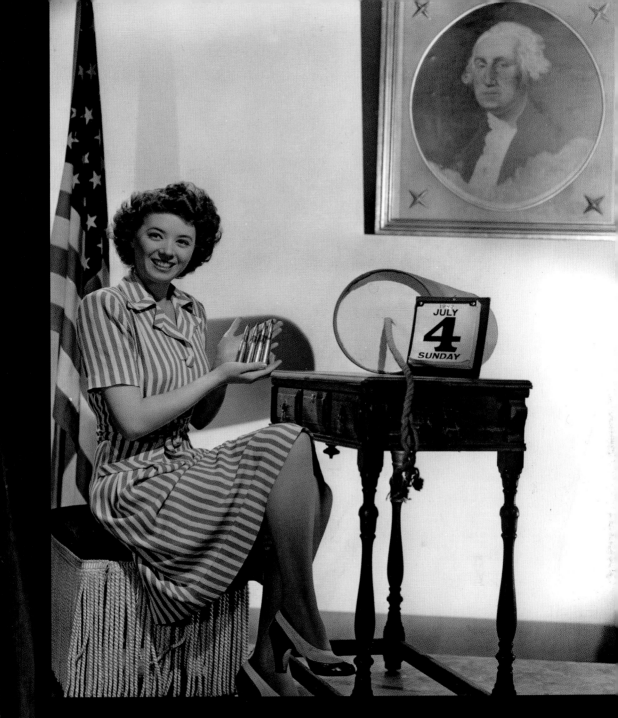

Opposite: Marguerite Chapman flashes a "V for Victory," welcoming in the year 1944. A short-lived, sultry star of Columbia Pictures' "B" features—particularly gung-ho, patriotic war films—she later appeared in *Man Bait* (1952) and *The Seven Year Itch* (1955). *Courtesy Marc Wanamaker, Bison Archives*

Above: Boyish Jeff Donnell offers explosive support to the United States war effort in this photo by Joe Walters. Originally playing innocent teenage roles in films like *My Sister Eileen* (1942), Donnell transitioned to mature parts in *The Blue Gardenia* (1953) and *In a Lonely Place* (1950). *Courtesy Author's Collection*

[VERSO:] BE PATRIOTIC! That's what Columbia's Jeff Donnell urges. Don't waste good money for July 4th fireworks…buy Bonds instead. Jeff points out that the powder used in a Giant Salute can furnish enough death-dealing power to send Four Sons of Heaven to their Celestial Ancestors. Bonds beget bullets…that's the patriotic way to celebrate July 4th! Jeff will soon be seen in Columbia's Nine Girls.

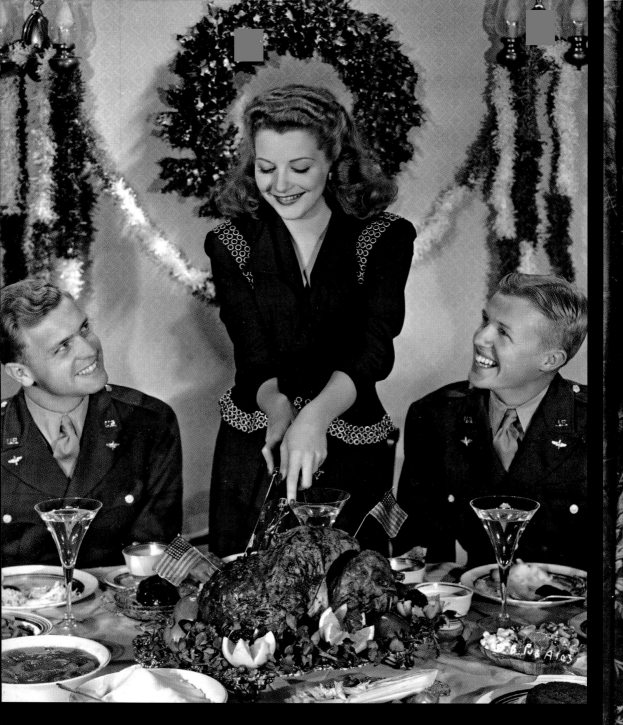

Above: Julie Bishop carves a mean turkey as she celebrates a combined Thanksgiving/Christmas dinner with awestruck Army Air Corps pilots. Beginning her career as plucky child star Jacqueline Wells, she changed her name to Julie Bishop in 1941 before later starring opposite John Wayne in several films. *Courtesy Author's Collection*

Opposite: Shapely Leslie Brooks gives her Christmas tree that patriotic touch by decorating it in war bonds and stamps during World War II. Playing attractive leads in low-budget Hollywood films, Brooks appeared in *Cover Girl* (1944) and *The Corpse Came C.O.D.* (1947). *Courtesy Author's Collection*

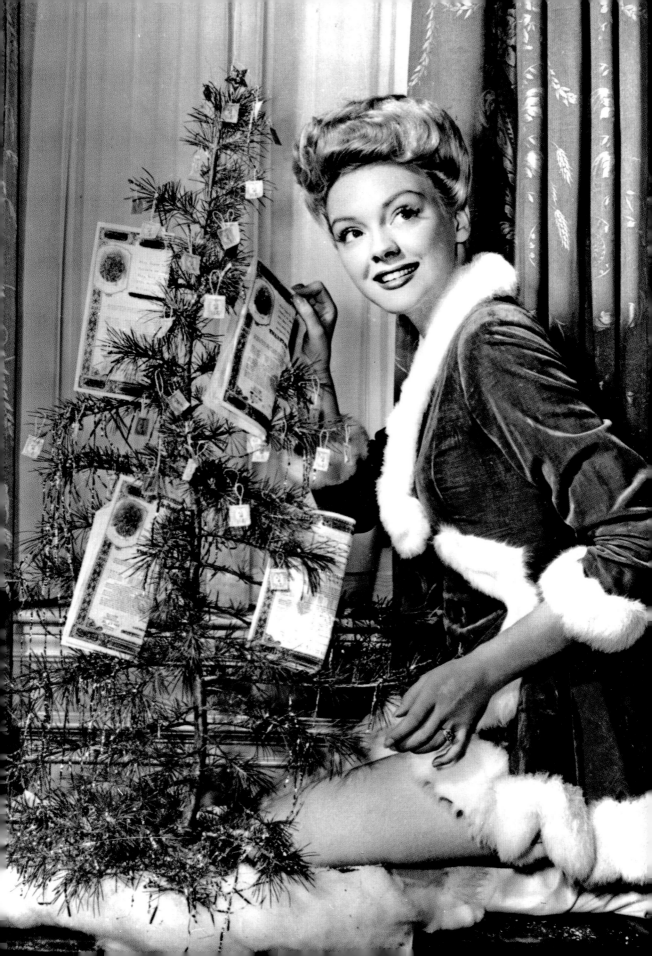

A grateful Ann Miller seals a Valentine's card to one lucky GI with a heartfelt kiss. Her zesty personality, shapely legs, and frenetic dancing brightened many film musicals, particularly *On the Town* (1949) and *Kiss Me Kate* (1953). *Courtesy Author's Collection*

[VERSO:] VICTORY VALENTINE—Seal your Valentine v-mail letter to your serviceman with a heart shaped kiss, suggests Ann Miller. Ann, soon to be seen in the Columbia picture, Hey, Rookie! also reminds you the post office says mail Valentines overseas by January 15.

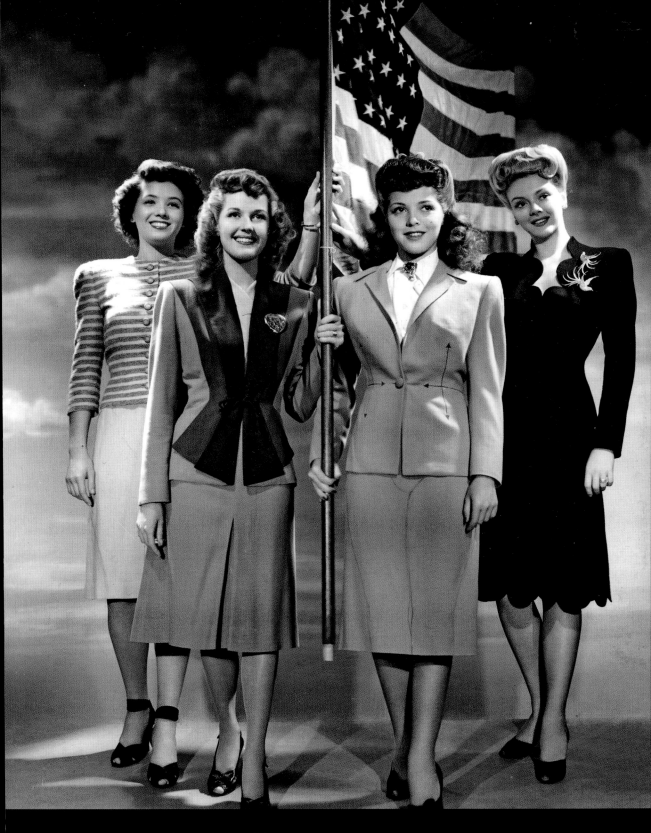

Pretty young starlets proudly raise the flag, rallying support for the American war effort both overseas and here at home. Jeff Donnell, Anita Louise, Marguerite Chapman, and Leslie Brooks pledge allegiance to their country in a patriotic display of fervor. *Courtesy Author's Collection*

CHAPTER SIX

Television

Opposite: *The Tonight Show* staff prepares to ring in the New Year c. 1963. Originally shot on an NBC soundstage at 30 Rockefeller Center, *The Tonight Show* featured star Johnny Carson, announcer Ed McMahon, and original musical director Skitch Henderson providing light-hearted late-night entertainment for night-owl television viewers. *Courtesy Author's Collection*

[VERSO:] NEW YEAR'S EVE REVELERS—Johnny Carson (left), his announcer Ed McMahon (center), and musical director Skitch Henderson provide their own festive setting to celebrate New Year's Eve, since the three of them will be doing their NBC-TV "Tonight Show Starring Johnny Carson" Monday, Dec. 31.

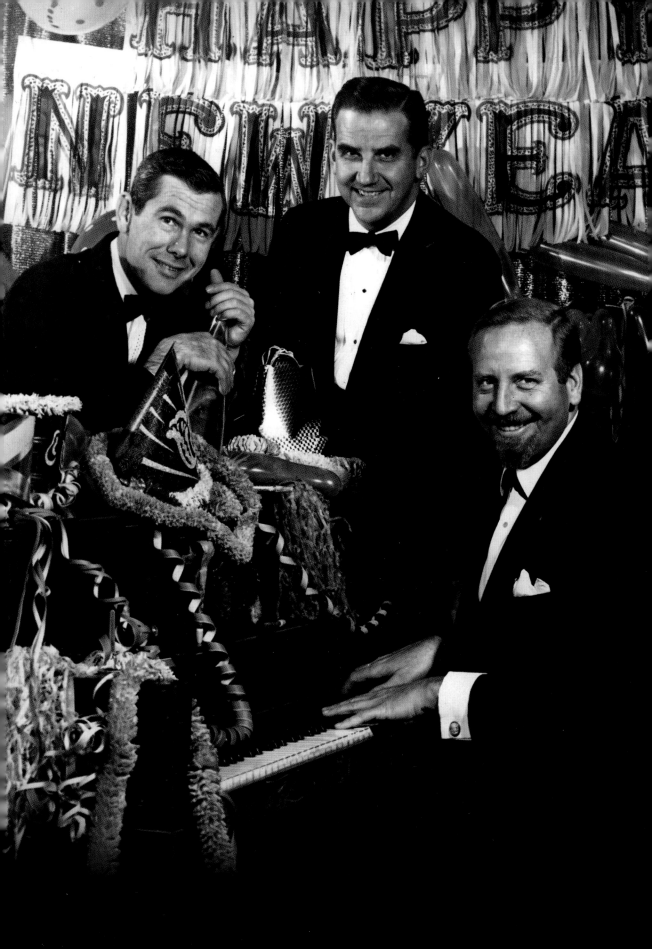

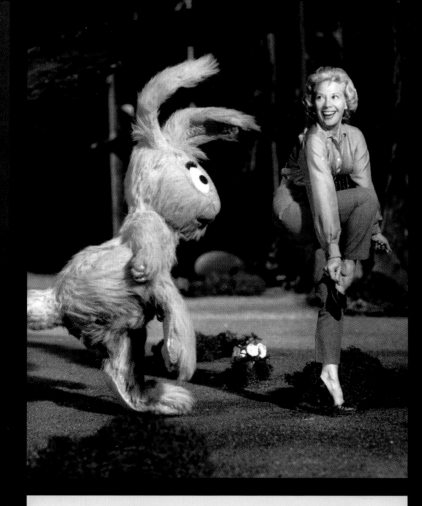

Opposite: Aptly named Karen Valentine plays Cupid on Valentine's Day. Star of the 1970s hit television series *Room 222*, the sparkling Valentine also appeared in *Love, American Style* and other TV shows. She exchanged sarcastic quips with Paul Lynde, George Gobel, and many others as a regular panelist on *The Hollywood Squares*. *Courtesy Author's Collection*

[VERSO:] The perfect messenger of heart-felt greetings on St. Valentine's Day, February 14, is Karen Valentine - of the ABC Television Network's Room 222 (Wednesdays, 8:30-9:00 p.m., EST).

Above: Multi-talented performer Dinah Shore hops along with Peter Cottontail in preparation for Easter. A mainstay of the 1950s and 1960s, Shore conquered the fields of recording, radio, film, and television, becoming the first woman to headline her own variety TV series and establish a women's major golf championship. *Courtesy Author's Collection*

[VERSO:] EASTER VISITOR — Dinah dances with an Easter bunny, animated plastic creation of cartoonist Art Clokey, in a tricky bit of color video tape filming on the DINAH SHORE CHEVY SHOW Sunday, March 22, over NBC-TV.

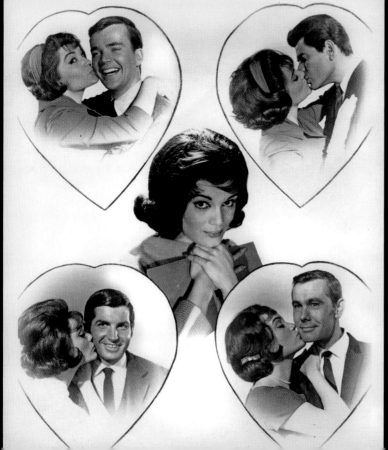

Left: Girl singer Connie Francis can't decide among her Prince Charmings for Valentine's Day. Top female vocalist six years running, Francis recorded the hit song "Who's Sorry Now" before starring in the film *Looking for Love* (1962). She ponders romance with (clockwise) Jim Hutton, Joby Baker, Johnny Carson, and George Hamilton. *Courtesy Jeffrey Mantor, Larry Edmunds Bookshop*

Sheriff Andy Taylor suggests caution on an explosive Fourth of July. Skyrocketing to fame with his role in the acclaimed film *A Face in the Crowd* (1957), Andy Griffith headlined his own successful television shows *The Andy Griffith Show* (1960–1968) and *Matlock* (1986–1995), as well as starring in many mini-series, TV movies, and films. *From the Author's Collection*

Go-go girl Barbara Eden dreams of an explosive July 4. Everyone's favorite genie in the hit 1960s television series *I Dream of Jeannie*, Eden blinked her way to fame in over twenty films, including *Seven Faces of Dr. Lao* (1964), before segueing into the medium of TV. *Courtesy Author's Collection*

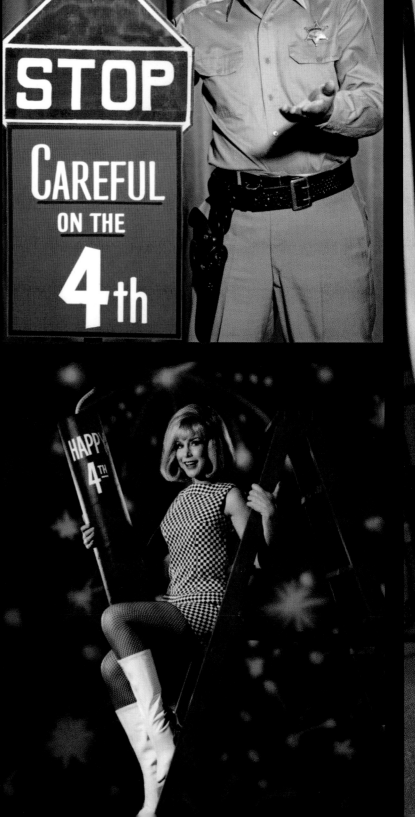

Sally Field hangs ten for a totally rad Fourth of July. Winner of two Academy Awards for Best Actress, Sally Field starred in breezy television shows like *Gidget* (1965–1966) and The *Flying Nun* (1967–1970) before starring in such films as *Mrs. Doubtfire* (1993) and *Lincoln* (2012). *Courtesy Author's Collection*

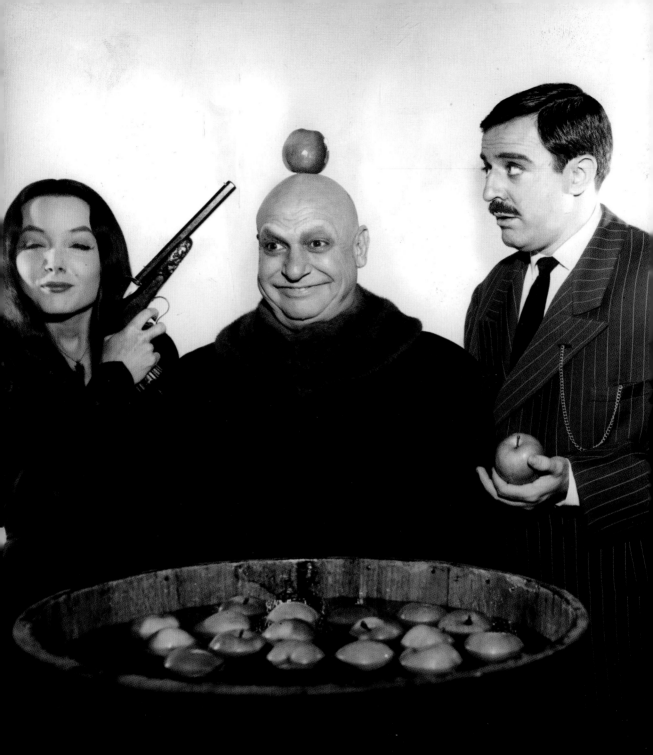

The Addams Family practices a little William Tell before
bobbing for apples on Halloween. Based on Charles
Addams' spooky cartoons of an eccentric but loving
family, the 1960s TV show *The Addams Family* starred
Carolyn Jones and John Astin as Morticia and Gomez
Addams, with former child actor Jackie Coogan playing
the wacky Uncle Fester. *Courtesy Author's Collection*

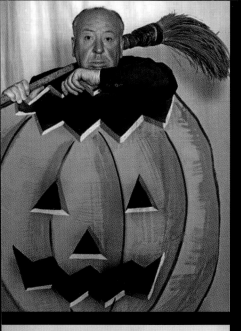

Master of Suspense Alfred Hitchcock offers a touch of fright for Halloween. English-born film director Hitchcock concocted elaborate tales of mistaken identity and intrigue in such films as *Rebecca* (1940), *Notorious* (1946), and *North By Northwest* (1959), as well as his spine-chilling TV show, *Alfred Hitchcock Presents*. *Courtesy Author's Collection*

A forlorn turkey observes television performer Art Linkletter chewing the fat on Thanksgiving. The only person to appear concurrently on five TV shows, the multi-talented Linkletter hosted the grand opening of Disneyland, wrote more than twenty books, and dedicated his time to humanitarian purposes. *Courtesy Jeffrey Mantor, Larry Edmunds Bookshop*

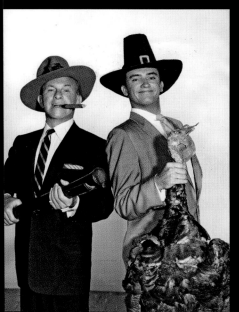

George Burns and son Ronnie go a-huntin' for that special Thanksgiving turkey. Star of radio, television, and film in partnership with his wife, Gracie Allen, Burns won an Academy Award for the film *The Sunshine Boys* (1975) and later played God in the 1977 movie *Oh God!* and its sequel. *Courtesy Author's Collection*

[VERSO:] IT WAS EITHER HIM OR US…A pair of proud early American (Television) settlers, the father-and-son team of George and Ronnie Burns, pose happily with the traditional Thanksgiving turkey and the rifle that brought it down ("we thought it was a bit tough").

George and Gracie Allen, who began their popular weekly comedy program, "The Burns and Allen Show," in 1950, and in 1955 added son Ronnie to the script, are now in their eighth consecutive year in television — an unprecedented reign in situation comedy fare.

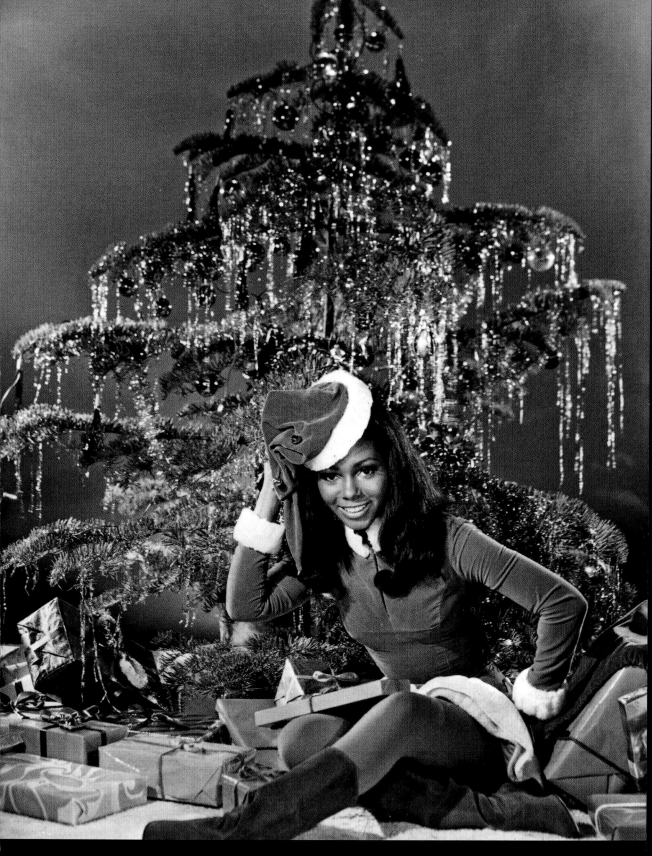

Shapely Santa Claus Judy Pace offers a little leggy holiday cheer this Christmas. Discovered by fright director William Castle, sexy but innocent Pace played television's first black female protagonist in *Peyton Place* (1964–1969) before appearing in the films *Cotton Comes to Harlem* (1970) and *Brian's Song* (1971). *Courtesy Author's Collection*

[VERSO:] Judy Pace of ABC-TV's PEYTON PLACE is both beautiful and ornamental in this Christmas scene.

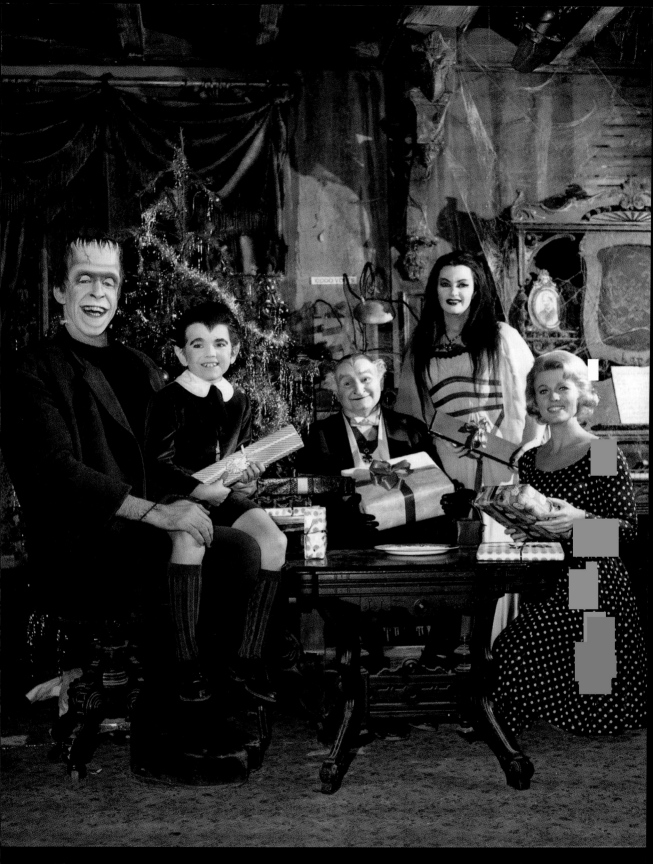

The Munsters scare up a large haul of Christmas presents. Starring Fred Gwynne, Butch Patrick, Al Lewis, Yvonne De Carlo, and Beverley Owen, the 1960s television show *The Munsters* highlighted the comic misadventures of a friendly but clueless family of monsters who never quite understood why people responded to them so strangely. *Courtesy Author's Collection*

CHAPTER SEVEN

Easter

Opposite: Ann Miller models an Easter bonnet topped off
by a live bunny in this still by Ned Scott. She co-starred in
the Technicolor musical *Easter Parade* (1948) opposite Judy
Garland and Fred Astaire. Other M-G-M musicals include
the aptly titled *Lovely to Look At* (1952) and *Deep In My
Heart* (1954). *Courtesy Author's Collection*

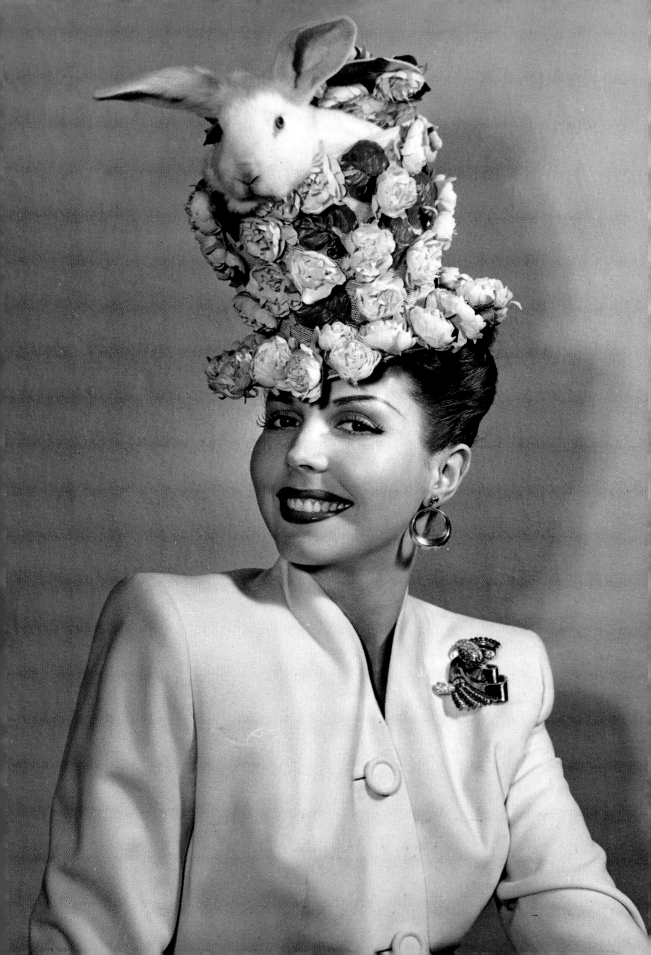

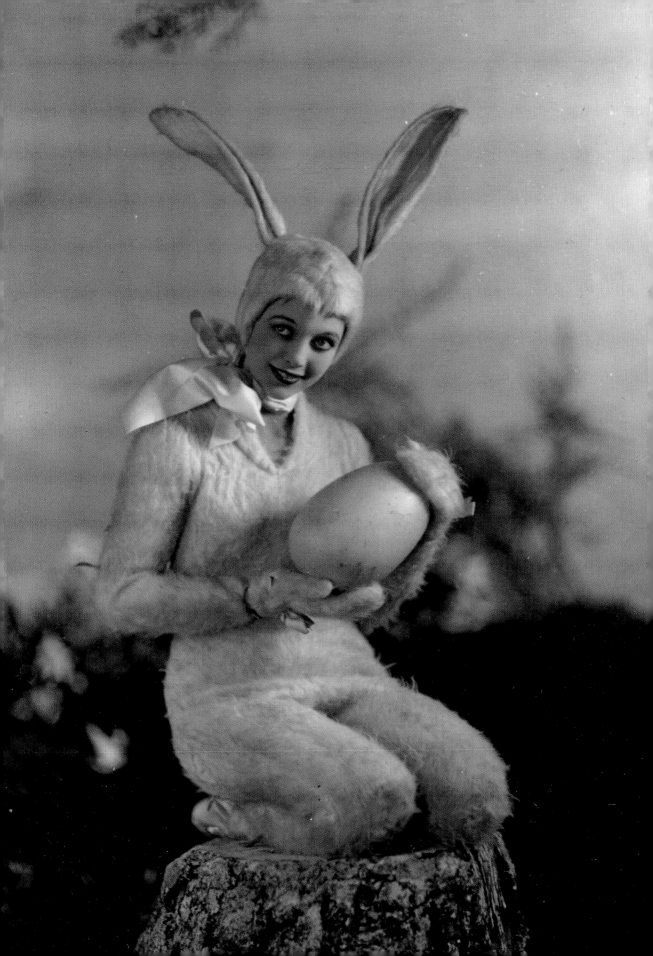

Opposite: Loretta Young holds a large Easter egg while wearing what looks to be a very itchy bunny suit. She starred in numerous pre-code gems, including *Born to be Bad* (1934). After winning the Oscar as Best Actress for *The Farmer's Daughter* (1947) she transitioned to television, starring in her own series.

Above: Sally Blane adds a dash of sex appeal to this Easter publicity still by photographer Ernest A. Bachrach. She worked steadily in the late silent era through the late 1930s and appeared with her younger sister Loretta Young in *The Story of Alexander Graham Bell* (1939). *Courtesy Author's Collection*

[VERSO:] The Easter Bunny comes to Hollywood in the guise of Sally Blane, Wampas Baby Star and starlet of Radio Pictures. Sally, according to the inspired photographer, dressed up to entertain her baby sister and made this surprising discovery on her front lawn. Anyway, it's a pretty picture.

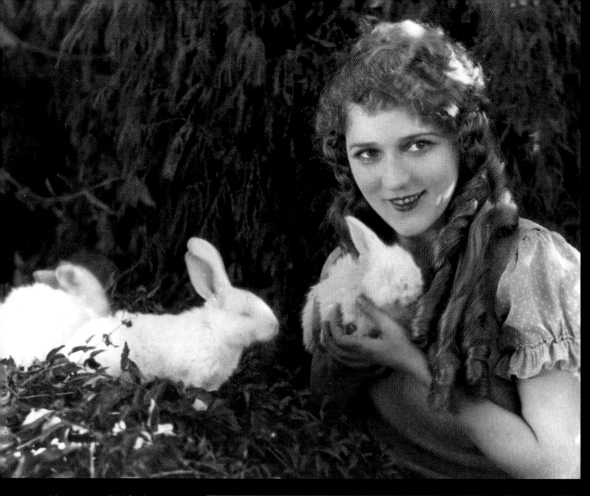

Above: Mary Pickford visits a real Easter bunny and its friends, who keep multiplying by the minute. She may have been dubbed "America's Sweetheart," but Pickford was one of the most powerful and influential actresses in Hollywood history, co-founding United Artists and producing her own films. *Courtesy Author's Collection*

Opposite: Norma Shearer sings in the choir on Easter morning in this studio portrait by Ruth Harriet Louise. Shearer and Louise reigned as two of the most influential women at M-G-M. Louise distinguished herself as the lone female studio stills photographer in Hollywood. *Courtesy Darin Barnes Collection*

[VERSO:] Easter morn. Norma Shearer, Metro-Goldwyn-Mayer star poses as the choir boy singing Easter ballads.

Marceline Day walks atop the hill of Calvary in this dramatic portrait by Ruth Harriet Louise with Cahuenga Peak serving as a backdrop. Day co-starred opposite Lon Chaney in *London After Midnight* (1927), Buster Keaton in *The Cameraman* (1928), and Clara Bow in *The Wild Party* (1929).

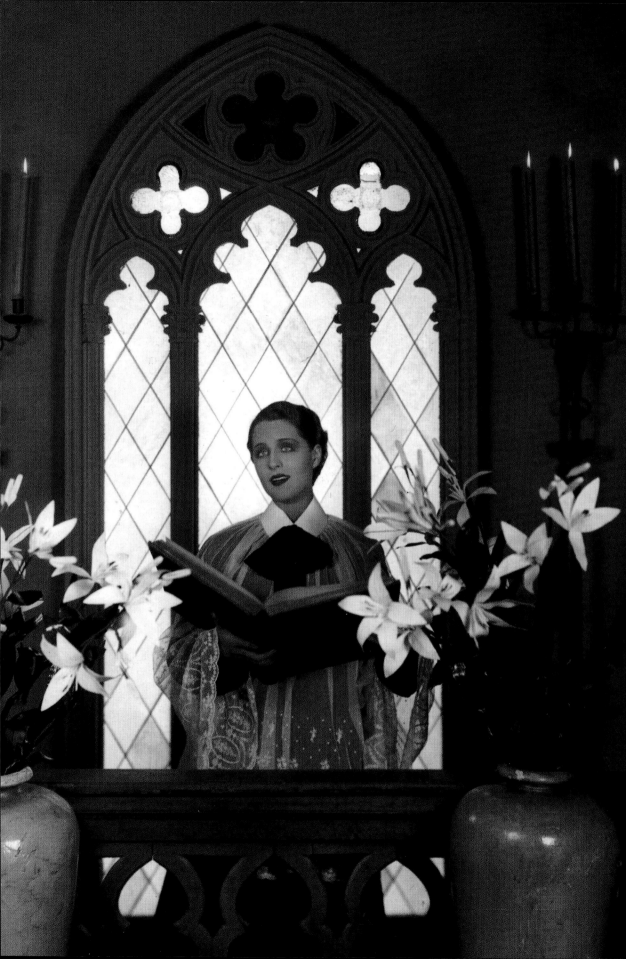

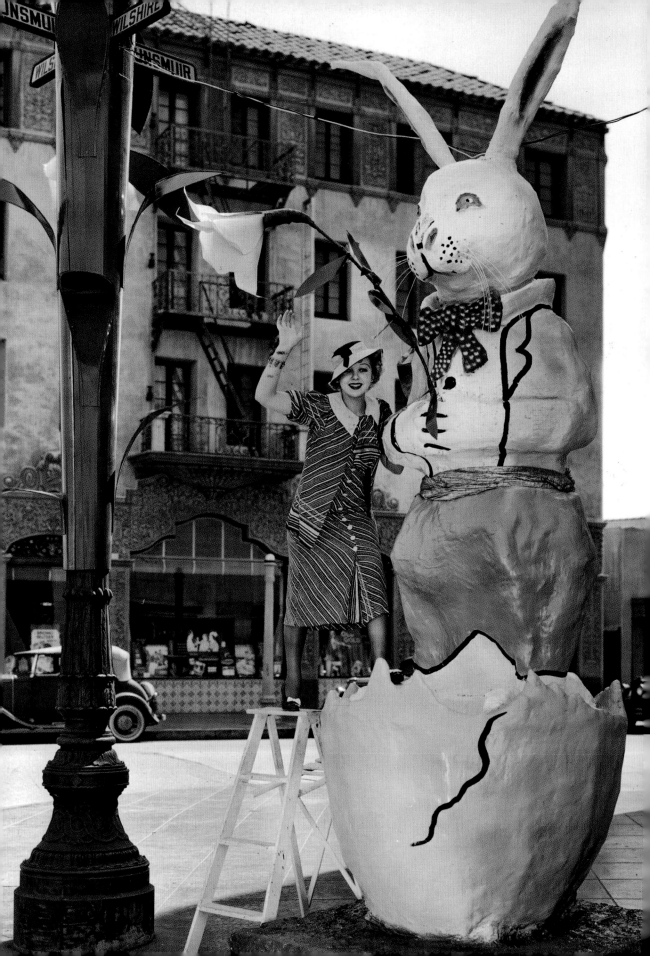

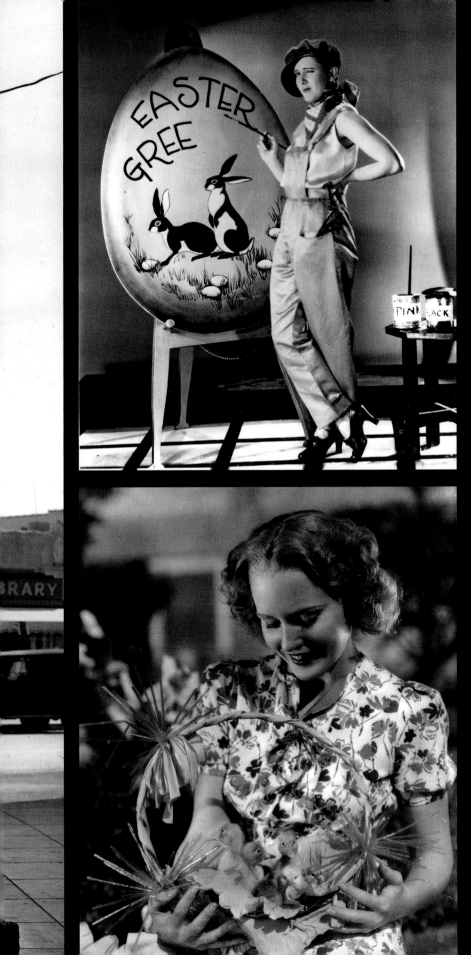

Opposite: Ida Lupino helps decorate the city—specifically the corner of Wilshire and Dunsmuir in the Miracle Mile section of Los Angeles. After several years as an actress Lupino became a pioneering independent writer, producer, and director, working in both film and television. *Courtesy Author's Collection*

[VERSO:] BIG BUNNY BUSINESS – In preparation for Easter, Ida Lupino, young Paramount player, puts finishing touches on a huge Easter rabbit designed to impart a festive holiday touch to one of the screen colony's fashionable streets. March 22, 1934

Above Left: Comic leading lady Jean Arthur paints her Easter greetings on an oversize egg. She hit her stride in the 1930s, starring in several films for director Frank Capra, including *Mr. Deeds Goes to Town* (1936), *You Can't Take It With You* (1938), and *Mr. Smith Goes to Washington* (1939). *Courtesy Author's Collection*

Left: Spring brings forth new life, as Madge Evans discovers while gazing down on a batch of baby chicks. She began her career as a baby herself, appearing in advertisements for Fairy Soap and making her film debut at age five. Broadway beckoned before she returned to Hollywood as a contract player at M-G-M. *Courtesy Author's Collection*

[VERSO:] THE DAWN OF A NEW EASTER Lilies, chicks and ducklings are Easter symbols to Madge Evans, Metro-Goldwyn-Mayer featured player.

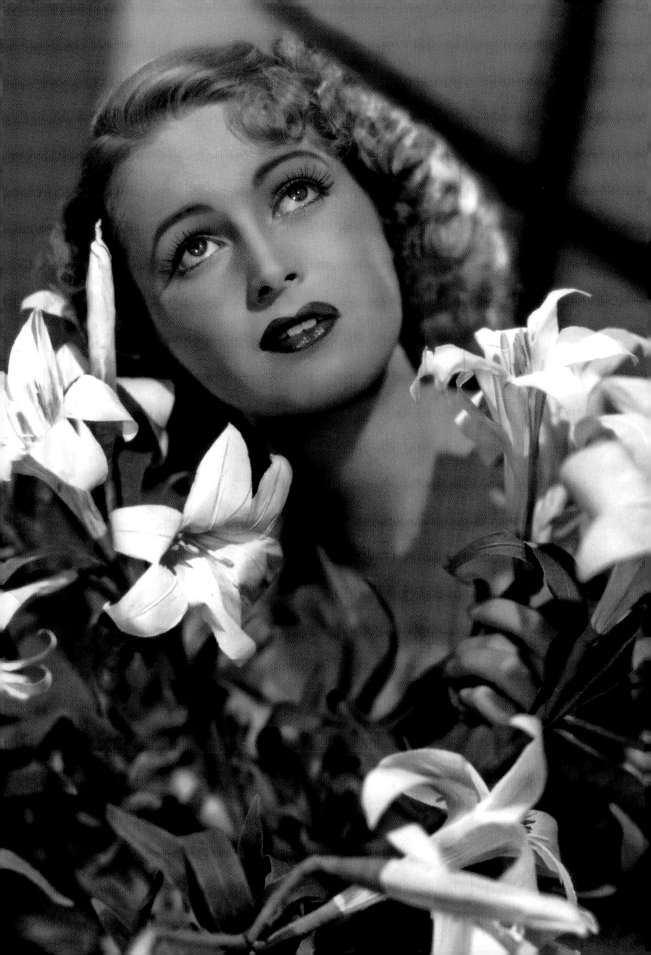

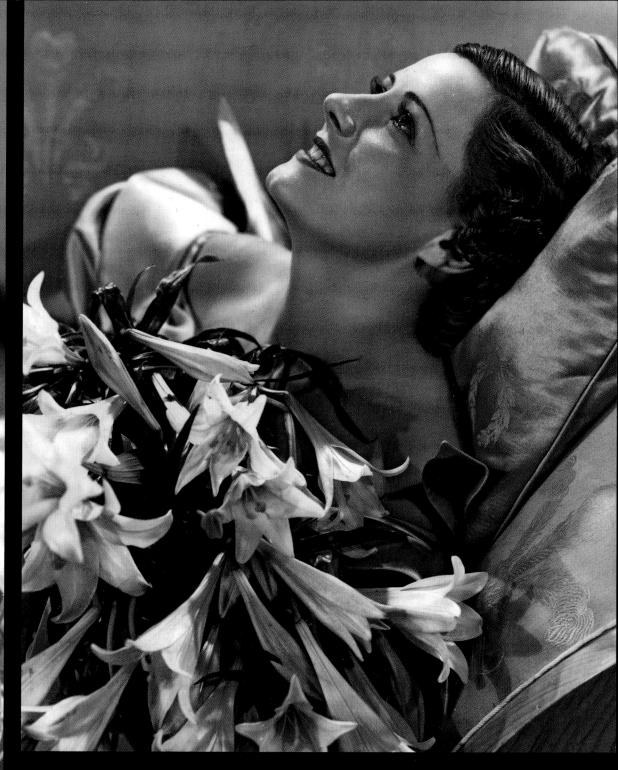

Opposite: Elegant ingénue June Lang enjoys a fragrant bunch of white lilies. She played supporting roles in *Music in the Air* (1934) starring Gloria Swanson, *Bonnie Scotland* (1935) with Laurel & Hardy, and a pair of films starring Shirley Temple. *Courtesy Author's Collection*

[VERSO:] The spirit of Easter, when Nature bedecks herself in the radiance of Spring raiment fittingly is portrayed by lovely June Lang, 20th Century-Fox star, in this specially posed portrait. The youthful player, soon to be seen in Shirley Temple's "Wee Willie Winkie", is one of the screenland's outstanding beauties.

Above: Actress Irene Dunne basks in the early light of Easter morning with a fresh batch of lilies. A great actress and deft screwball comedienne, she starred in *Theodora Goes Wild* (1936), *The Awful Truth* (1937), *Love Affair* (1939), and *My Favorite Wife* (1940). *Courtesy Author's Collection*

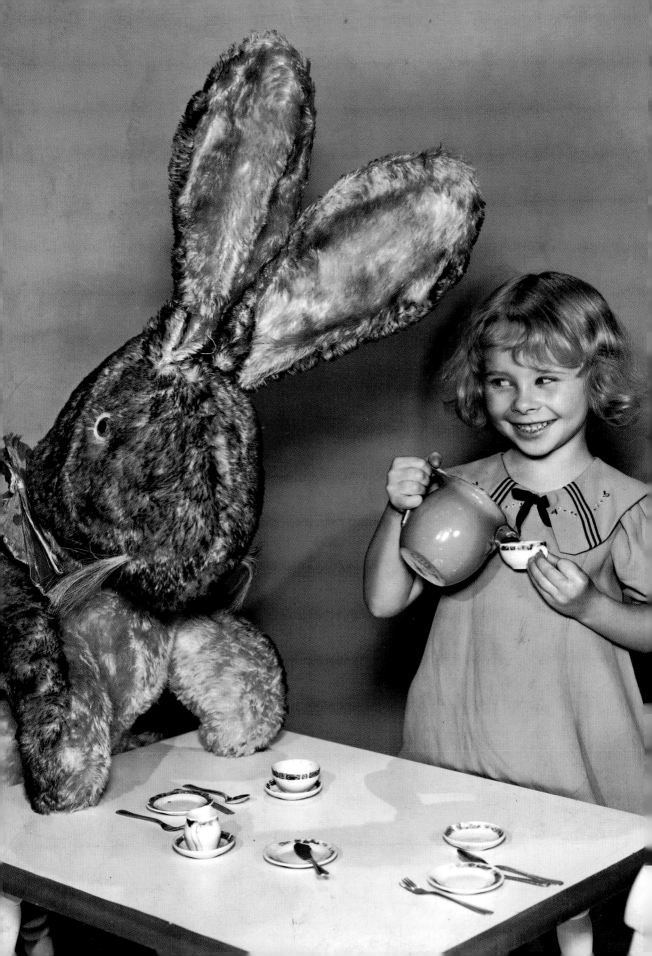

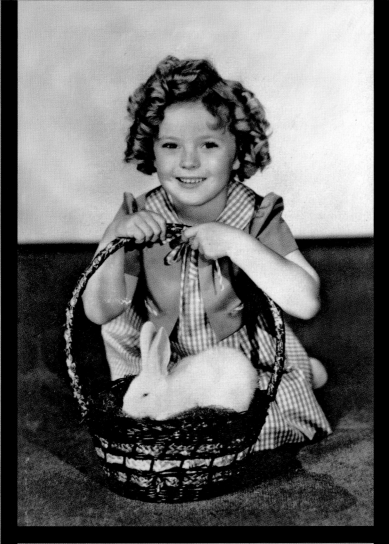

Opposite: Based on her wicked grin, pint-sized starlet Janet Chapman has clearly spiked the Easter Bunny's tea in this photo by Scotty Welbourne. Her screen career lasted from 1938 until 1946 and included a role in *Presenting Lily Mars* (1943), starring Judy Garland. *Courtesy Author's Collection*

[VERSO:] TINY CINEMA CINDERELLA – JANET CHAPMAN. Warner Bros. six-year-old starlet, saved the family fortunes when she first won the stellar role in "Little Miss Thoroughbred" and then scored a sensational hit in it. It was the first time she'd faced a giant motion picture camera.

Left: Shirley Temple is fully prepared to hunt Easter eggs now that she has both bunny and basket in hand. A natural performer, Temple could sing, dance, and act. Her curly hair, dimples, and delightful screen presence made her a huge hit with audiences during the Great Depression. *Courtesy Author's Collection*

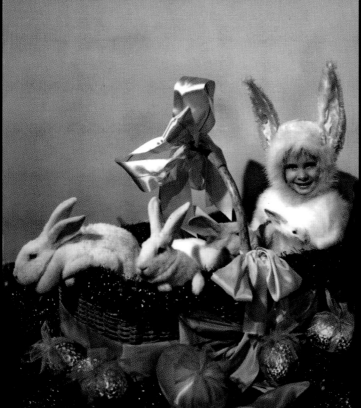

Bottom Left: Margaret O'Brien sits in a basket of bunnies for Easter Sunday. She is best remembered for her role as Judy Garland's little sister in the classic *Meet Me In St. Louis* (1944). Other notable films include *Jane Eyre* (1943), *Our Vines Have Tender Grapes* (1945), and *Little Women* (1949). *Courtesy Author's Collection*

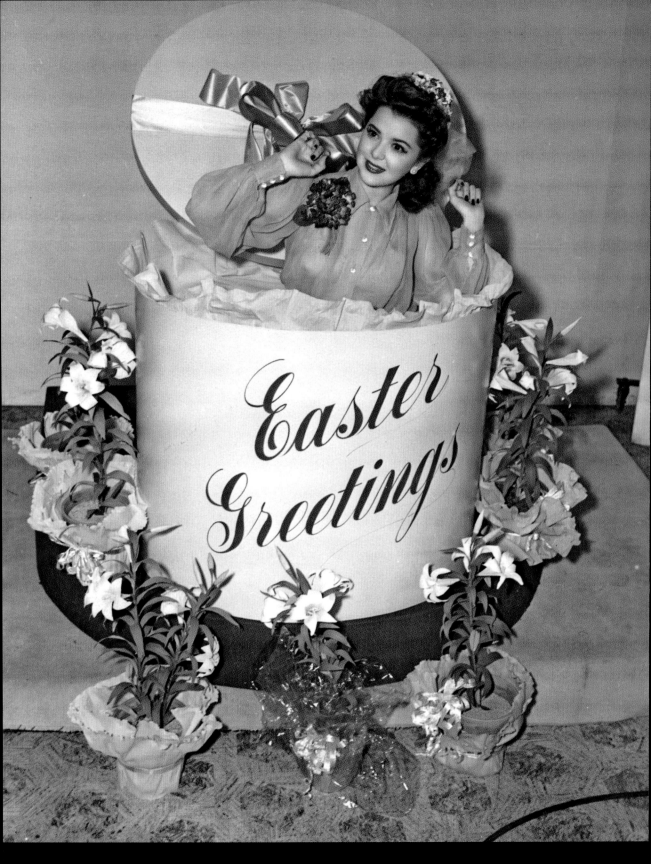

Ann Rutherford pops out of a hatbox in this 1938 publicity still. She co-starred opposite Mickey Rooney in the popular *Andy Hardy* film series and played one of Scarlett O'Hara's sisters in *Gone with the Wind* (1939). *Courtesy Marc Wanamaker, Bison Archives*

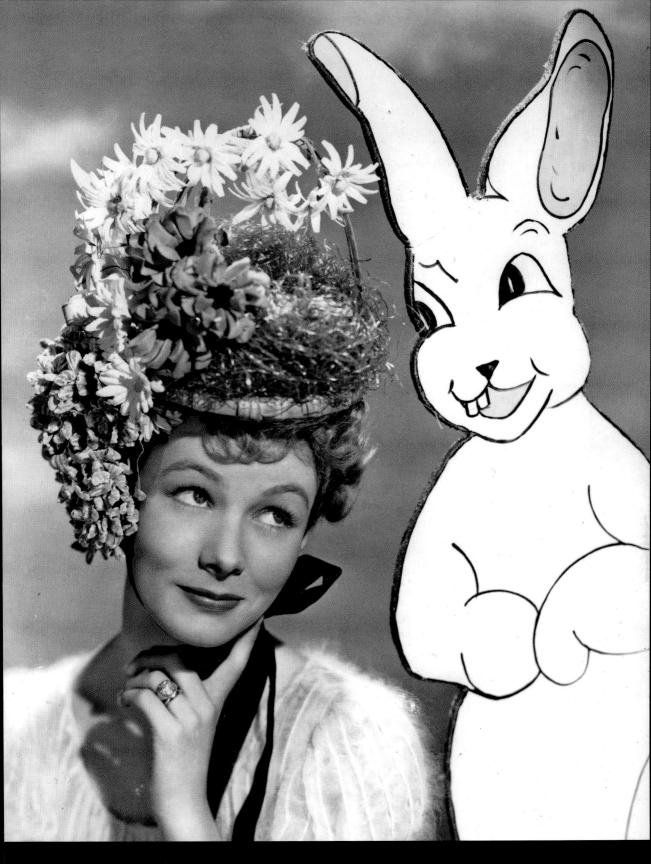

Veronica Lake wears a fetching Easter bonnet while the cartoon bunny looks to make his move. Unrecognizable without her trademark peek-a-boo hairstyle, the government prompted Lake to change it after several women who copied her look were involved in wartime factory accidents. *Courtesy Author's Collection*

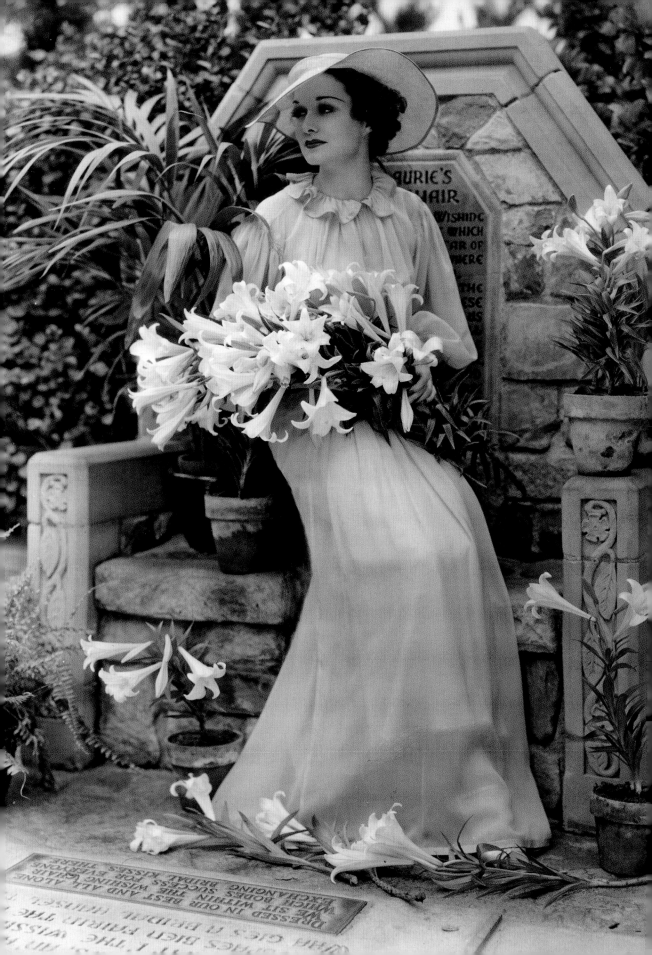

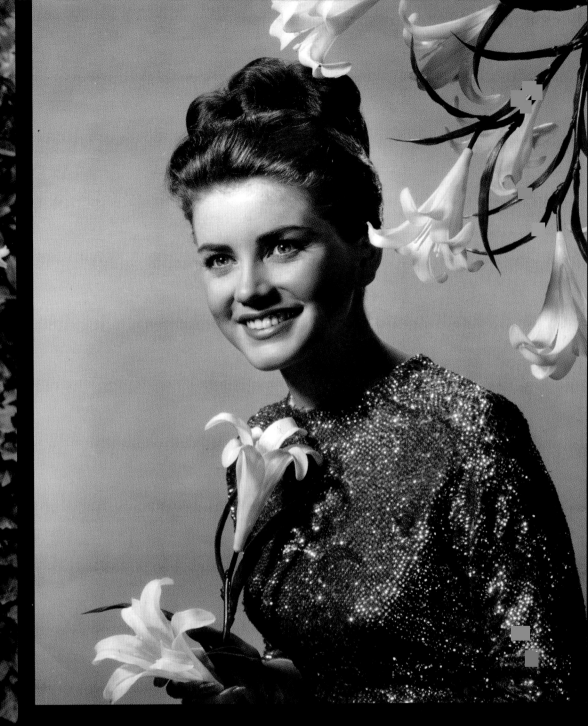

Opposite: Gail Patrick was at her best when playing a claws-out, conniving character in films such as *My Man Godfrey* (1936), *Stage Door* (1937), and *My Favorite Wife* (1940). She later found success in television and served as executive producer for the hit series *Perry Mason*. *Courtesy Author's Collection*

Above: Dolores Hart's piety and passion are sincere. In 1963, she stunned Hollywood by leaving to become a nun. Prior to that, she appeared alongside Elvis in *Loving You* (1957) and *King Creole* (1958) before starring in the teen romp *Where the Boys Are* (1960). *Courtesy Author's Collection*

[VERSO:] AN EASTER PICTURE – Gail Patrick, Paramount screen actress, makes a lovely Easter picture as she sits in the famous Annie Laurie chair at the Wee Kirk O' the Heather in Forest Lawn Cemetery near Los Angeles.

Susan Hayward enjoys springtime in the company of plush Easter bunnies and a bouquet of lilies. She played tough but tragic women and received five Academy Award nominations for Best Actress, taking home the statuette for her portrayal of serial killer Barbara Graham in *I Want To Live!* (1958). *Courtesy Author's Collection*

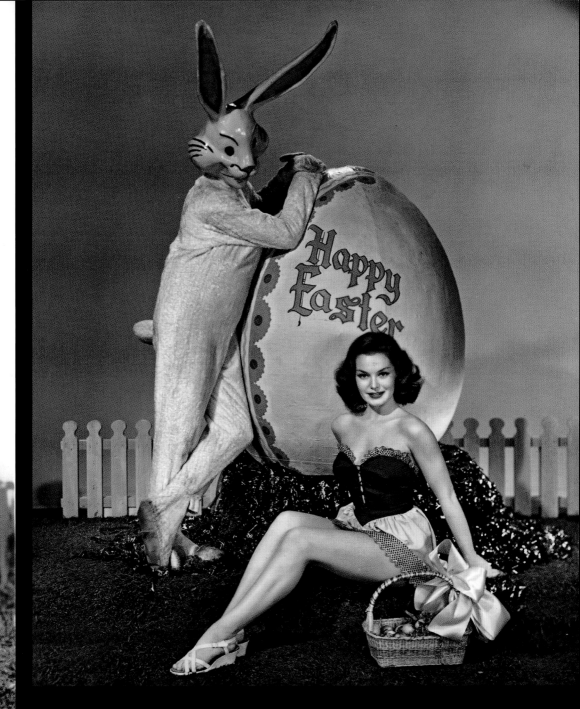

Dorothy Hart spent her career relegated to "B" movies and had a stint as "Jane" opposite Lex Barker in *Tarzan's Savage Fury* (1952). She became a stalwart in the film noir genre with supporting roles in *The Naked City* (1948), *Larceny* (1948), *Undertow* (1949), and *Loan Shark* (1952). *Courtesy Author's Collection*

[VERSO:] HAPPY EASTER---FROM HOLLYWOOD

The Easter bunny gets distracted (and who wouldn't?) by Hollywood's Dorothy Hart as he pauses in his rounds to send greetings to all. The rabbit's visit to Hollywood served a dual purpose since he was doing a bit of technical advising on the production of "Harvey," which will star Jimmy Stewart with an invisible rabbit. Miss Hart's latest movie is "Outside the Wall," starring her with Richard Basehart and Marilyn Maxwell.

Right: Pier Angeli kneels reverently beside a cross and lilies in this religiously themed Easter photo. After launching her career in her home country of Italy, Angeli starred in Hollywood productions, including *Somebody Up There Likes Me* (1956) opposite Paul Newman and *Battle of the Bulge* (1965) with Henry Fonda. *Courtesy Author's Collection*

[VERSO:] The true glory of Easter is reflected in the face of M-G-M's lovely young star Pier Angeli.

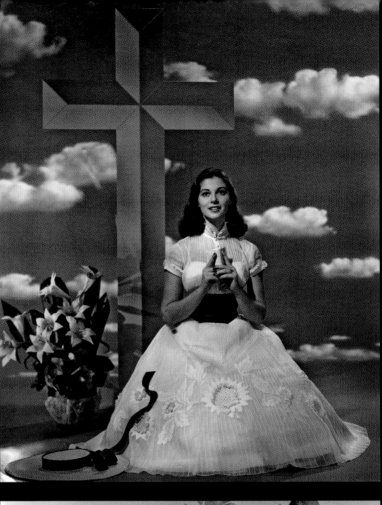

Lower Right: Born into a show business family, Gloria DeHaven worked at M-G-M, where she had featured roles in *Summer Stock* (1950) starring Judy Garland and *Three Little Words* (1950) with Fred Astaire. She has enjoyed a lengthy career in both prime time and daytime television. This portrait is by renowned photographer Clarence Sinclair Bull. *Courtesy Author's Collection*

Opposite: Gail Russell has an angelic glow, as if approaching a church altar. She played a pious Quaker opposite John Wayne in *Angel and the Badman* (1947). Other noteworthy films include *The Uninvited* (1944) with Ray Milland and *Night Has a Thousand Eyes* (1948) alongside Edward G. Robinson. *Courtesy Author's Collection*

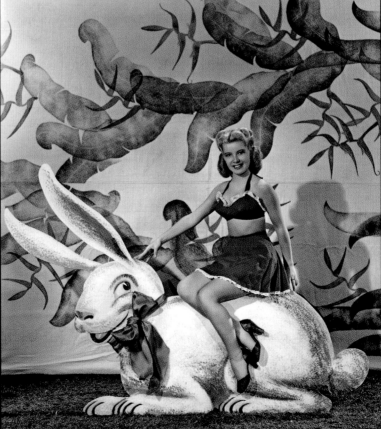

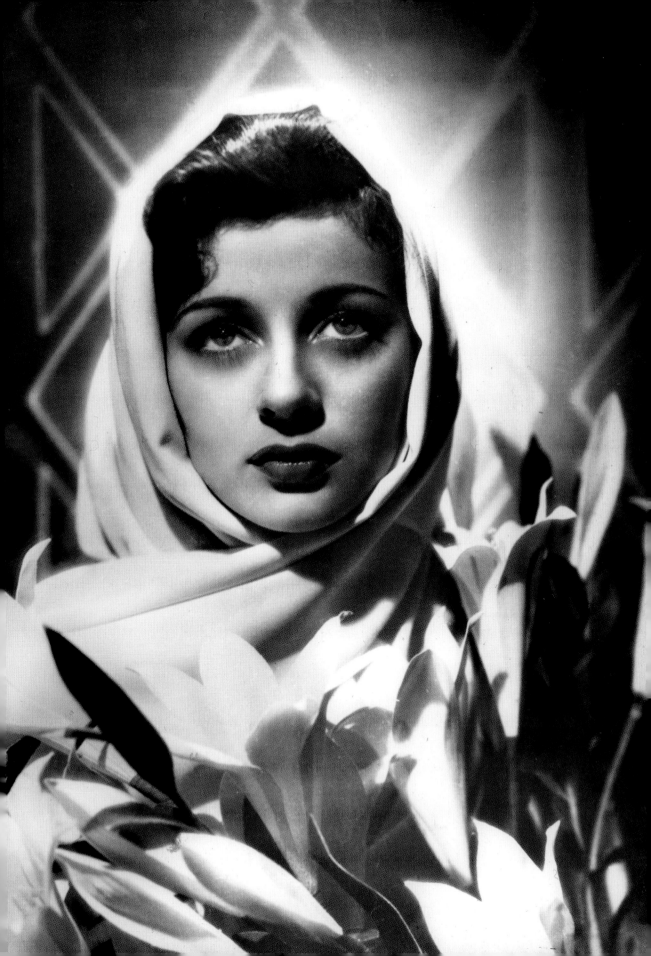

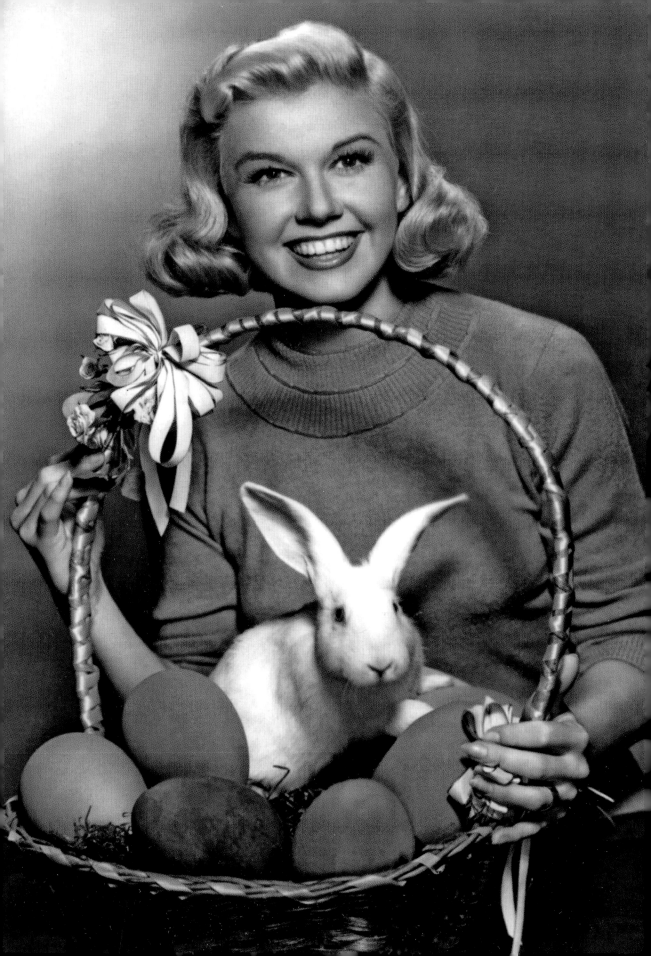

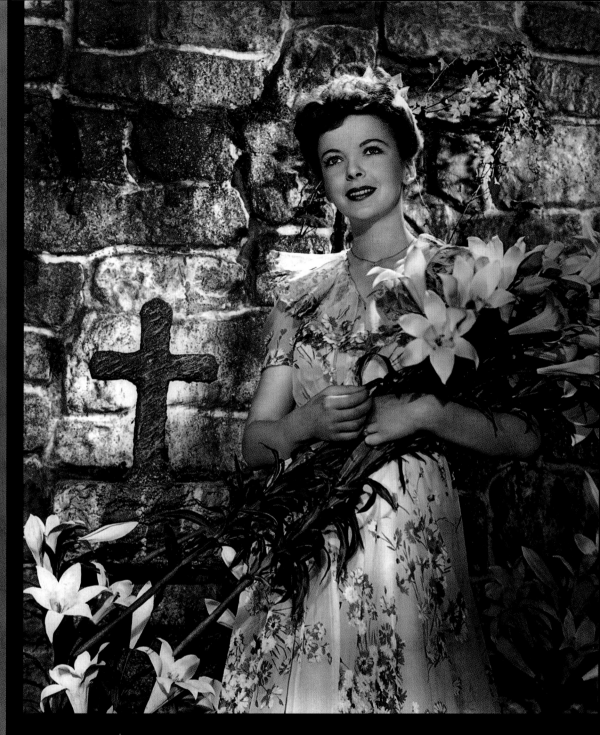

Opposite: Doris Day beams radiantly with her
Easter bunny and basket full of eggs. A top box
office star in the 1950s and 1960s, she famously
co-starred opposite Rock Hudson in *Pillow Talk*
(1959), *Lover Come Back* (1961), and *Send Me No
Flowers* (1964). *Courtesy Author's Collection*

Above: Ida Lupino wears her Sunday best for Easter
services, but don't be fooled by her delicate beauty.
Tough as nails, Lupino held her own opposite the
noir genre's top leading men in films such as *They
Drive By Night* (1940), *Road House* (1948), and *On
Dangerous Ground* (1951). *Courtesy Author's
Collection*

Fourth of July

Opposite: Long-legged Ann Miller patriotically struts her stuff before the flag in honor of the Fourth of July. During the 1940s, she enthusiastically tapped her way through such films as *Time Out for Rhythm* (1941), *True to the Army* (1942), and *Reveille With Beverly* (1943). *Courtesy of Photofest*

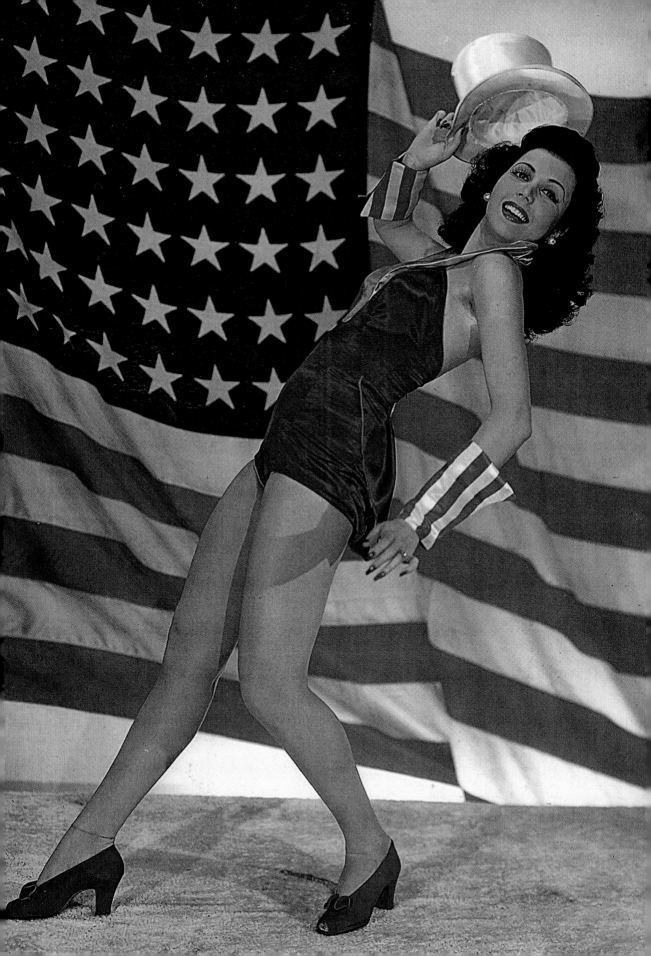

Don't try this at home! Wallace Beery and daughter Carol Ann celebrate Independence Day by shooting off fireworks. During a thirty-five-year film career, Beery played everything from drag to menacing heavies to lovable slobs. He won the Academy Award for Best Actor in 1931 for the M-G-M weepie *The Champ*. *Courtesy Author's Collection*

[VERSO:] EXCLUSIVE
　　　FOURTH OF JULY
Fourth of July is a great day for Carol Ann and daddy, Wally. They both save half the day and the early part of the evening, to celebrate Independence Day, by shooting all kinds of fireworks. Mr. Beery will next be seen in M-G-M's "Molly, Bless Her," with Sophie Tucker.

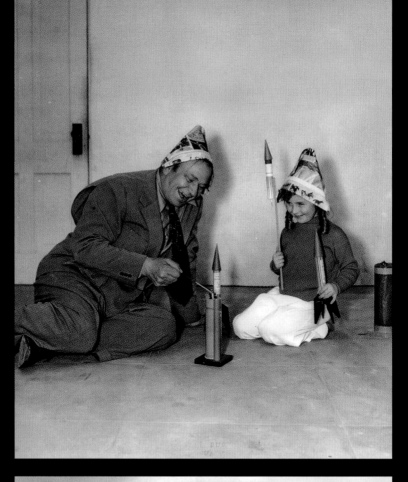

Vivacious flapper Colleen Moore energetically welcomes the Fourth of July as a high-stepping Uncle Sam. Her bob-haired, jazz-mad heroines lit up screens in the 1920s in such films as *Naughty But Nice* (1927), *Synthetic Sin* (1929), and *Why Be Good?* (1929). *Courtesy Author's Collection*

Opposite: It will be a hot time in the old town tonight as cowgirl Grace Bradley prepares to shoot off fireworks. Former stage dancer Bradley portrayed sultry, flippant leading ladies and second leads in "B" pictures before marrying William (Hopalong Cassidy) Boyd in 1937 and riding off into the sunset. *Courtesy Author's Collection*

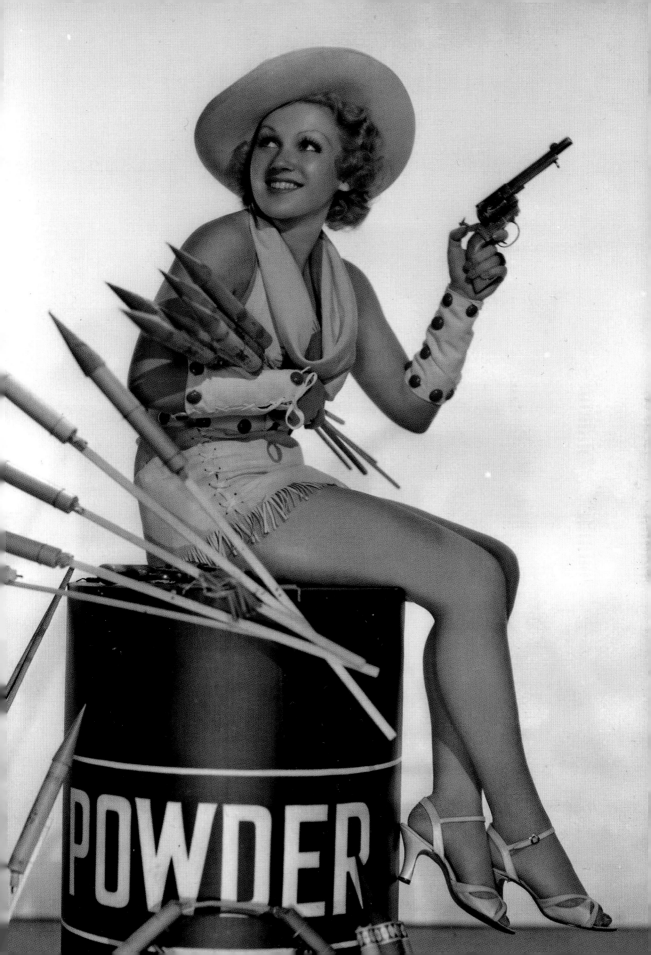

Zoe Dell Lantis, Jack Benny, and Betty Grable enthusiastically march in Fourth of July greetings on the back lot of Paramount Studios. Dressed in Revolutionary War garb, the trio drum up support for such Paramount Pictures titles as *Artists and Models Abroad* (1938), starring Benny. *Courtesy Author's Collection*

[VERSO:] July may go, but Jack Benny, star of Paramount's 1938 edition of Artists and Models, goes marching on. His fife and drum escort is made up of Zoe Dell Lantis (left) and Betty Grable (right).

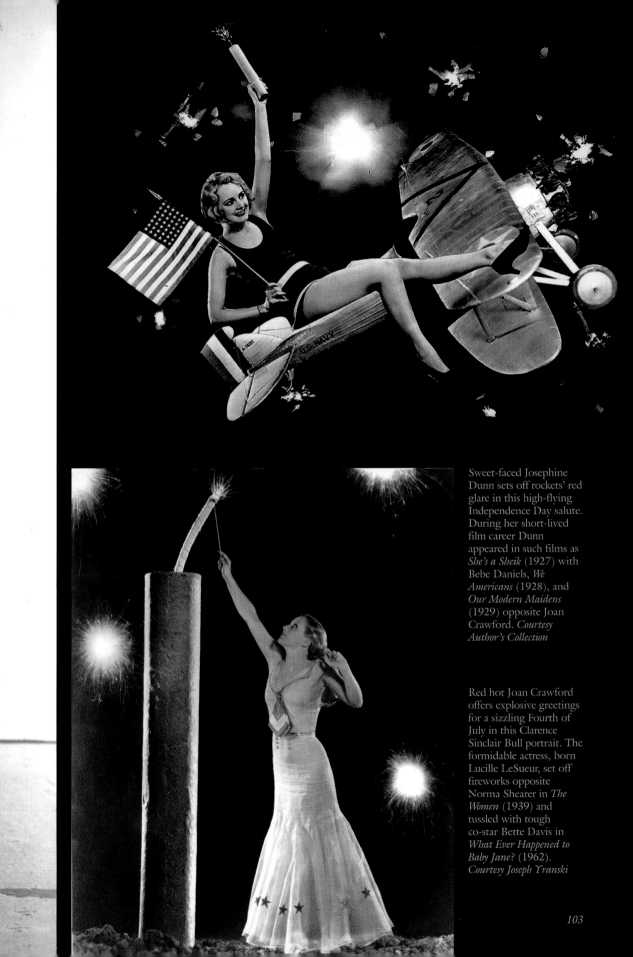

Sweet-faced Josephine Dunn sets off rockets' red glare in this high-flying Independence Day salute. During her short-lived film career Dunn appeared in such films as *She's a Sheik* (1927) with Bebe Daniels, *We Americans* (1928), and *Our Modern Maidens* (1929) opposite Joan Crawford. *Courtesy Author's Collection*

Red hot Joan Crawford offers explosive greetings for a sizzling Fourth of July in this Clarence Sinclair Bull portrait. The formidable actress, born Lucille LeSueur, set off fireworks opposite Norma Shearer in *The Women* (1939) and tussled with tough co-star Bette Davis in *What Ever Happened to Baby Jane?* (1962). *Courtesy Joseph Yranski*

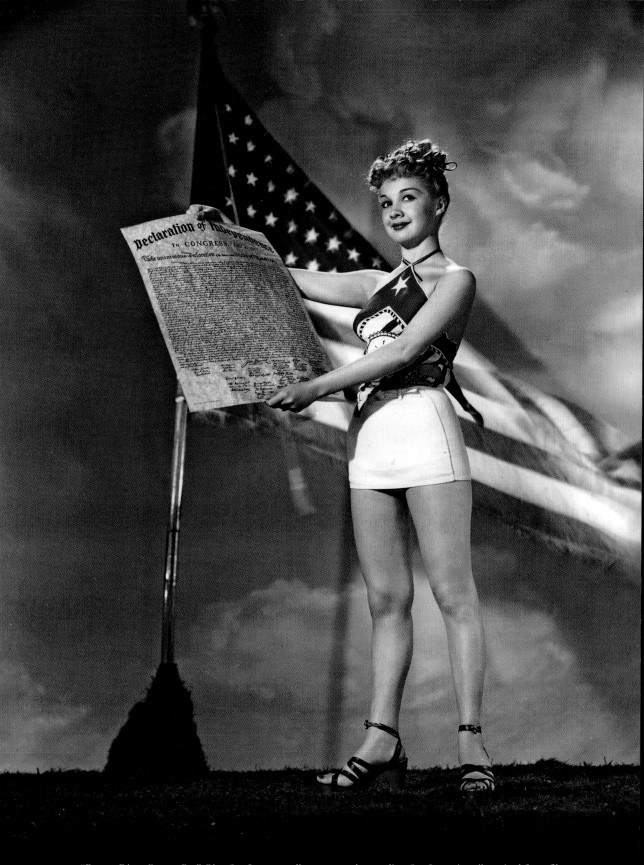

"Puerto Rican Pepper Pot" Olga San Juan proudly displays the Declaration of Independence on its special day. Adding a touch of Latin flavor to 1940s musicals and comedies, San Juan virtually retired from films soon after marrying star Edmond O'Brien in 1948. *Courtesy Author's Collection*

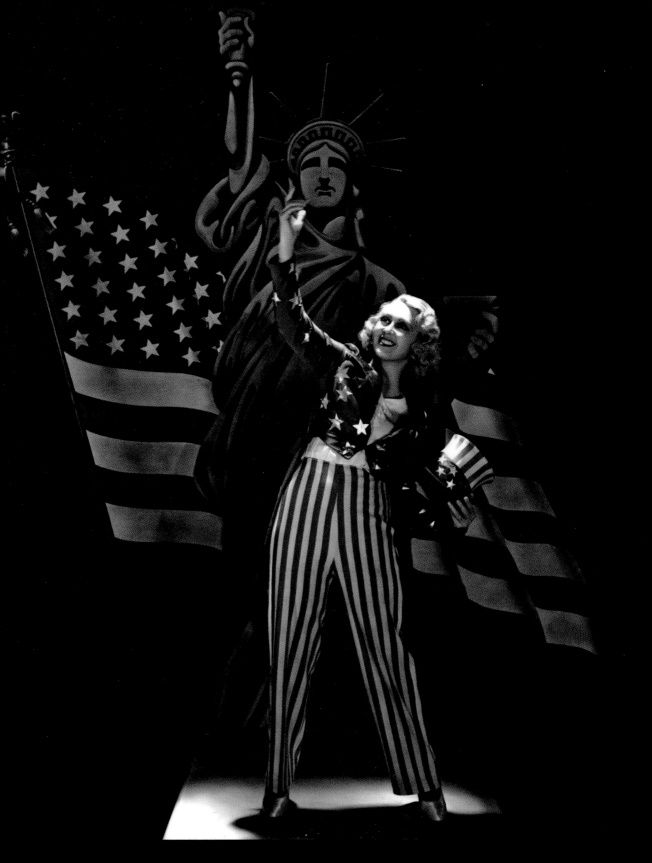

Upbeat Uncle Sam Joan Blondell proudly salutes the regal Statue of Liberty, welcoming newcomers seeking freedom to American shores. Warner Bros. star Blondell played cynical, wise-cracking dames with a heart of gold opposite such co-stars as James Cagney in 1930s pre-codes and musicals. *Courtesy Author's Collection*

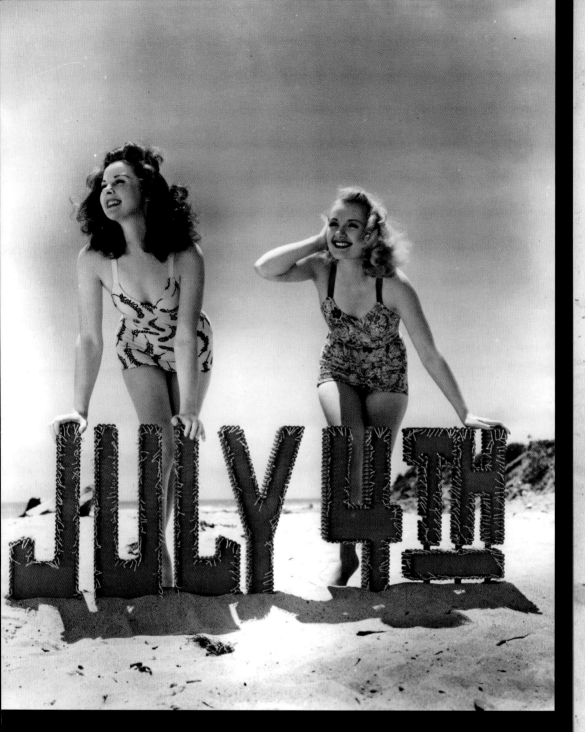

Above: Skimpily clad Susan Hayward and
Virginia Dale offer a shapely stand-up July 4
salute from a sunny California beach. Hayward
auditioned for the role of Scarlett in *Gone with
the Wind* (1939) under the name Edythe
Marriner. Dale hoofed it up with Fred Astaire in
Holiday Inn (1942). *Courtesy Author's Collection*

Opposite: Angela Greene offers curvy but playful
Fourth of July greetings at the beach. Playing small
roles in such classic films as *Mr. Skeffington* (1944)
and *Mildred Pierce* (1945) helped beauty Greene
graduate to attractive second leads in Westerns and
TV shows before concluding her career in
Futureworld (1976). *Courtesy Author's Collection*

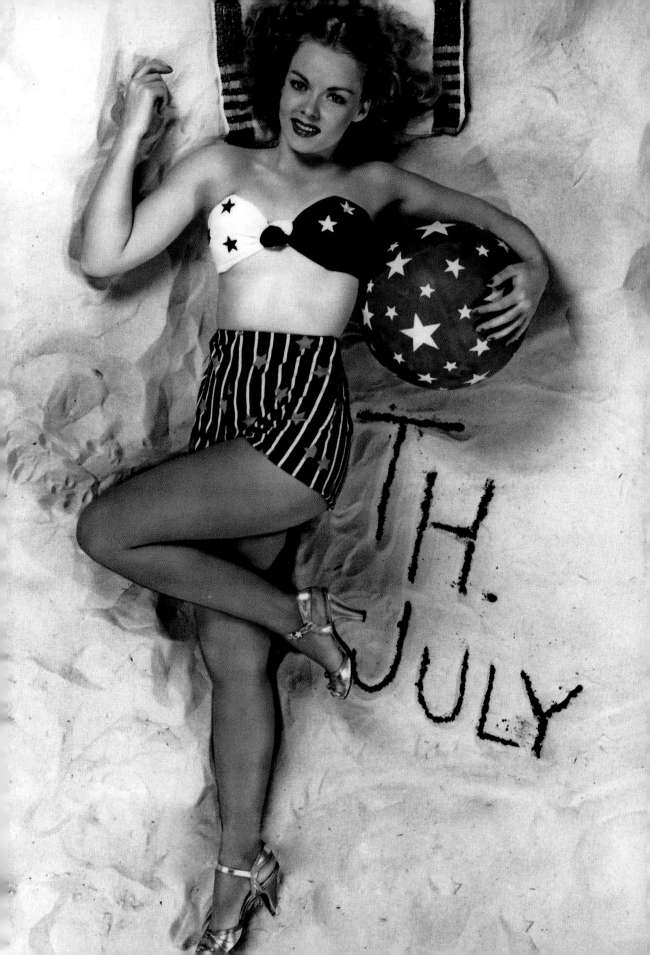

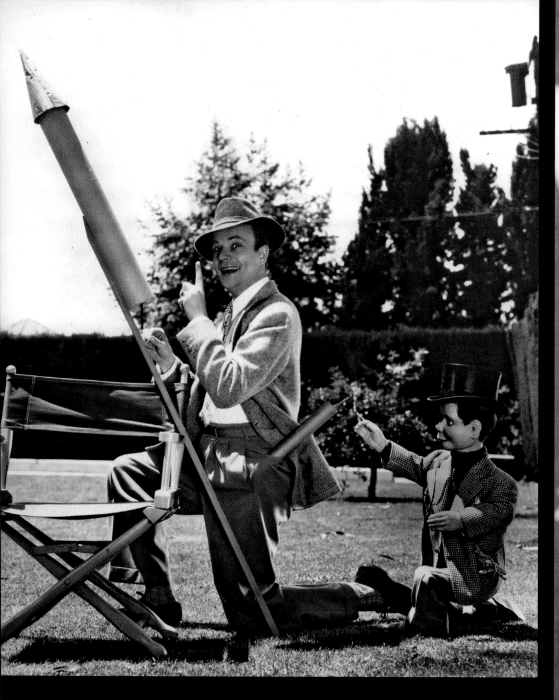

Dapper Charlie McCarthy prepares to light Edgar Bergen's fire for an explosive Independence Day. Ventriloquist Bergen entertained millions on radio, films, and TV, giving life to comic bon vivant dummy Charlie and his hayseed "brother" Mortimer Snerd. He earned a special Academy Award in 1937 for creating Charlie. *Courtesy Author's Collection*

[VERSO:] POP GOES THE BERGEN!
It occurs to Charlie McCarthy that this way of celebrating the Fourth of July might serve a double purpose. Maybe, thinks Charlie, when the firecracker in Edgar Bergen's pocket explodes it will blast out that much discussed raise of his 50-cents-a-week allowance. Charlie and his master will be heard throughout the Summer on the Chase and Sanborn program over the NBC-Red Network Sundays at 8:00 p.m., EST.

Sexy-voiced Lizabeth Scott proudly waves Old Glory, saluting America's Independence Day. Brought to Hollywood by producer Hal Wallis, the alluring Scott starred in such noir films as *Dead Reckoning* (1947), *Pitfall* (1948), and *Too Late For Tears* (1949) before departing the screen in 1957. *Courtesy Author's Collection*

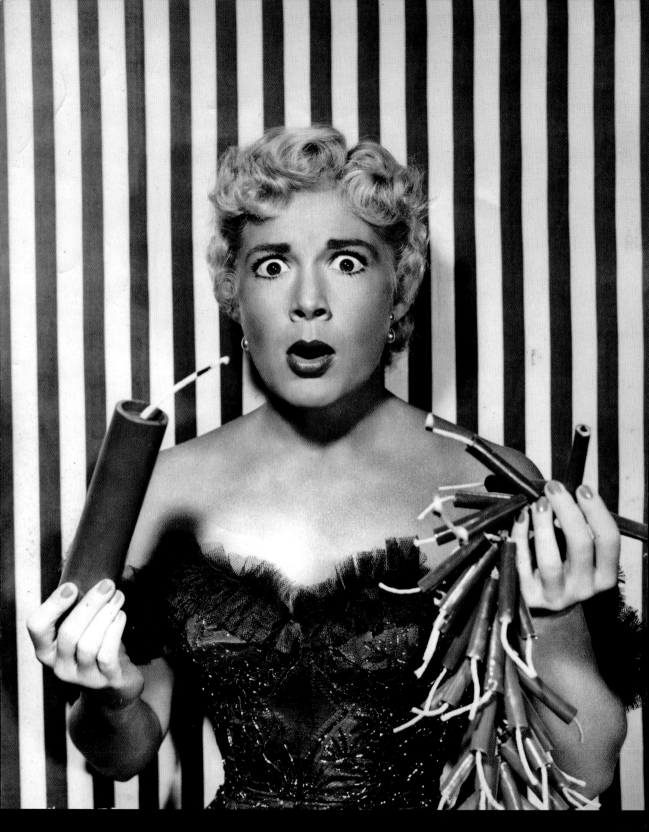

Hotsy totsy Betty Hutton prepares to shoot off fireworks
for an explosive Independence Day. Uninhibited and
exuberant "Blonde Bombshell" Hutton enlivened many
1940s and 1950s films before personal problems forced
her off the screen. She was later discovered working as a
cook and housekeeper in a Rhode Island Catholic rectory.
Courtesy Author's Collection

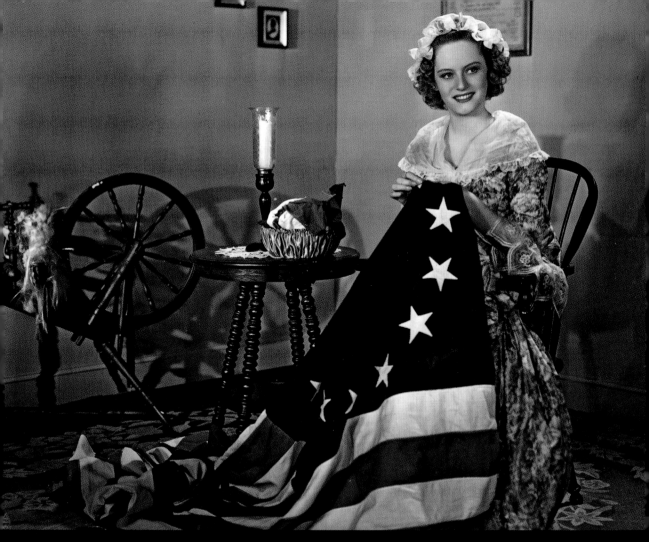

Stylish Alexis Smith apes Betsy Ross to sew an American flag in this photo by Bert Longworth. Portraying charming but calculating leading ladies on screen for Warner Bros. and other studios, Smith remained happily married to actor Craig Stevens for more than fifty years. *Courtesy Author's Collection*

[VERSO:] Because January 1st is the 190th birthday anniversary of Betsy Ross, the famous seamstress who designed and made the American flag, Warner Bros. featured player Alexis Smith, soon to be seen in STEEL AGAINST THE SKY, dons colonial costume and gives us a picture of what the birth of "Old Glory" was like.

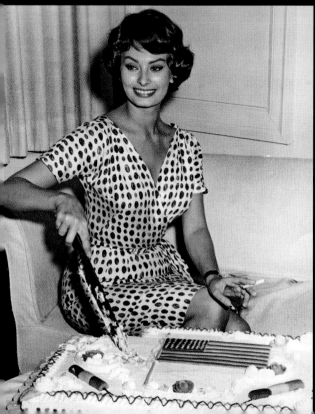

Voluptuous Sophia Loren carves a patriotically decorated cake saluting the Fourth of July during the production of *That Kind of Woman* (1959). The statuesque Italian starred opposite Cary Grant in *Houseboat* (1958) and won an Academy Award for her searing role in *Two Women* (1961). *Courtesy Author's Collection*

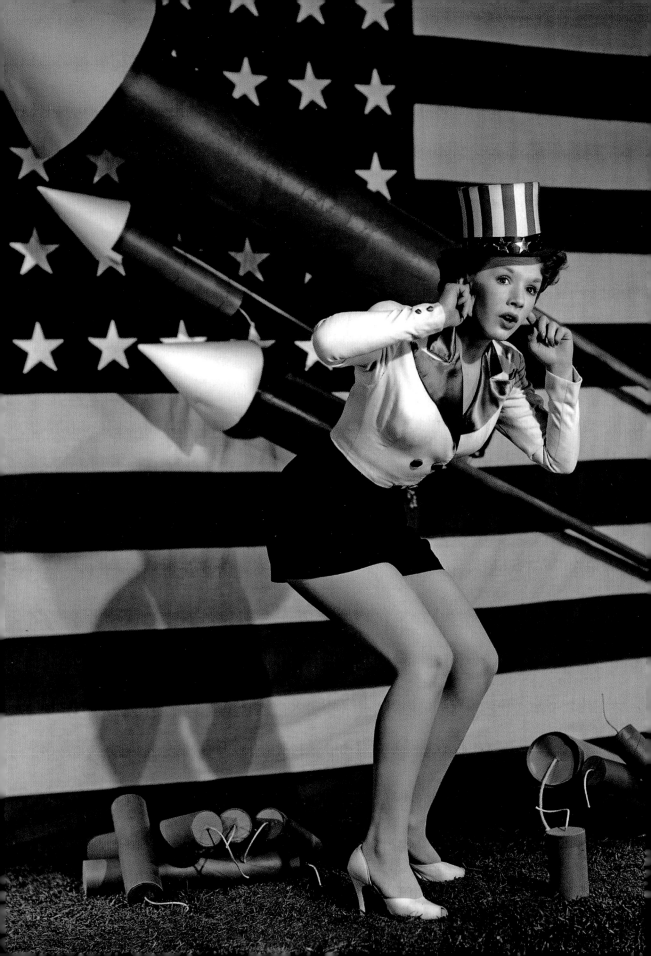

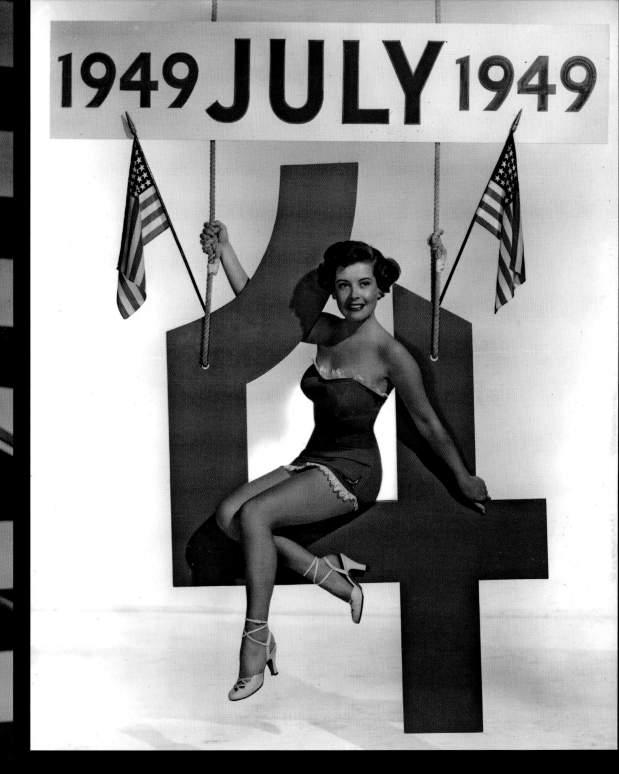

1949 JULY 1949

Opposite: Perky Piper Laurie anticipates detonation of Fourth of July fireworks. Typecast by Universal in cute ingénue roles in 1950s fantasy adventures and mindless comedies, she eventually earned acclaim opposite Paul Newman in *The Hustler* (1961). Laurie won an Academy Award nomination for her role in *Carrie* (1976). *Courtesy Author's Collection.*

Above: Shapely Gloria DeHaven offers swinging greetings for a high-flying July 4, 1949. Daughter of actor Carter DeHaven, she performed on the vaudeville circuit before landing a cameo in Charlie Chaplin's 1936 film *Modern Times.* Her vivacious, charming personality lit up 1940s M-G-M musicals. *Courtesy Author's Collection*

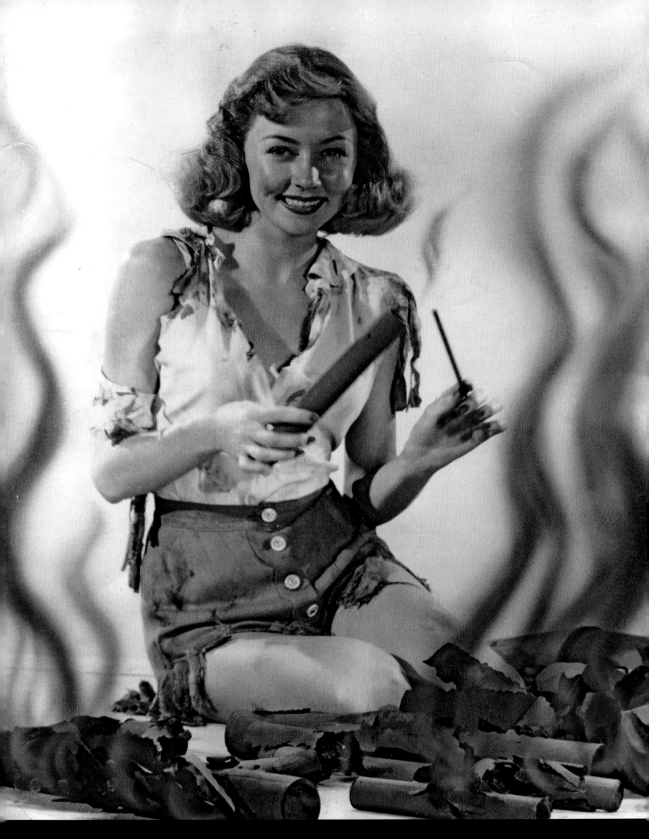

Sultry Gloria Grahame offers fiery July 4 greetings to fellow Americans. Playing saucy, seductive vixens in such film noirs as *Crossfire* (1947), *A Woman's Secret* (1949), and *Sudden Fear* (1952), she won an Academy Award as Supporting Actress for her role in the 1953 film *The Bad and the Beautiful. Courtesy, Author's Collection.*

[VERSO:] This could happen to you this 4th of July if you're as careless as Gloria Grahame, but the chances are 99 to 1 that you wouldn't look as good as the shapely star of RKO Radio's Rough-shod after such a major explosion.

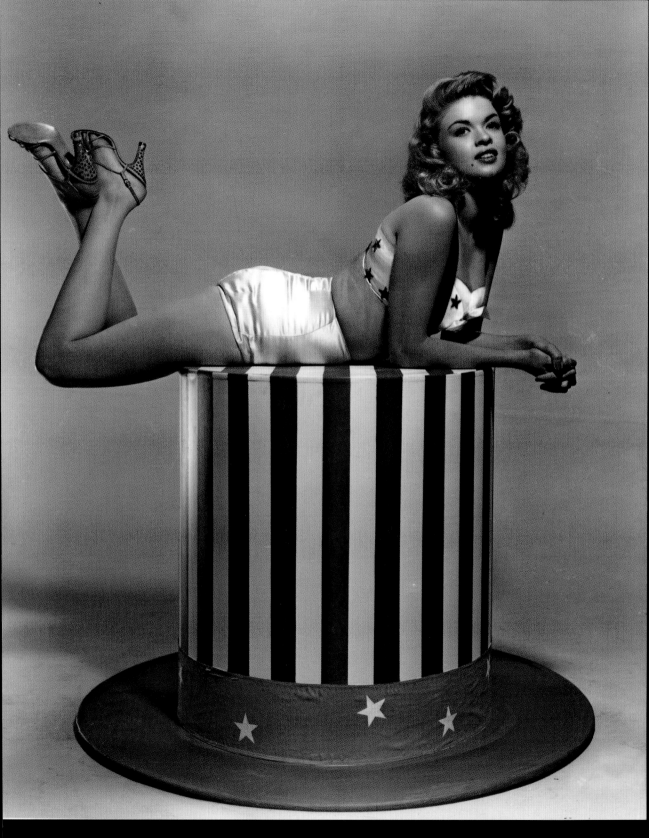

Curvaceous sexpot Jayne Mansfield sends a shapely
Independence Day hello lying on a giant Uncle Sam
top hat. Aping Marilyn Monroe with her breathless,
dizzy blonde film portrayals, Mansfield became
famous after appearing in both the stage and film
versions of *Will Success Spoil Rock Hunter?* (1957),
which amply displayed her physical assets. *Courtesy
Author's Collection*

CHAPTER NINE

Halloween

Vivacious silent film actress Mary Miles Minter strikes a jaunty pose for this 1921 Halloween photo. She starred in several films directed by William Desmond Taylor. At the peak of her popularity, Taylor's 1922 murder engulfed Minter in scandal and brought her career to an end one year later. *Courtesy Collections of the Margaret Herrick Library*

Opposite: Nancy Carroll casts a ghostly shadow in this studio publicity portrait. While popular and talented, her demanding personality sometimes overshadowed her screen talents and alienated colleagues. By the mid-1930s, she was relegated to "B" movies and eventually returned to the stage. *Courtesy Author's Collection*

Above: Spirited personality Madge Bellamy made her film debut in 1920. She made headlines in 1943, when she was arrested for assault with a deadly weapon after firing three shots at her former lover. Though the charges were suspended, her acting career was over by 1946. This bewitching photo is by Hoover Art Studios in 1921. *Courtesy Author's Collection*

Esther Ralston springs out of a smiling jack-o-lantern, offering Happy Halloween greetings. Hailed for her beauty, Ralston was named "The American Venus" and starred in a 1926 comedy of the same name. In 1927, she starred opposite Clara Bow and Gary Cooper in *Children of Divorce*. *Courtesy Author's Collection*

Clara Bow lights up Halloween night in this publicity still from the 1920s. Her sexy, carefree abandon embodied the spirit of the era. Dubbed the "It" Girl, Bow's meteoric career ended amidst a string of scandals and misfortune. Bow married cowboy star Rex Bell and spent most of her life in seclusion.

Right: Joan Crawford stirs up publicity in this striking Halloween photo. A true chameleon, she was able to adapt her looks and screen persona to changing public tastes, beginning with her days as a star at M-G-M, a mid-career stint at Warner Bros. and finally as a free agent. *Courtesy Author's Collection*

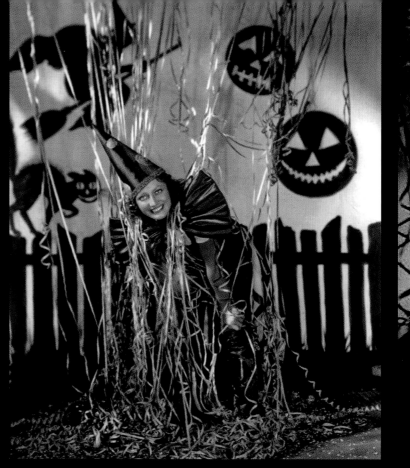

Below: Anita Page plots her escape with a stolen art deco pumpkin in this photo taken c. 1930. A popular starlet in the late 1920s and early 1930s, Page was under contract to M-G-M and appeared opposite Joan Crawford, Lon Chaney, Buster Keaton, and William Haines. *Courtesy Author's Collection*

Opposite: Judy Garland scares up a big screen success in this festive Halloween photo. She spent most of her early childhood touring the vaudeville circuit before signing with M-G-M and followed the yellow brick road to super stardom in the 1939 classic *The Wizard of Oz. Courtesy Author's Collection*

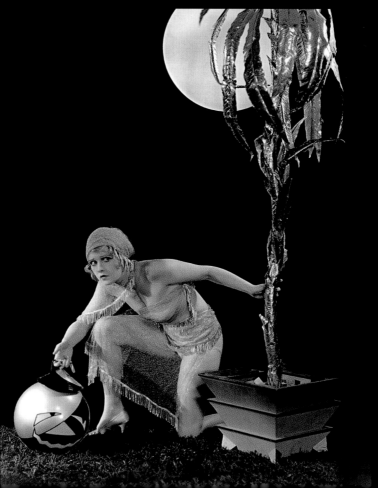

Nan Grey attempts to bewitch success while
basking in the glow of a full moon. She
appeared in horror films including *Dracula's
Daughter* (1936) and *The Invisible Man
Returns* (1940). Grey is best remembered
for her role in *Three Smart Girls* (1936)
opposite Deanna Durbin and its 1939
sequel. *Courtesy Author's Collection*

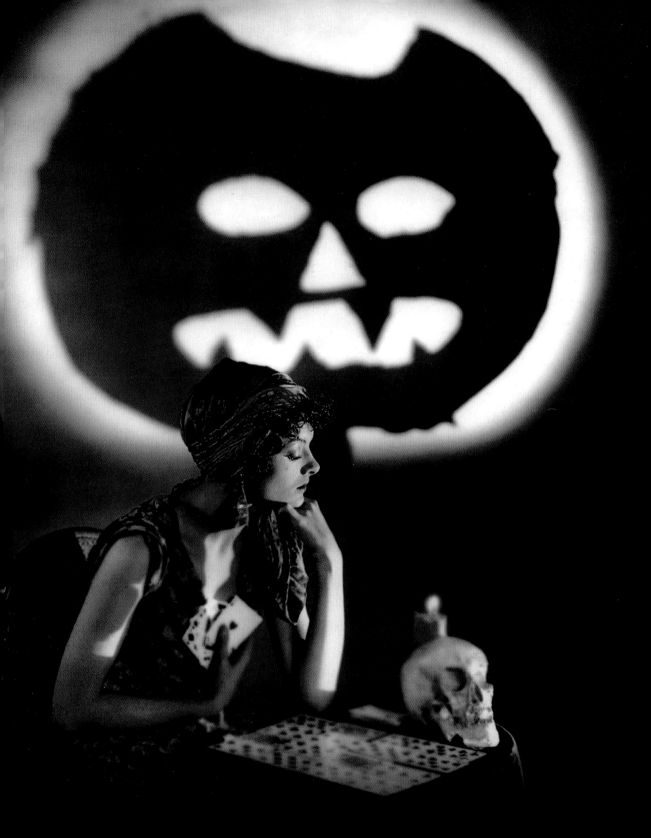

This still of Myrna Loy illustrates how her striking features led to her playing exotic beauties in films such as *The Mask of Fu Manchu* (1932). Artfully composed and rich in detail, this photo also illustrates the work of the early motion picture stills photographers who turned mere advertising into works of art. *Courtesy Author's Collection.*

[VERSO:] "Myrna Loy, Warner Bros. player, takes advantage of the mystic season of Halloween to get a line on what the future holds for her. One of its gifts is sure - the leading role in Arthur Somers Roche's story THE GIRL FROM CHICAGO."

Right: Child stars Robert Coogan and a candy-demanding Jackie Cooper get ready for Halloween trick or treating. The fearsome young lads co-starred together in the Paramount films *Skippy* and *Sooky*, both in 1931. *Courtesy Author's Collection*

[VERSO:] CELEBRATING – Robert (Sooky) Coogan and Jackie (Skippy) Cooper enter into the spirit of Hallowe'en. The two starlets of Paramount's "Skippy" are together again in "Sooky".

Opposite: Ever the gentleman, Robert Preston lights a cigarette for his skeleton "friend," only to have his pocket picked clean in return. He scored a Broadway triumph in *The Music Man*, repeating the role in the hit screen adaptation in 1962. *Courtesy Author's Collection*

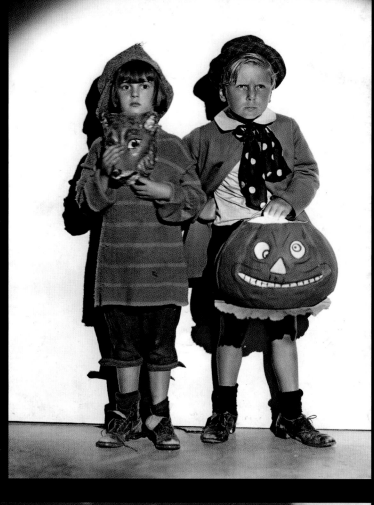

Scary stories spook Betty Grable in this alluring Halloween pin-up photo. While she routinely starred in lighthearted musicals and comedies, Grable made a rare foray into darker territory with the film *I Wake Up Screaming* in 1941. *Courtesy Author's Collection*

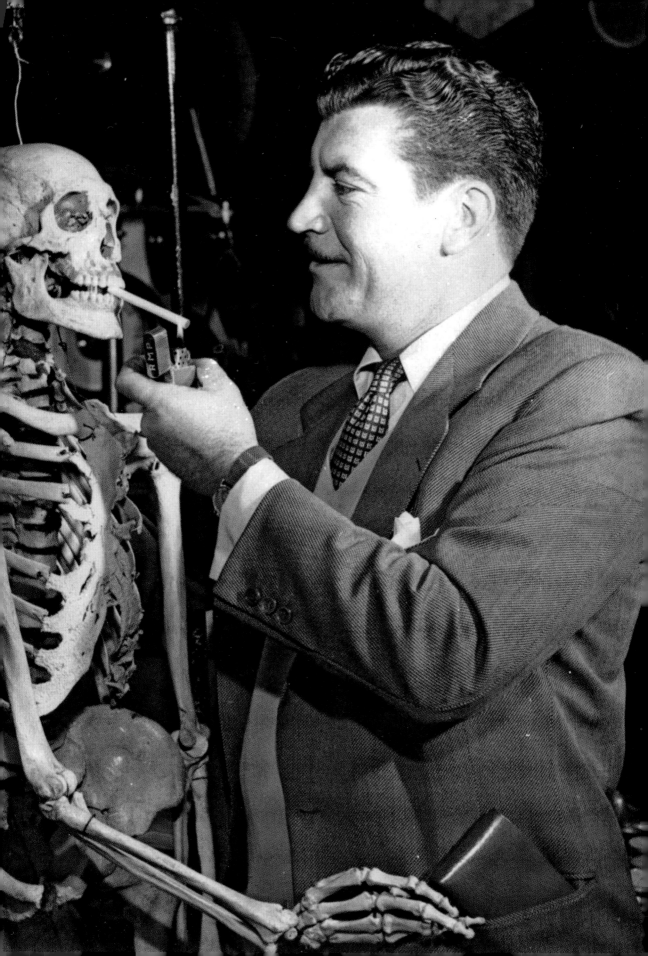

Ruth Roman offers up a seductive wink mirroring that of her jack-o'-lantern, which is minus the dazzling smile. She is perhaps best remembered for her role in Alfred Hitchcock's classic *Strangers on a Train* (1951). Other memorable films include *Tomorrow Is Another Day* (1951) and *Down Three Dark Streets* (1954). *Courtesy Author's Collection*

Bathing Beauty Esther Williams paints a papier-mâché pumpkin in a rare venture outside the swimming pool. The outbreak of World War II dashed her dreams of competing in the Olympics, but she found stardom in a series of opulent aqua-musicals at M-G-M. *Courtesy Author's Collection*

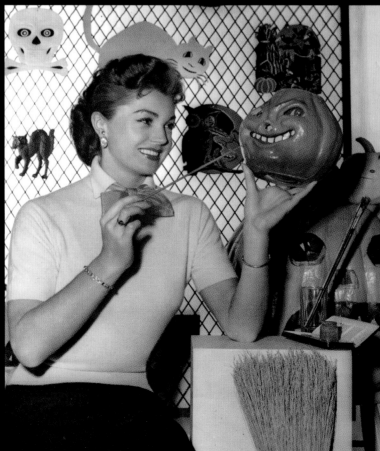

Seductive beauty Linda Darnell readies her dance card for a Halloween party. Her raven hair and tawny complexion photographed beautifully in Technicolor films such as *Blood and Sand* (1941), co-starring Tyrone Power and *Forever Amber* (1947). (Original Wilde/Cushman Archive Collection)

Starlets Janis Paige, Peggy Knudsen, and Martha Vickers
get into the spirit of the season by bobbing for apples. In
between film roles, these young actresses were kept busy
posing for the cameras in order to keep their names and
faces in front of the movie-going public. *Courtesy
Author's Collection*

Dusty Anderson exudes plenty of feline appeal in this
Halloween photo by Cronenweth. She was a pin-up girl
during World War II and appeared in several films
starring Rita Hayworth, including *Cover Girl* (1944) and
Tonight and Every Night (1945). Anderson married
director Jean Negulesco and retired from the screen.
Courtesy Author's Collection

[VERSO:] PRETTY KITTY..Black cats are supposed to
 be bad luck on Halloween or any other time, but
 when pretty Dusty Anderson, of Columbia's "Hail
 the Chief," impersonates a feline, it becomes strictly
 something else again. 1945

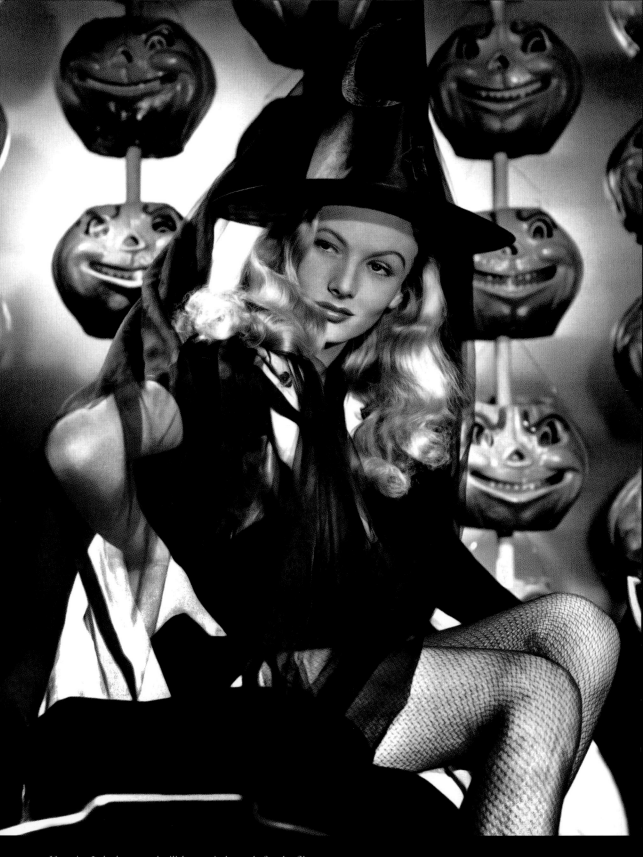

Veronica Lake brews a devilish stew in her role for the film
I Married A Witch (1942) as a chorus of maniacal
pumpkins grins in the background. Highlights of her
career include *Sullivan's Travels* (1941), *This Gun for Hire*
(1942), and *The Blue Dahlia* (1946). *Courtesy Photofest*

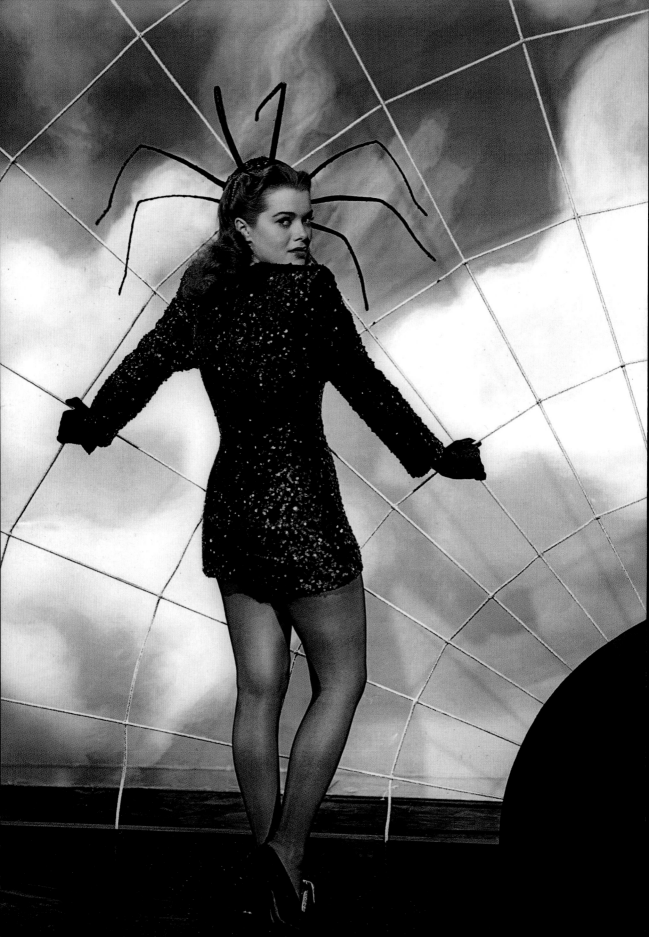

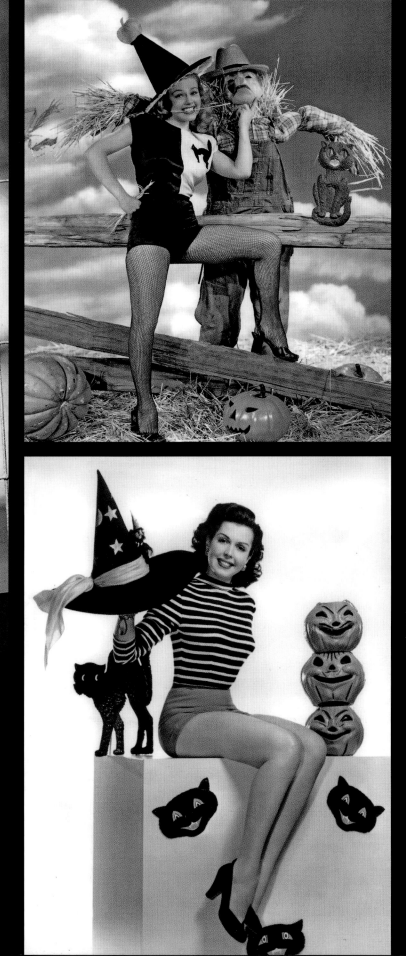

Opposite: Janis Paige prepares to entrap a victim in her dangerous web. After hearing her sing at the Hollywood Canteen during World War II, Warner Bros. signed her to a contract. She appeared in several minor ingénue roles in "B" movies, but found far greater success on Broadway and in television. *Courtesy Author's Collection*

Sexy starlet Martha Vickers befriends a local scarecrow just in time for the fall harvest. She made headlines when she became the third wife of Mickey Rooney, but that union proved to be tumultuous and short-lived. *Courtesy Author's Collection*

Ann Miller shows off her glamorous gams in this Halloween pin-up. After years on screen at M-G-M, she performed on Broadway in the hit musical *Sugar Babies* with Mickey Rooney. A role in David Lynch's *Mulholland Drive* (2001) marked her final film appearance. *Courtesy Author's Collection*

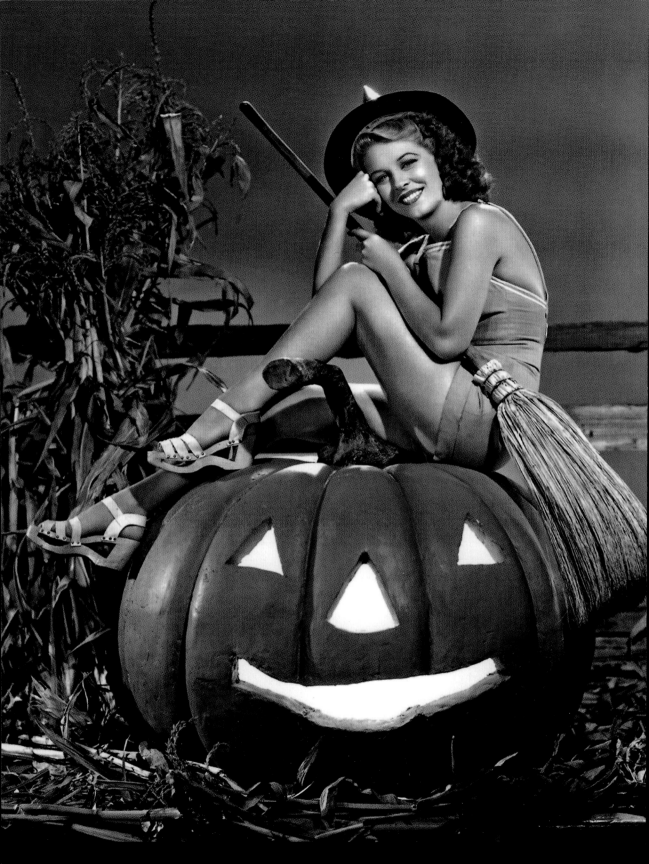

Anne Nagel shows a little leg as she sits atop a smiling jack-o'-lantern. She appeared opposite horror icons Bela Lugosi and Boris Karloff in *Black Friday* (1940) and Lon Chaney Jr. in *Man Made Monster* (1941). Troubled marriages and alcoholism contributed to her early death at age fifty. *Courtesy Author's Collection*

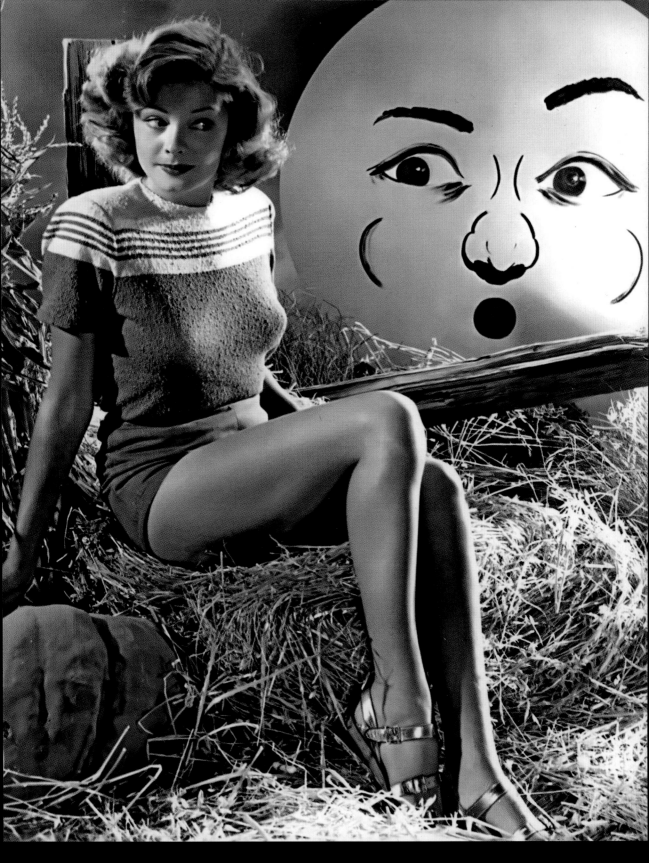

Svelte Jane Greer shows off her assets while the moon whistles in approval. Howard Hughes spotted her photograph in *Life* magazine, leading to a contract at RKO. She was paired with Robert Mitchum in the film noir classics *Out of the Past* (1947) and *The Big Steal* (1949). *Courtesy Author's Collection*

Sandra Dee sits on a bale of hay beside an angry jack-o'-lantern in this Halloween still. She starred opposite Lana Turner in *Imitation of Life* (1959) and in several beach films, including *Gidget* (1959). Dee has a place in pop culture thanks to the song "Look at Me I'm Sandra Dee" from the hit musical *Grease*. *Courtesy Author's Collection*

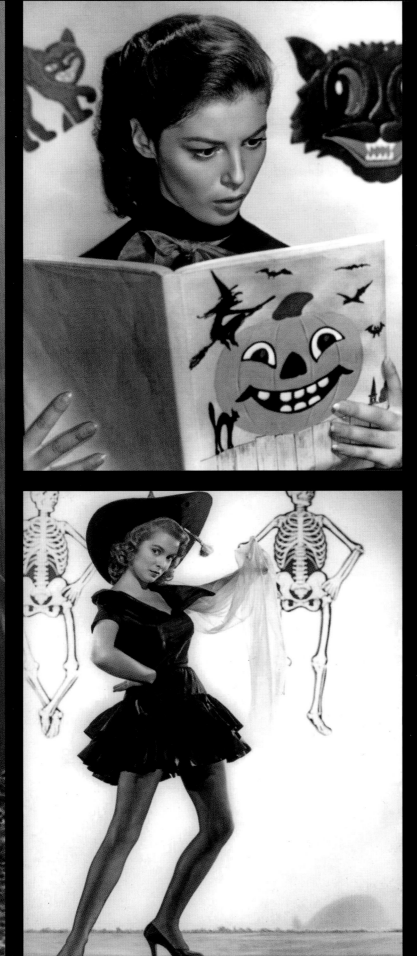

Engrossed in a Halloween haunted tale, Pier Angeli simply can't put the book down. She was romantically involved with James Dean and Kirk Douglas before marrying singer Vic Damone. Career setbacks led her to starring in several horror exploitation films before she was found dead of an overdose of barbiturates at age thirty-nine. *Courtesy Author's Collection*

Janet Leigh strikes a seductive pose in a sexy witch ensemble. Best remembered for her harrowing shower scene in the Alfred Hitchcock classic *Psycho* (1960), she also starred in *Touch of Evil* (1958) and *Bye Bye Birdie* (1963). Jamie Lee Curtis—her daughter with actor Tony Curtis—starred in the horror classic *Halloween* (1978). *Courtesy Author's Collection*

Thanksgiving

Opposite: Clifton Webb carves the holiday turkey in a
publicity photo from the film *Cheaper by the Dozen*
(1950). He often played debonair, elegant, and
effeminate characters and co-starred in a string of
classics including *Laura* (1944), *The Razor's Edge*
(1946), *Titanic* (1953), and *Three Coins in the Fountain*
(1954). *Courtesy Author's Collection.*

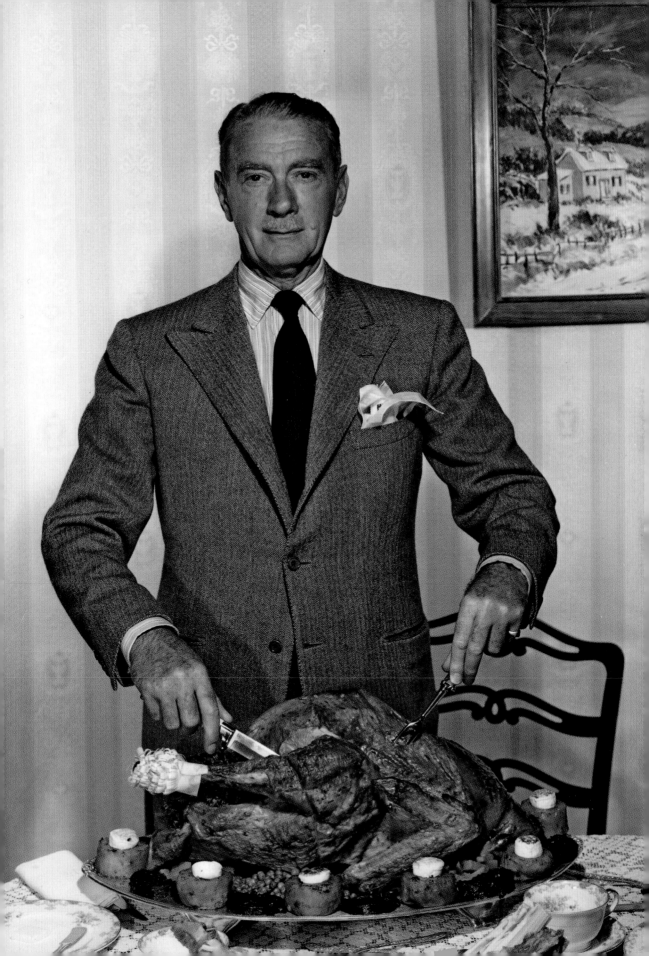

Mary Philbin begins early preparations for a Thanksgiving feast. She made her film debut at Universal in 1921 and is best remembered for co-starring opposite Lon Chaney in *The Phantom of the Opera* (1925) and Conrad Veidt in *The Man Who Laughs* (1928). *Courtesy Author's Collection*

[VERSO:] Mary Philbin, Universal star, sharpens her axe and fixes the Turkey with puissant glare as Thanksgiving draws near.

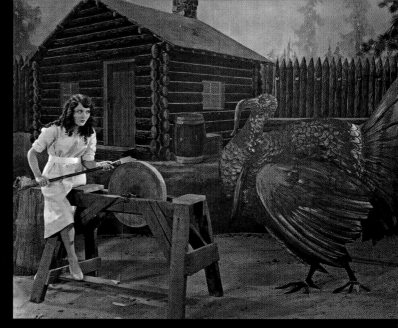

Colleen Moore opts for a vegetarian Thanksgiving by dining *with* her turkey instead of *eating* it. Moore starred in the 1923 film *Flaming Youth*, which ignited the public's fascination with the flapper. Unfortunately this film has been lost, along with roughly 80% of all silent films. *Courtesy Joseph Yranski*

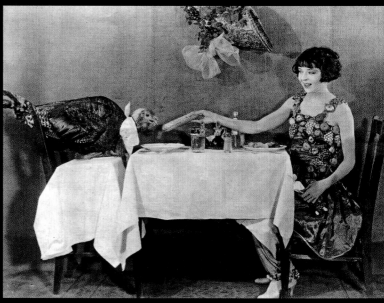

Marie Dressler and Polly Moran set the trap for an unsuspecting turkey. Both women began their careers in vaudeville before entering silent film in the 1910s. Their first pairing came in 1927, launching a unique comedy partnership that resulted in nine feature films. *Courtesy Author's Collection*

[VERSO:] LOS ANGELES---Here's your Thanksgiving Turkey. Marie Dressler and Polly Moran of the Metro-Goldwyn-Mayer studio set out to entice their own dinner. Pity the poor turkey. 11/2/27

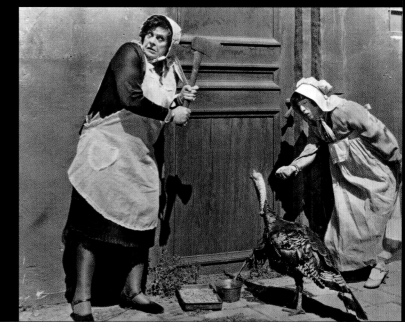

Mary Doran rides off into the sunset on her
Thanksgiving turkey. As a busy bit player at M-G-M,
Doran played small parts opposite M-G-M's brightest
stars, including Norma Shearer, Joan Crawford, and Jean
Harlow. She also worked at other studios but never
achieved major stardom. *Courtesy Author's Collection*

[VERSO:] EXCLUSIVE RIDE'EM GAL! Mary Doran,
 one of Metro-Goldwyn-Mayer's most charming
 featured players, is off for a real Thanksgiving ride on
 old man Turkey, himself. Incidentally, Miss Doran
 takes this opportunity to extend her Thanksgiving
 greetings to you. Stamped October 17, 1930

MC-8-

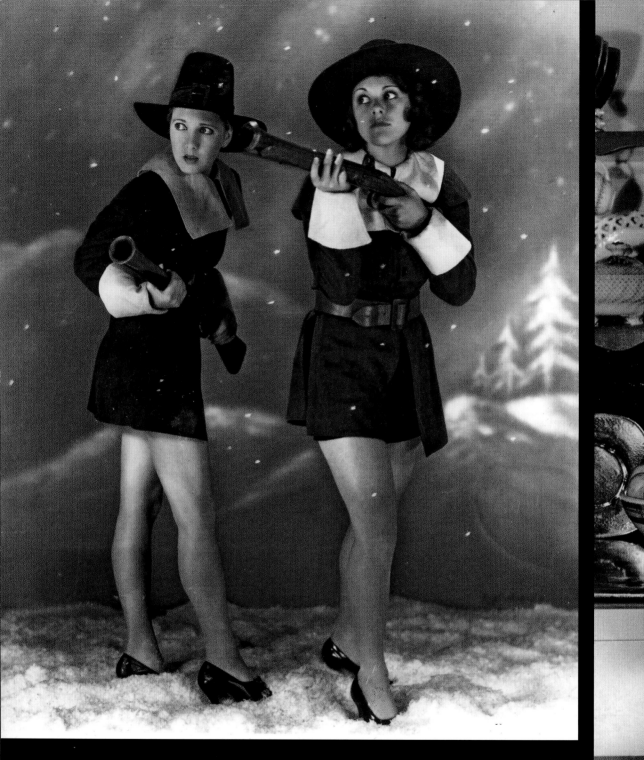

Above: Jean Arthur and Lillian Roth pose as sexy pilgrims on the hunt for their prey. Arthur hit her stride in the 1930s, starring in several films for director Frank Capra. Singer Lillian Roth led a troubled personal life but lived to tell the tale in her autobiography. *Courtesy Author's Collection*

Opposite: Shirley Temple gets into the spirit of the season in this Thanksgiving publicity still. She was thirteen in this 1941 photo and made her final film appearance in 1949. A brief stint in television followed before she embarked on a career in politics, serving as a United States ambassador to Ghana and Czechoslovakia. *Courtesy Author's Collection*

[VERSO:] Miss. Temple is eating a drumstick from her Thanksgiving Day Feast, and it is so good it caused her to break into her Joyful Dance. This photo is a Publicity photo from the film, "Kathleen" (1941).

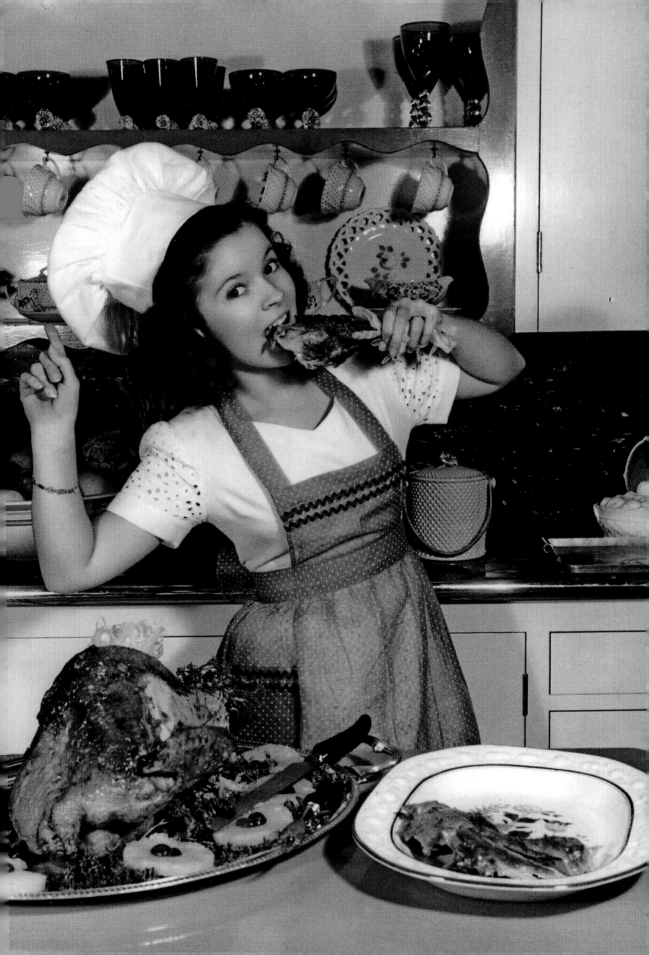

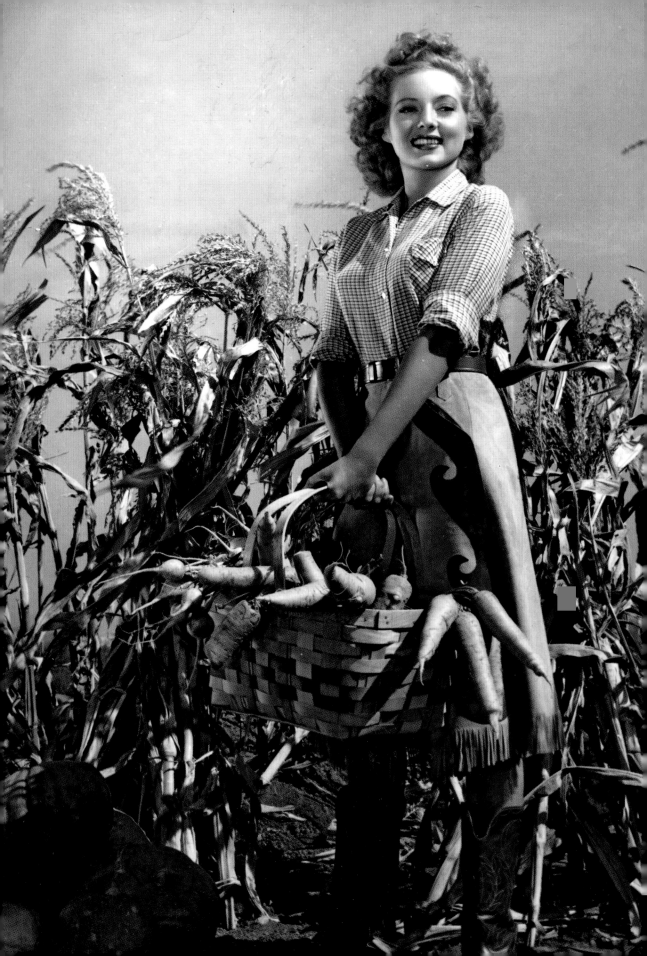

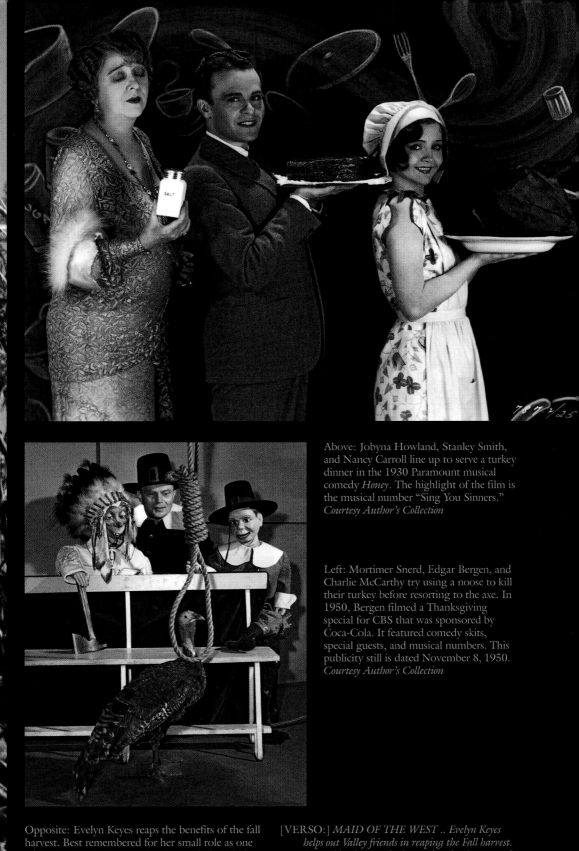

Above: Jobyna Howland, Stanley Smith, and Nancy Carroll line up to serve a turkey dinner in the 1930 Paramount musical comedy *Honey*. The highlight of the film is the musical number "Sing You Sinners." *Courtesy Author's Collection*

Left: Mortimer Snerd, Edgar Bergen, and Charlie McCarthy try using a noose to kill their turkey before resorting to the axe. In 1950, Bergen filmed a Thanksgiving special for CBS that was sponsored by Coca-Cola. It featured comedy skits, special guests, and musical numbers. This publicity still is dated November 8, 1950. *Courtesy Author's Collection*

Opposite: Evelyn Keyes reaps the benefits of the fall harvest. Best remembered for her small role as one of Scarlett O'Hara's sisters in *Gone with the Wind*, she played the lead in several sizzling "B" noirs, including *Johnny O'Clock* (1947), *The Prowler* (1951), *99 River Street* (1953), and *Hell's Half Acre* (1954). *Courtesy Author's Collection*

[VERSO:] *MAID OF THE WEST .. Evelyn Keyes helps out Valley friends in reaping the Fall harvest. Her golden hair perfectly matches the ripe tones of the pumpkins and other field vegetables. Evelyn has just completed "Dangerous Blondes" at the Columbia Studios.* 1943

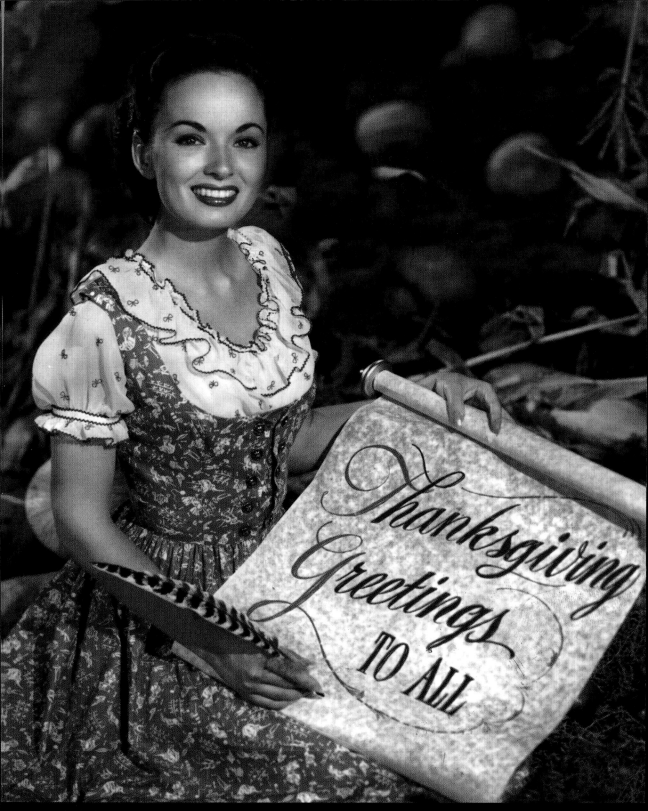

Beginning her career on the radio and Broadway before entering films, Ann Blyth was cast in several light-hearted musical comedies before her career defining performance as "Veda" in *Mildred Pierce* (1945). Blyth held her own opposite Joan Crawford and was rewarded with an Academy Award nomination for Best Supporting Actress. *Courtesy Author's Collection*

[VERSO:] GREETINGS FROM ANN BLYTH
Ann Blyth, seated in the midst of the traditional plenty of American harvest time, sends Thanksgiving greetings to all from Hollywood. Universal-International's young film beauty is currently starring with David Farrar, "England's Clark Gable," in "The Golden Horde," a Technicolor production telling an exciting and expansive story of Genghis Khan's attempted rape of Samarkand in the 13th Century.

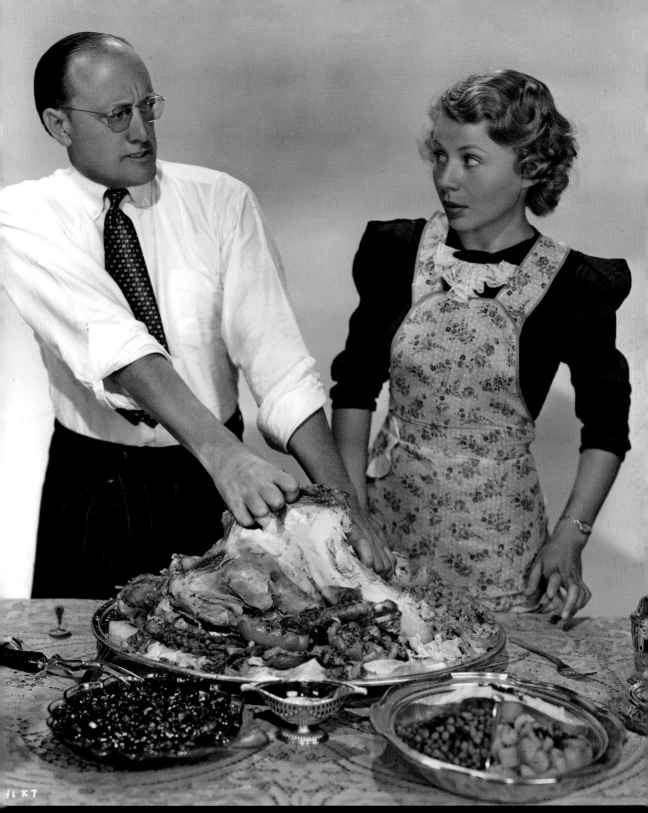

11 X 7

Pete Smith tears into a turkey in front of Sally Payne, who appears daunted and possibly ready to flee the scene. Smith wrote and produced over 200 short one-reel films for M-G-M called "Pete Smith Specialties," covering a wide variety of topics including pet peeves, oddities, and the perils of domestic life. *Courtesy Author's Collection*

[VERSO:] WHEN ALL ELSE FAILS…If you can't succeed in getting the final pieces of meat off a turkey's frame, resort to this method Pete Smith tells Sally Payne. His latest Metro-Goldwyn-Mayer Specialty "Let's Talk Turkey," pictured the correct method of carving a fowl. Felix E. Feist directed

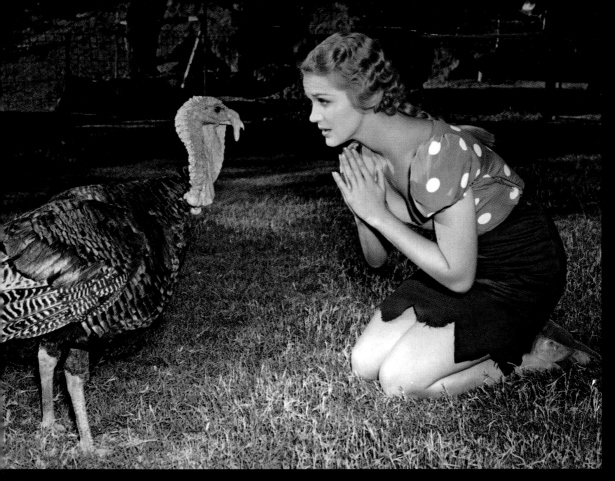

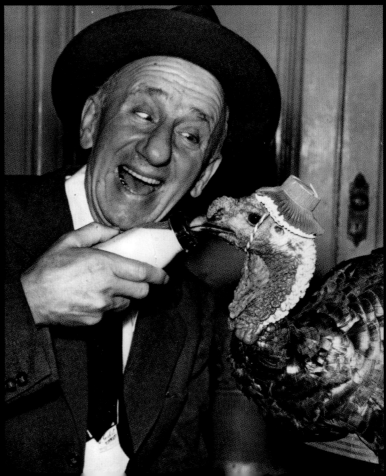

Martha O'Driscoll begs the turkey for forgiveness before it becomes the Thanksgiving Day main course. She starred as "Daisy Mae" in the first screen adaptation of the comic *Li'l Abner* (1940). Other notable credits include roles in *The Lady Eve* (1941) and Cecil B. DeMille's *Reap the Wild Wind* (1942). *Courtesy Author's Collection*

Jimmy Durante possessed skills as a pianist, singer, songwriter, comedian, and actor during his storied career. His gravelly voice, New York accent, and down-to-earth personality made him a popular performer. To younger generations, he is known as the voice of the cartoon *Frosty the Snowman* (1969). *Courtesy Author's Collection*

[VERSO:] NOT TO BE OPENED UNTIL THANKSGIVING NEW YORK: Jimmy "The Nose" Durante, comic supreme, fattens up his personal turkey in preparation for the Annual Macy's Thanksgiving Day Parade, Nov. 23. The "ever-lovin'" Durante will lead the gala affair as Grand Marshal on the American Eagle Float.

Dancer Vera-Ellen prepares a balletic and artful turkey execution. Her dance skills are on full display in the "Miss Turnstiles" sequence in *On the Town* (1949) starring Gene Kelly. She also co-stars in the beloved holiday hit *White Christmas* (1954) alongside Bing Crosby, Danny Kaye, and Rosemary Clooney. *Courtesy Author's Collection*

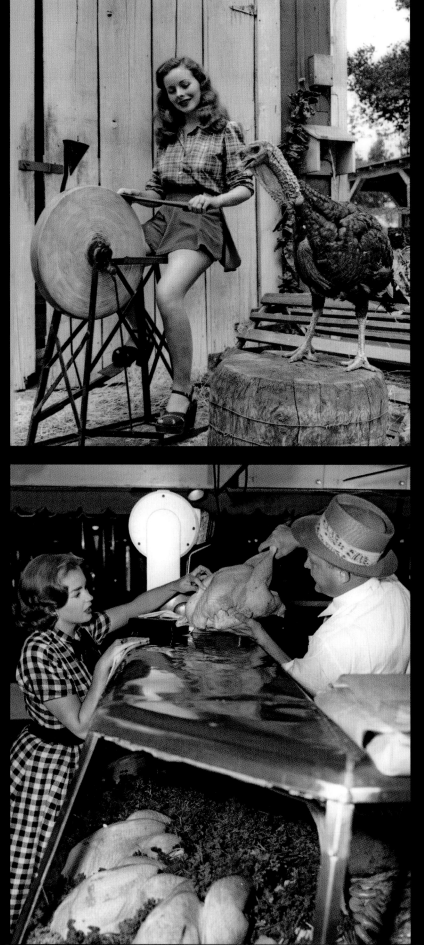

Sexy starlet Jeanne Crain sharpens her axe as the turkey watches in horror. She co-starred in the classic *Leave Her To Heaven* (1945) opposite Gene Tierney. In 1949, her career hit a peak with *A Letter to Three Wives* and *Pinky*, which earned her an Academy Award nomination for Best Actress. *Courtesy Author's Collection*

English-born actress Dawn Addams embraces the American tradition of Thanksgiving. She co-starred in *The Moon Is Blue* (1953), *The Robe* (1953), and *A King in New York* (1957). Toward the end of her career, she took roles in British horror films including *The Vampire Lovers* (1970). *Courtesy Author's Collection*

[VERSO:] TURKEY TIME... in Hollywood finds M-G-M's Dawn Addams bustling about at the Farmer's Market, filmdom's shopping center, selecting the fixin's for her Thanksgiving dinner. Dawn who appears in M-G-M's Technicolor production "Plymouth Adventure" finds today's abundant variety of foods a far cry from the meager fare of the first Thanksgiving. FIRST ON THE LIST....is Tom Turkey. Dawn expertly selects a bird of just the proper size and weight for her needs. 1952

Judy Canova carved out a niche as a boisterous hayseed comedian in a career that included Broadway, films, radio, and television. A series of low budget films were built around her persona and featured such titles as *Hit the Hay* (1945) and *Singin' in the Corn* (1946). *Courtesy Author's Collection*

[VERSO:] *GETTING THE BIRD*
Judy Canova's pretense of slumber doesn't seem to be deceiving her wary quarry. That blunderbuss the NBC star is packing looks as though it could make hash of her potential Thanksgiving dinner.

CHAPTER ELEVEN

Christmas

Opposite: Chipper, charming Debbie Reynolds
whispers sweet nothings to a lonely snowman. The
unsinkable Reynolds survived tough marriages, divorce
doldrums, and bankruptcy to rise triumphantly after
auctions of her own high-end movie memorabilia.
Reynolds is perhaps best known for roles in *Singin' in
the Rain* (1952) and *The Unsinkable Molly Brown*
(1964). *Courtesy Author's Collection*

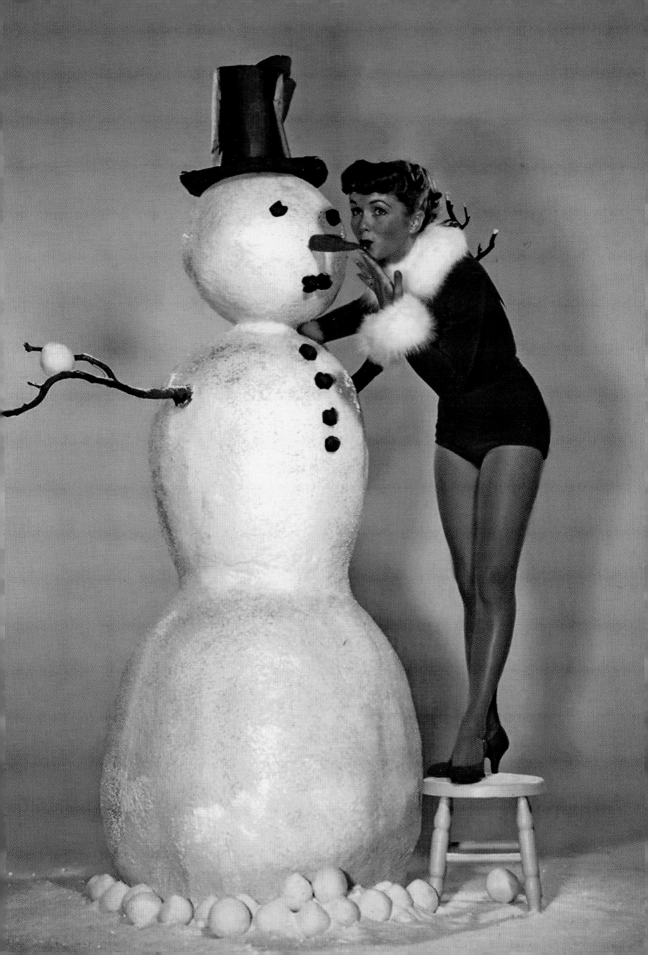

Upper Left: Screen vamp Mae Busch suggests shopping early to avoid the Christmas rush. Best remembered for co-starring with Stan Laurel and Oliver Hardy in shorts and films as Ollie's shrewish wife, Busch also played opposite Erich von Stroheim in *Foolish Wives* (1922) and Lon Chaney in *While the City Sleeps* (1928). *Courtesy Jeffrey Mantor, Larry Edmunds Bookshop*

Lower Left: Snow bunny Myrna Loy brings a snowman to life this chilly Christmas. The perfect wife opposite William Powell in *The Thin Man* series of films, Fredric March in *The Best Years of Our Lives* (1946), and Cary Grant in *Mr. Blandings Builds His Dream House* (1948), Loy's essential decency gave her roles heart. *Courtesy Author's Collection*

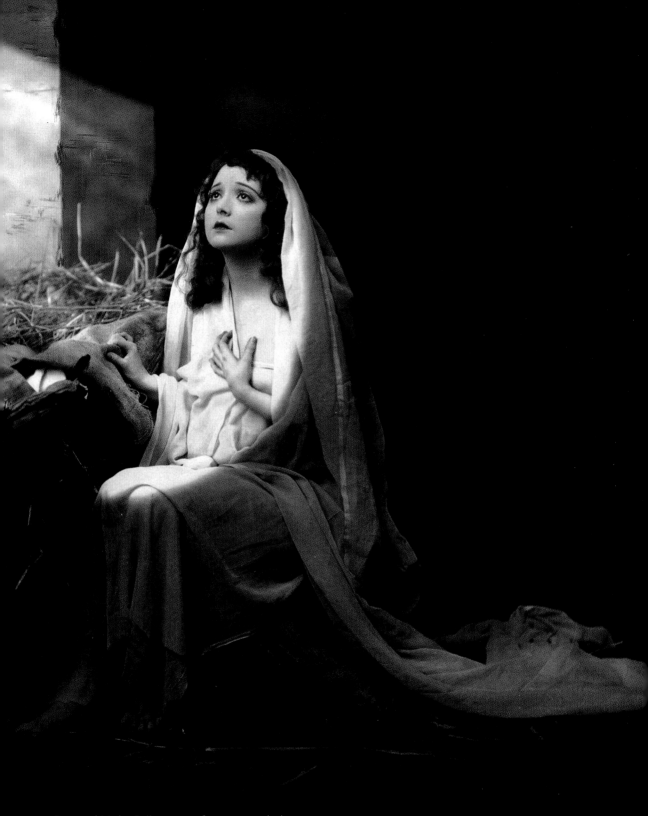

Doe-eyed Madge Bellamy prays for a room at the inn as
a pensive Madonna in this photo by the Evans Studio.
Passionate and emotional off-screen, the expressive
Bellamy brought tender vulnerability to her starring roles
in the silent films *Lorna Doone* (1922) and John Ford's
The Iron Horse (1924). *Courtesy Collections of the
Margaret Herrick Library*

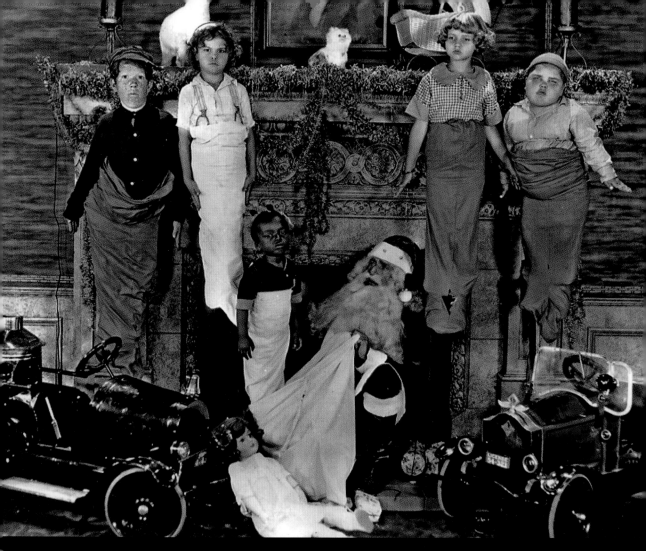

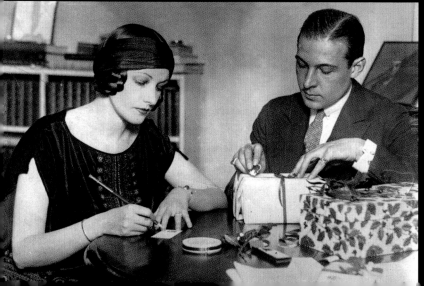

The original *Our Gang* series of kids feels a little stuffed on Christmas Day. Brought to life by producer Hal Roach in 1922, the film franchise demonstrated kids doing the crazy things kids normally do. Santa Claus greets Allen "Farina" Hoskins, Mickey Daniels, Jackie Condon, Mary Kornman, and Joe Cobb. *Courtesy Author's Collection*

1920s heartthrob Rudolph Valentino and wife Natacha Rambova meticulously wrap Christmas presents. Latin lover Valentino mesmerized filmgoers with his deep gaze and sensual moves. His films *The Sheik* (1921) and The *Son of the Sheik* (1926) demonstrate his physical vitality and intense charisma. He died unexpectedly at the age of thirty-one. *Courtesy Donna L. Hill Collection*

A scantily clad Grace Bradley decks the tree with festive Christmas decorations. Discovered singing and dancing on the Broadway stage, Grace Bradley traveled west to Hollywood after signing with Paramount Pictures. She played second-lead party girls in musicals and comedies, a feisty femme fatale. *Courtesy Author's Collection*

Here comes Santa Claus in the guise of Joan Crawford, bringing presents for all good boys and girls. Extremely savvy to the importance of publicity in shaping a career, Crawford posed for all types of studio portraits, particularly with the great stills photographer George Hurrell. *Courtesy Author's Collection.*

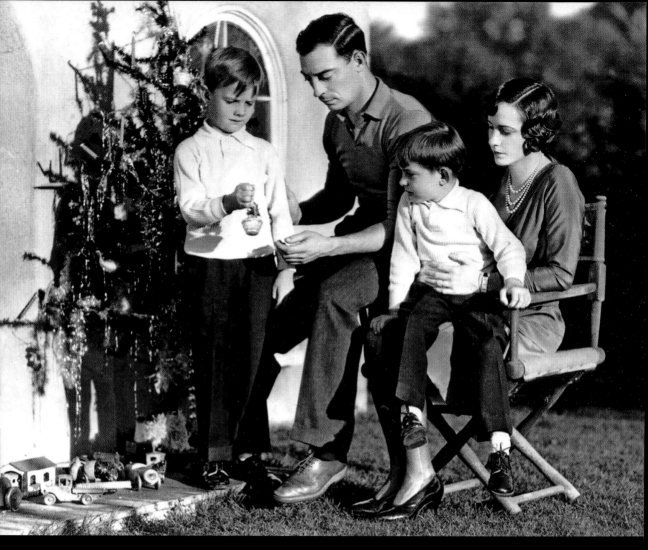

Inventive screen comedian Buster Keaton helps his family decorate the Christmas tree. Called "The Great Stone Face," the athletic Keaton performed spectacular stunts in his imaginative silent comedy films, including *Sherlock, Jr.* (1924), *The General* (1926), and *The Cameraman* (1928), before becoming a gagman and writer for other comedians. *Courtesy Author's Collection*

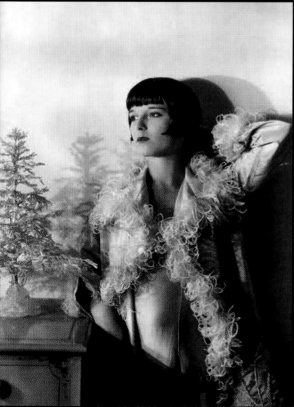

A pensive Louise Brooks considers holiday decorating. Self-possessed, independent-minded Brooks followed her own path in Hollywood, sometimes to her detriment. Headstrong and sexually alluring, she starred in Paramount's *Beggars of Life* (1928) before starring in European films *Pandora's Box* (1929) and *Diary of a Lost Girl* (1929). *Courtesy Louise Brooks Society*

159

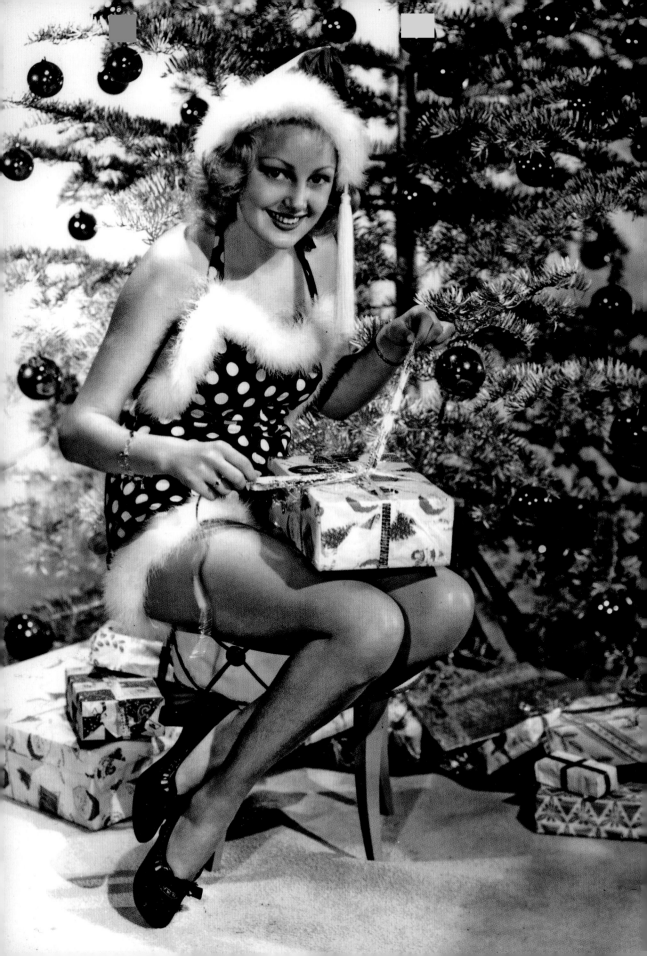

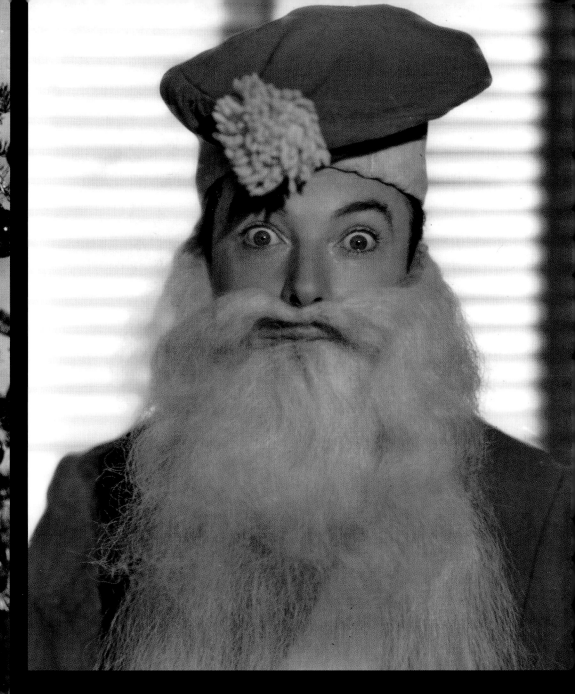

Opposite: Sexy Santa Virginia Dale proffers presents and perks beside the Christmas tree. Often playing the shapely, sensual love interest, Dale appeared in such films as *Buck Benny Rides Again*, *The Quarterback*, and *Dancing on a Dime*, all in 1940. Her career petered out in the late 1940s, forcing her move into television. *Courtesy Author's Collection*

Above: Musical comedy star Jack Haley gives a little ho-ho-ho as a bug-eyed Santa Claus in this M. B. Paul photo. Remembered affectionately for his role as the Tin Man in the classic *The Wizard of Oz* (1939), Haley sang and danced his way through many a Fox musical. *Courtesy Author's Collection*

[VERSO:] GOO-GOO EYES FROM SANTA CLAUS:
"Peek-a-boo, it's really only me behind the Santa Claus whiskers!" confesses Jack Haley. It's just his way of reminding folks that the Yuletide season is here and to prepare for the gala Christmas party he's going to have on his Saturday night Log Cabin Jamboree, which also features Virginia Verrill, Wendy Barrie, Warren Hull and Ted Rio-Rito's orchestra. (NBC-Red Network, 8:30 to 9:00 p.m. EST, with a re-broadcast for Pacific Coast listeners from 9:30 to 10:00 p.m. EST.)

Claudette Colbert admires her oversized portrait lining Vine Street in Hollywood for the 1932 Santa Claus Lane shopping season. Sophisticated and charming, Colbert gave her parts a down-to-earth common sense and humorous attitude. She earned an Academy Award for her role in *It Happened One Night* (1934). *Courtesy Author's Collection*

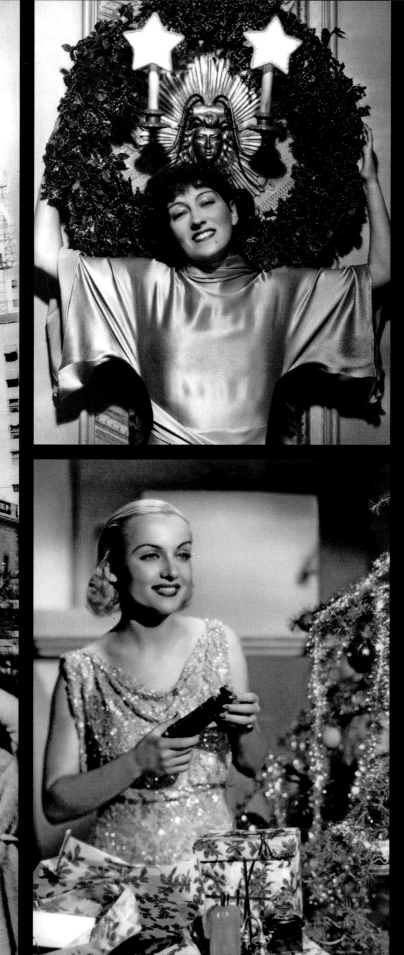

Fashionista Gloria Swanson embraces the holiday style in this Christmas photo. The petite Swanson began her career as a Mack Sennett Bathing Beauty before moving on to appear in Cecil B. DeMille marriage melodramas as a provocative clothes horse. She starred in Erich von Stroheim's *Queen Kelly* (1929) and Billy Wilder's *Sunset Blvd.* (1950). *Courtesy Author's Collection*

[VERSO:] A MERRY, MERRY CHRISTMAS! The Yuletide Spirit as personified by Gloria Swanson, lovely Metro-Goldwyn-Mayer star, who wishes everyone both in and out of the cinema world a very merry Christmas.

Comely comedienne Carole Lombard decks the halls in time for Christmas. Often playing ditzy but sexy screen heroines, the effervescent Lombard married and divorced debonair William Powell before finding lasting love with handsome Clark Gable. She died tragically at the age of thirty-three in a plane crash outside Las Vegas, Nevada. *Courtesy Author's Collection*

Platinum blonde bombshell Jean Harlow bids a hearty hello to the holiday season in this Jean Hanner photo. Displaying great comedic timing and a sexy come-on, shapely superstar Harlow stole the film *Dinner at Eight* (1933) from an all-star cast. She died tragically of uremic poisoning at the age of twenty-six.

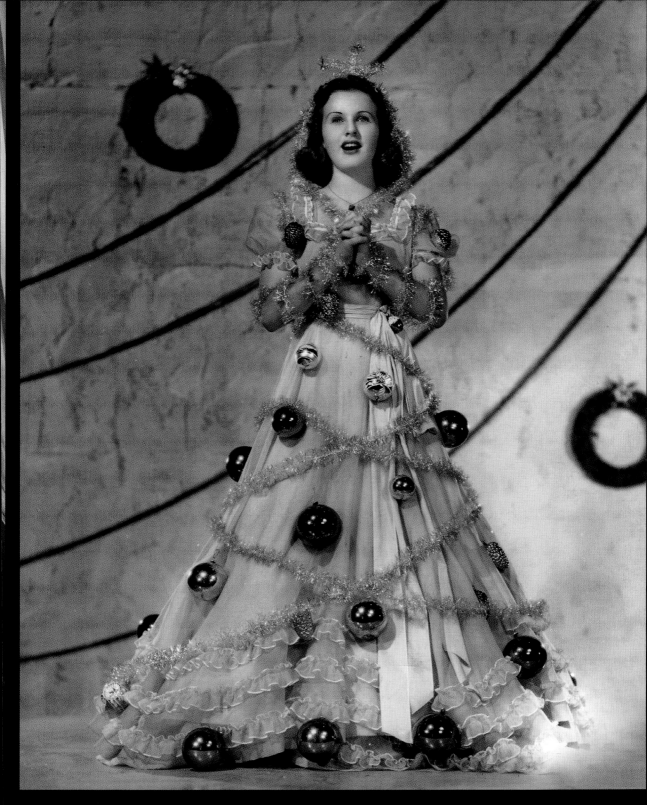

Gifted young singer and actress Deanna Durbin dons her decorative holiday apparel for Christmas. Universal's answer to M-G-M's Judy Garland, Durbin saved the studio from bankruptcy with her magnificent voice and charming personality. Uneasy with stardom, she walked away from films at the age of twenty-seven. *Courtesy Author's Collection*

[VERSO:] Christmas Carols seem to be embodied in this likeness of Deanna Durbin as the gifted child sings of the Yuletide, arrayed in a gown with ornaments resembling a Christmas tree.

Universal Pictures "THAT CERTAIN AGE" directed by Edward Ludwig to be presented by General Film Distributors Ltd. at the Leicester Square Theatre on Thursday, December 8th.

Above: Luminous, sensual Ann Sheridan hugs one of Santa's reindeer. Nicknamed "The Oomph Girl" by Warner Bros., the earthy Sheridan displayed great versatility in such 1940s films as *They Drive By Night* (1940), *Kings Row* (1942), and *George Washington Slept Here* (1942)—a shapely favorite of American GIs.

Opposite: Ravishing young Ava Gardner prepares to don her Santa Claus outfit. Luscious catnip to men, she married lusty Hollywood heavyweights Mickey Rooney, Artie Shaw, and Frank Sinatra while starring in mostly "B" pictures. Voluptuous Gardner received rave reviews for performances in *The Killers* (1946), *Mogambo* (1953), and *The Barefoot Contessa* (1954). *Courtesy Author's Collection*

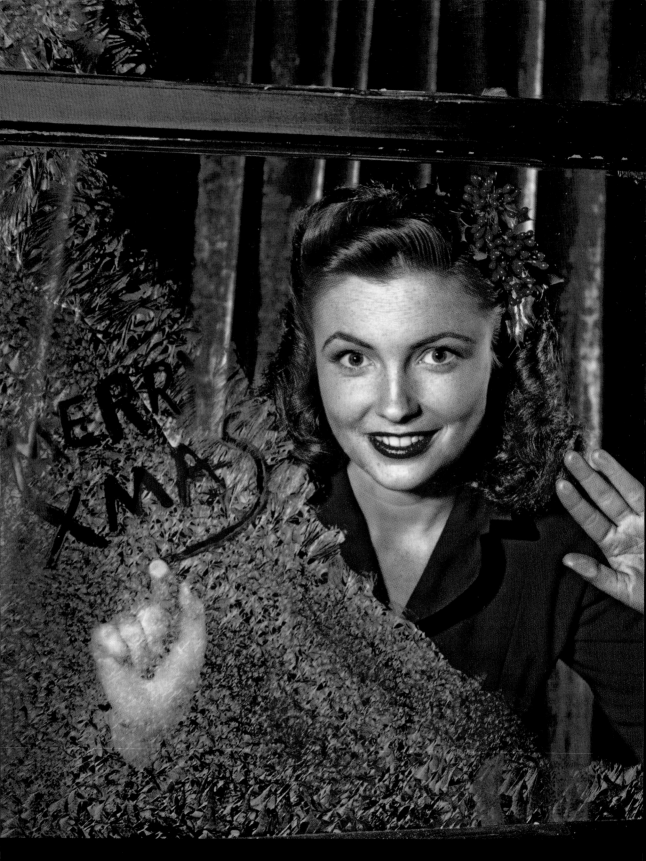

Perky young Joan Leslie draws a festive Christmas
greeting on a snowy night. Playing sweet, innocent
ingénues in such Warner Bros. films as *High Sierra*
(1941), *Sergeant York* (1941), and *Yankee Doodle*
Dandy (1942), Leslie starred as herself in the
patriotic World War II film *Hollywood Canteen*
(1944). *Courtesy Author's Collection*

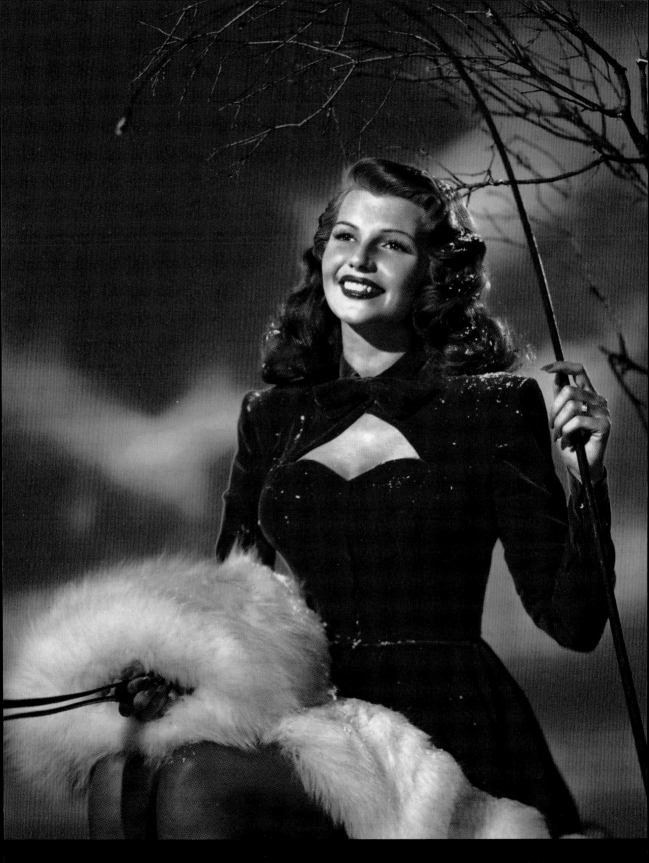

Lady in Red Rita Hayworth poses as a lovely St. Nicholas during the Yuletide season. Hayworth's potent sexual charisma exploded off the screen in such films as *Blood and Sand* (1941), *Cover Girl* (1944), and *Gilda* (1946), though she remained shy and unassuming off-screen. Early onset of Alzheimer's disease led to her death. *Courtesy Author's Collection*

Upper Right: Nubile Gwen Lee and suave Edward Nugent exchange a romantic kiss under holiday mistletoe. During her brief career at M-G-M, the sexy Lee played stylish but daffy second leads in films like *Laugh, Clown, Laugh* (1928). Nugent portrayed handsome young romantic interests in lighthearted comedies and musicals. *Courtesy Author's Collection*

VERSO:] UNDER THE MISTLETOE! Gwen Lee and Edward Nugent, Metro-Goldwyn-Mayer players both seem to have the same idea about the real Christmas spirit. And to think that mistletoe grows wild in the Hollywood hills.

Lower Right: Petite Dorothy Jordan patiently waits for her prince to come near the Christmas mistletoe. During her short four years in the film business, Jordan graduated from sultry dame to playing downtrodden, innocent roles. She retired from the screen after marrying RKO executive Merian Cooper. *Courtesy Author's Collection*

VERSO:] EXCLUSIVE WAITING!!
Dorothy Jordan, petite Metro-Goldwyn-Mayer featured player, seems to be all prepared to carry out her half of an old Christmas custom....but where, oh where, is the lucky boy? At any rate, Dorothy has decided that she'll be patient and wait. Oh, thrice lucky boy!

Opposite: Bubbly child star Shirley Temple enthusiastically celebrates Christmas Day. An apocryphal story claims that Temple stopped believing in old St. Nick when a department store Santa asked for her autograph. One of the most popular stars of the 1930s, she saved Fox from bankruptcy with her films' box office success. *Courtesy Author's Collection*

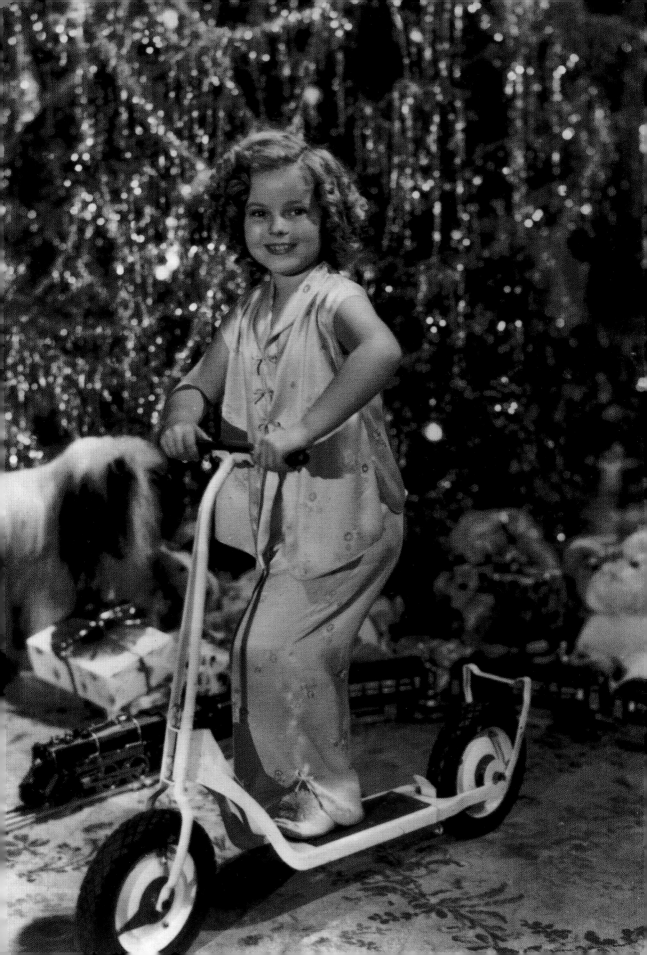

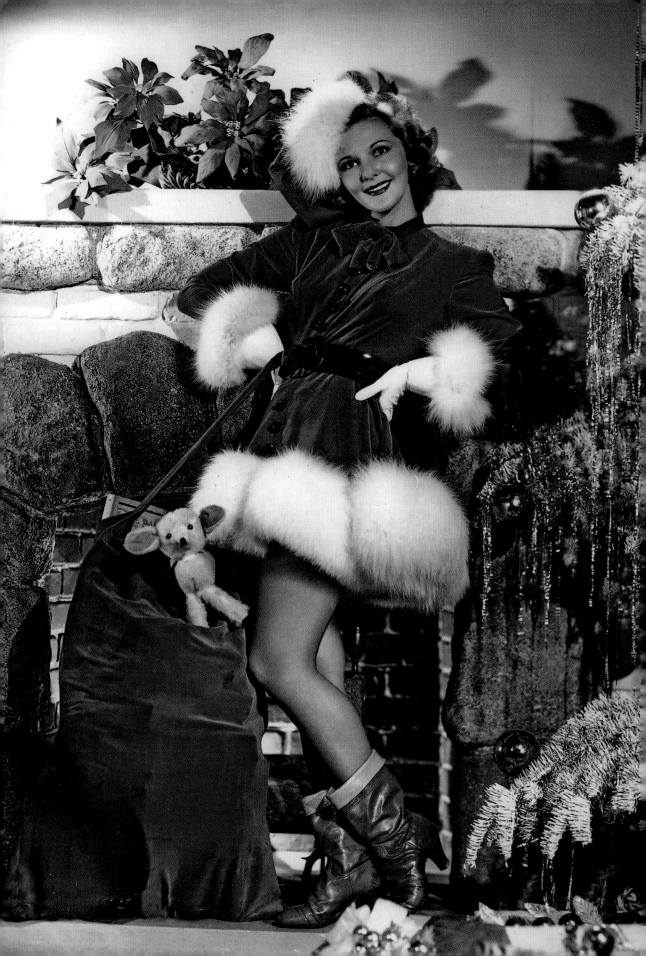

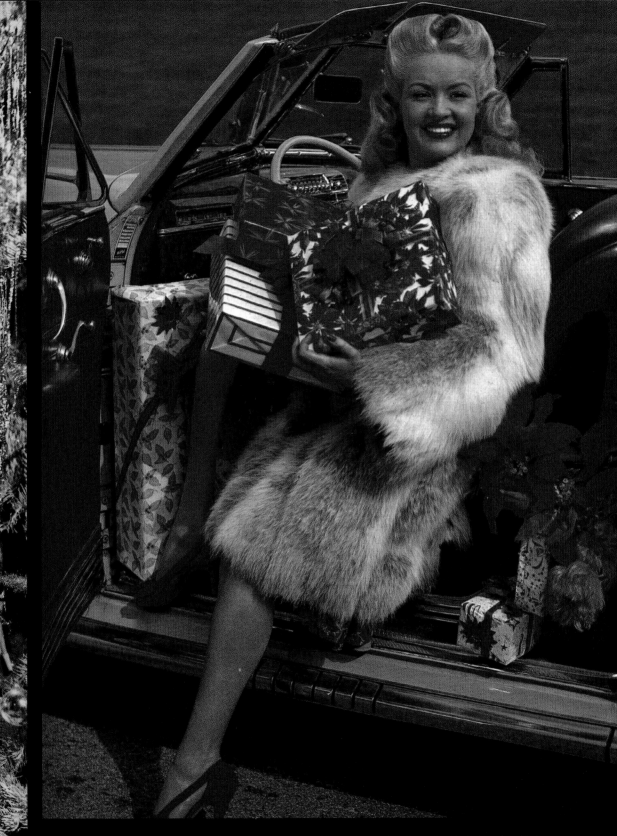

Opposite: Svelte singer/dancer Mary Martin delivers presents to good boys and girls. Born in Weatherford, Texas, Martin taught dance classes before moving on to Broadway, becoming a star when she sang "My Heart Belongs to Daddy." The mother of actor Larry Hagman, she starred in hit Broadway musicals *South Pacific* and *Peter Pan*. *Courtesy Author's Collection*

Above: Leggy lass Betty Grable finishes her Christmas shopping. Vivacious, charming Grable reigned as Hollywood's top musical comedy star in the late 1930s and early 1940s, appearing in *Million Dollar Legs* (1939), *Down Argentine Way* (1940), and *Pin Up Girl* (1944). In 1947, she ranked as the highest paid performer in America. *Courtesy Author's Collection*

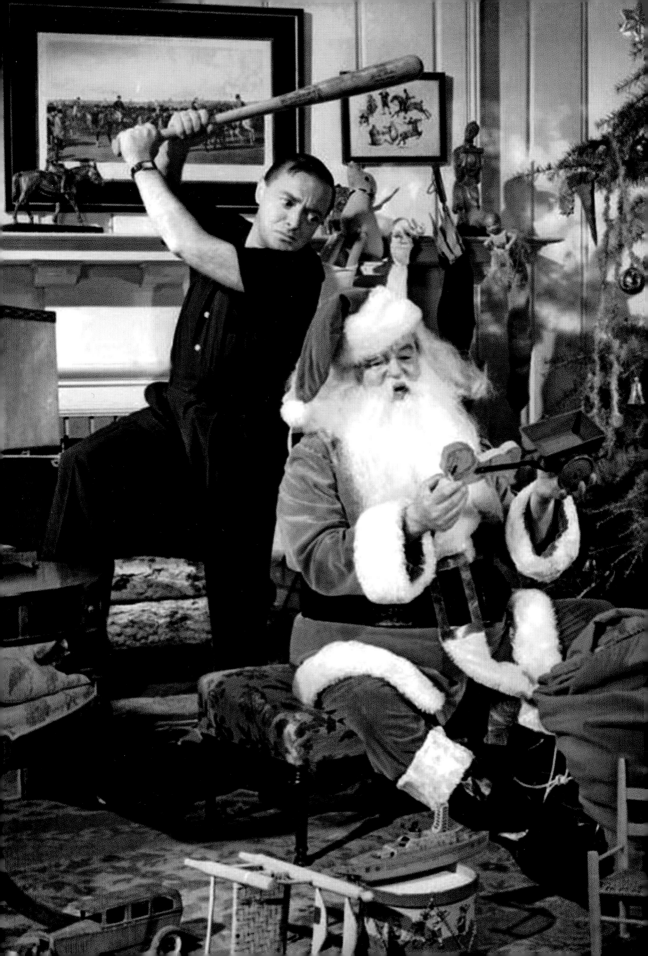

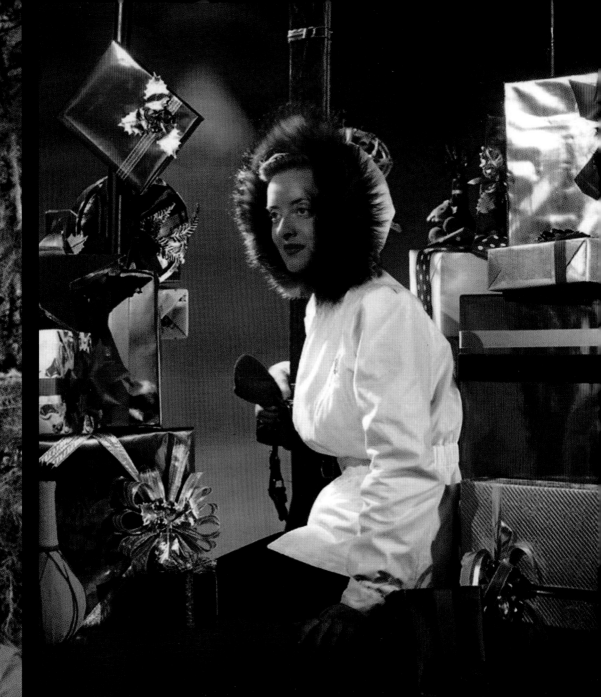

Opposite: A vicious Peter Lorre prepares to ring in the holidays by swinging at Sydney Greenstreet's gentle Santa Claus. Clicking together on screen, the diminutive Lorre and gigantic Greenstreet co-starred in nine movies, including such legendary films as *The Maltese Falcon* (1941) and *Casablanca* (1942). *Courtesy Author's Collection*

Above: Bette Davis sits surrounded by a mother lode of Christmas presents. The first female president of the Academy of Motion Picture Arts and Sciences, Hollywood Canteen president and founder Davis broke the studio's contract system in her ground-breaking career. She won two Oscars for her roles in *Dangerous* (1935) and *Jezebel* (1938). *Courtesy Author's Collection*

Swim queen Esther Williams
promotes ten more shopping days
until Christmas. Aquatic star Williams
headlined such M-G-M titles as
Bathing Beauty (1944), *Million Dollar
Mermaid* (1952), and *Dangerous When
Wet* (1953). Outside of films, she
designed swimwear and above-ground
pools. *Courtesy Author's Collection*

[VERSO:] M-G-M's Star Esther
 Williams Reminds You That
 There Are Only 10 Days to Xmas.

10

Graceful June Haver bows to mighty Santa Claus. Groomed as a possible successor to Betty Grable at Fox, pretty Haver starred in the 1945 film *Where Do We Go From Here?*, where she bewitched future husband Fred MacMurray. She entered a convent for a short time in 1953 before returning to the film world. *Courtesy Author's Collection*

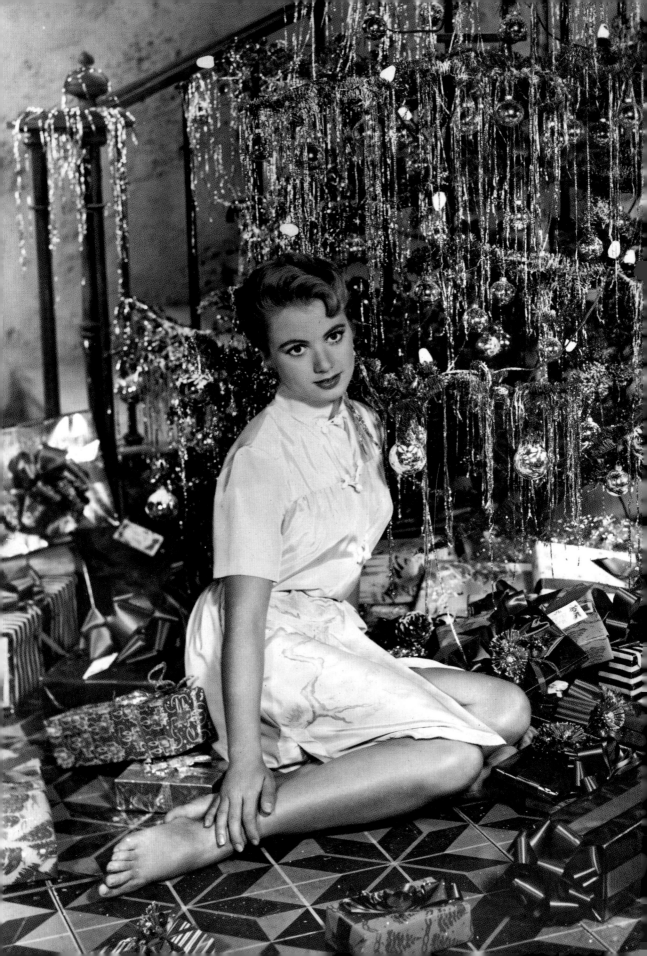

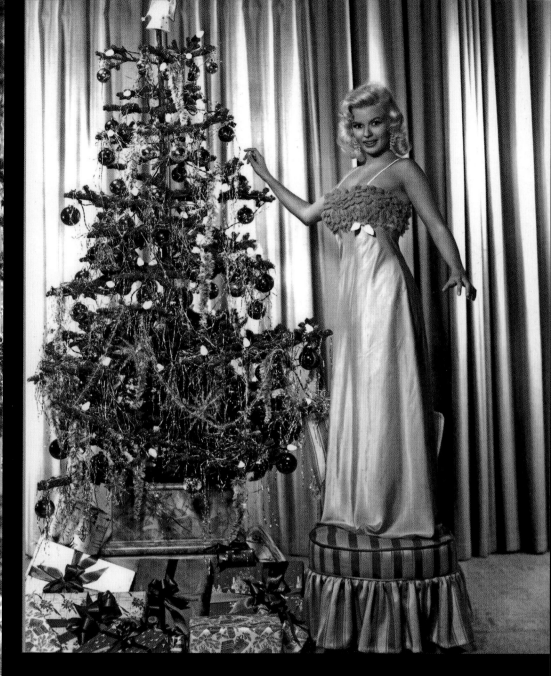

Opposite: Fetching ingénue Shirley Jones strikes a sexy pose beside the Christmas tree. Best remembered as the hip mother in the 1970s television show *The Partridge Family*, Jones also starred as "Marian the librarian" in the beloved *The Music Man* (1962). She won a Best Supporting Actress Oscar as a vengeful prostitute in *Elmer Gantry* (1960). *Courtesy Author's Collection*

Above: Voluptuous Jayne Mansfield decorates her well-endowed Christmas tree. Recognized more for her busty appearance than her acting chops, Mansfield became a star in the 1957 film *Will Success Spoil Rock Hunter?* A poor man's Marilyn Monroe, she played stereotypical dumb blonde roles throughout her career. *Courtesy Author's Collection*

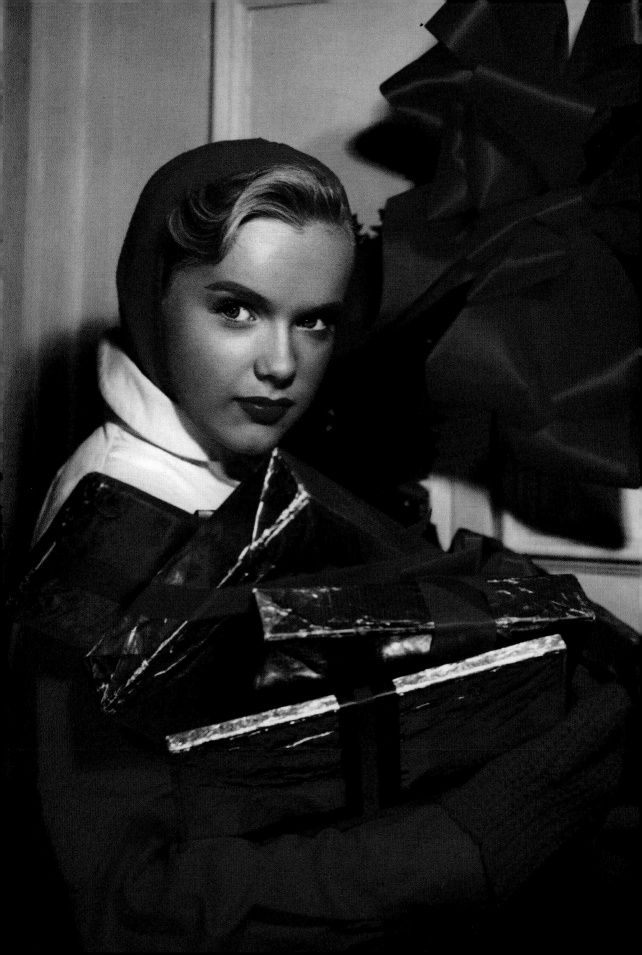

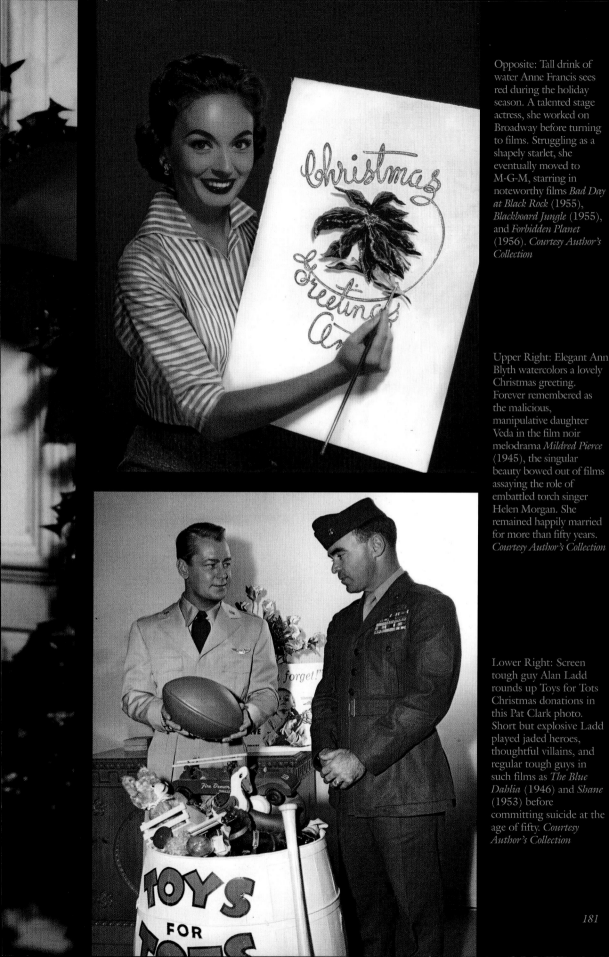

Opposite: Tall drink of water Anne Francis sees red during the holiday season. A talented stage actress, she worked on Broadway before turning to films. Struggling as a shapely starlet, she eventually moved to M-G-M, starring in noteworthy films *Bad Day at Black Rock* (1955), *Blackboard Jungle* (1955), and *Forbidden Planet* (1956). *Courtesy Author's Collection*

Upper Right: Elegant Ann Blyth watercolors a lovely Christmas greeting. Forever remembered as the malicious, manipulative daughter Veda in the film noir melodrama *Mildred Pierce* (1945), the singular beauty bowed out of films assaying the role of embattled torch singer Helen Morgan. She remained happily married for more than fifty years. *Courtesy Author's Collection*

Lower Right: Screen tough guy Alan Ladd rounds up Toys for Tots Christmas donations in this Pat Clark photo. Short but explosive Ladd played jaded heroes, thoughtful villains, and regular tough guys in such films as *The Blue Dahlia* (1946) and *Shane* (1953) before committing suicide at the age of fifty. *Courtesy Author's Collection*

181

Above: Leggy starlet Kathryn Grant prepares to mail herself as a giant Christmas present to one lucky recipient. Winning beauty pageants led to a film contract for the curvy Grant, where she played decorative love interests to a variety of top male stars. After marrying crooner Bing Crosby she retired from the screen. *Courtesy Author's Collection*

Opposite: Slaphappy Santas the Three Stooges (Curly Howard, Larry Fine, and Moe Howard) watch to see who has been naughty or nice for Christmas. Originally part of the act Ted Healy and His Stooges, the threesome began starring in their own series of Columbia film shorts in 1935. *Courtesy Author's Collection*

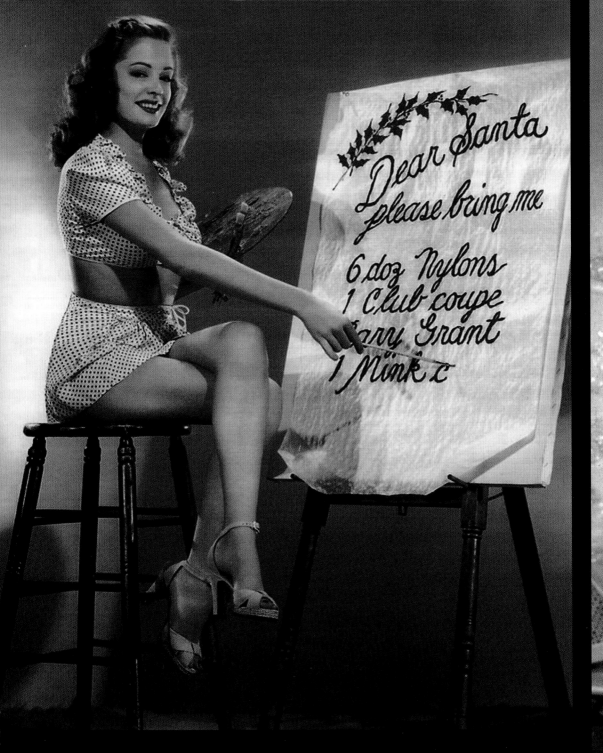

On the sign:

Dear Santa
please bring me

6 doz Nylons
1 Club coupe
...ary Grant
1 Mink c...

Above: Sultry Jane Greer drafts her Christmas wish list. After an attack of palsy left her face partially paralyzed at the age of fifteen, she learned deep facial expression, giving her performances depth. Her flinty film noir fatales in films like *They Won't Believe Me* (1947) and *The Company She Keeps* (1951) stole men's hearts and pocketbooks. *Courtesy Author's Collection*

Opposite: Luscious Elizabeth Taylor celebrates a mid-century Christmas. Married eight times, the voluptuous Taylor bewitched men with her piercing violet eyes. She gave passionate performances in films such as *Giant* (1956) and *Cat on a Hot Tin Roof* (1958) before devoting her life raising money to cure AIDS. *Courtesy Author's Collection*

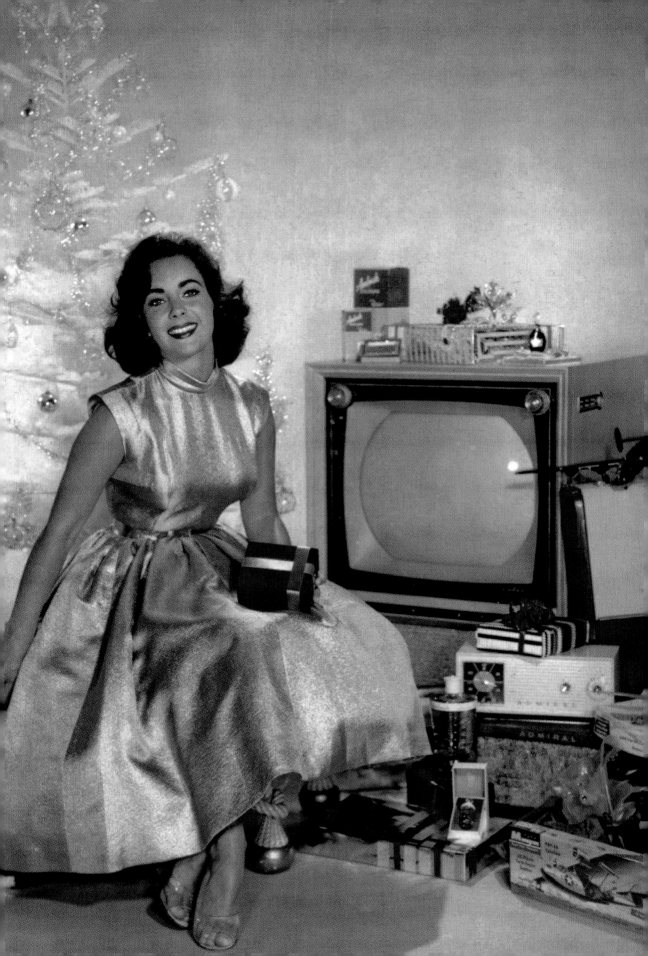

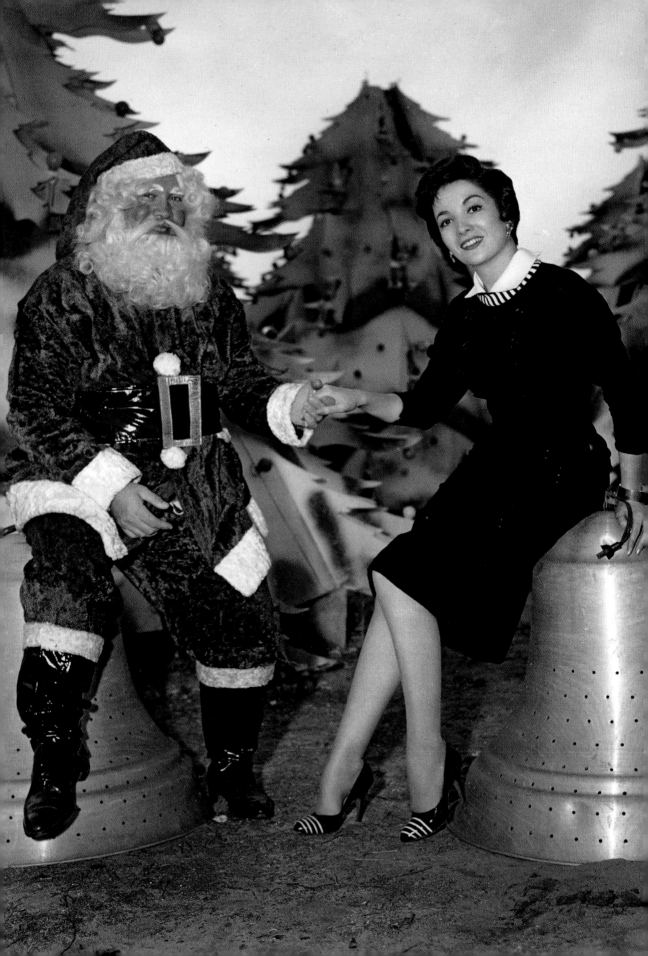

Opposite: Argentinian beauty Linda Cristal admires Hollywood Christmas parade decorations with dear old Santa Claus. Best remembered for her fiery role in the 1960s television western *High Chapparal*, Cristal played a variety of Latino and other ethnic female roles in films and TV before returning to her native country. *Courtesy Author's Collection*

Upper Left: Christmas goes to the dogs as gentle Lassie curls up with his holiday presents. A regal American collie, Lassie first starred in *Lassie Come Home* (1943) before headlining other sequels. He stole audiences' hearts with his savvy, touching performances. After making eight films, he starred in his own six-year television series. *Courtesy Author's Collection*

Left: Stunning Julie Christie salutes her mid-century modern aluminum Christmas tree. Star of such challenging and blockbuster 1960s movies as *Darling* (1965), *Dr. Zhivago* (1965), *Fahrenheit 451* (1966), and *Petulia* (1968), Christie won the Academy Award as Best Actress for her role in *Darling*. *Courtesy Author's Collection*

Lower Left: 1960s blonde bombshell Sharon Tate merrily decks her Christmas tree. Lithesome Tate played a shapely starlet in *Valley of the Dolls* (1967) and damsel-in-distress in *The Fearless Vampire Killers* (1967) before marrying director Roman Polanski. The Manson family murdered the pregnant Tate and four others in August 1969. *Courtesy Author's Collection*

Perky, petite, 1960s American Sweetheart Annette Funicello bundles up for a romantic holiday season. Walt Disney's #1 Mouseketeer in *The Mickey Mouse Club*, Funicello stole hearts with her soulful eyes and wholesome personality. She filled out some mean bikinis in 1960s beach pictures with co-star Frankie Avalon. *Courtesy Author's Collection.*

Bibliography

Dance, Robert. *Ruth Harriet Louise and Hollywood Glamour Photography*. Santa Barbara, CA: University of California Press, 2002.

Finler, Joel W. *Hollywood Movie Stills: Art and Technique in the Golden Age of the Studios.* London, England: Reynolds & Hearn Ltd., 2008.

Kobal, John. *The Art of the Great Hollywood Portrait Photographers, 1925-1940.* New York, NY: Alfred A. Knopf, 1980.

Kobal, John. *Hollywood Glamor Portraits: 145 Photos of Stars 1926-1949.* New York, NY: Dover Publications, Inc., 1976.

Louvish, Simon. *Keystone: The Life and Clowns of Mack Sennett.* New York, NY: Faber and Faber, Inc., 2003.

Shields, David S. *Still: American Silent Motion Picture Photography.* Chicago, IL: University of Chicago Press, 2013.

Slide, Anthony. *Inside the Hollywood Fan Magazine: A History of Star Makers, Fabricators, and Gossip Mongers.* Jackson, MS: University Press of Mississippi, 2010.

Stenn, David. *Clara Bow: Runnin' Wild.* New York, NY: Doubleday, 1988.

Vieira, Mark A. *George Hurrell's Hollywood: Glamour Portraits 1925 – 1992.* Philadelphia, PA: Running Press, 2013.

Vieira, Mark A. *Hurrell's Hollywood Portraits.* New York, NY: Harry N. Abrams, 1997.

Zimmerman, Tom and John Jones. *Light and Illusion: The Hollywood Portraits of Ray Jones.* Glendale, CA: Balcony Press, 1998.

Index

ABOUT THE *Authors*

Mary Mallory

Karie Bible

Mary Mallory's love for vintage film began when she was a child watching classic movies on television. While earning her undergraduate and master's degrees from the University of Texas at Austin, she processed film collections at the Harry Ransom Center, conducted research for several important film biographies, and assisted in selecting photographs for the documentary *Making of a Legend: Gone with the Wind*. After moving to Los Angeles, Mallory worked in film studios and photo archives while conducting freelance writing and research. She is the author of *Hollywoodland* and the eBook *Hollywoodland: Tales Lost and Found*. Mary blogs for *The Daily Mirror*, gives presentations, and consults on documentaries and books.

Karie Bible has been the official tour guide at Hollywood Forever Cemetery since 2002. In keeping with her love of living history, she leads the tour in vintage gowns from her collection that spans the 1920s through the 1950s. Karie has appeared in the segments *Hollywood Hideaways* and *Film Noir Fanatics* for Turner Classic Movies and has been a guest on two TCM video podcasts. She has appeared on CNN and The Reelz Channel and co-authored the book *Location Filming in Los Angeles* with historians Marc Wanamaker and Harry Medved. With an undergraduate degree in film from Santa Fe University of Art and Design, Bible has lectured at LA's Silent Movie Theatre, the Old Town Music Hall, the Homestead Museum, and the RMS *Queen Mary*.